A PERSONAL VIEW

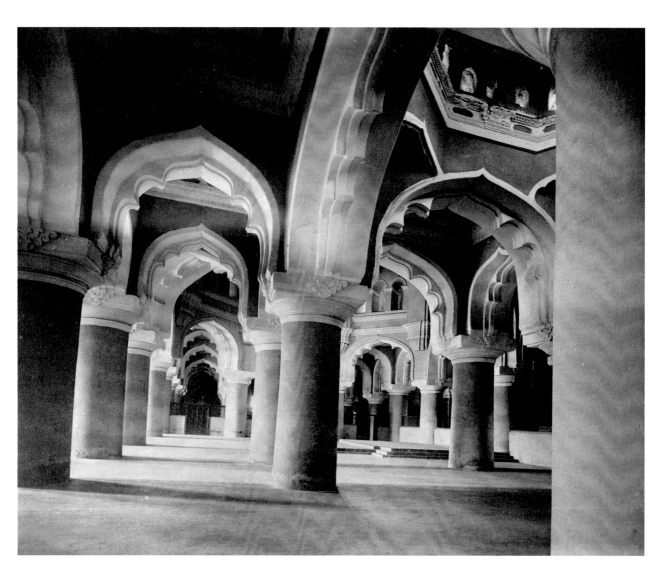

Photographer unknown
The Great Temple, Madura, India, n.d.

A PERSONAL VIEW

Photography in the Collection of
PAUL F. WALTER

THE MUSEUM OF MODERN ART,
NEW YORK

Distributed by New York Graphic Society Books
Little, Brown and Company, Boston

Copyright © 1985 The Museum of Modern Art
All rights reserved
Library of Congress Catalog Card Number 85—60761
Clothbound ISBN 0-87070-628-4
Paperbound ISBN 0-87070-629-2

Designed by Antony Drobinski, Emsworth Studios, New York
Production by Tim McDonough
Typeset by Concept Typographic Services Inc., New York
Printed by Rapoport Printing Corp., New York
Bound by Sendor Bindery, New York

The Museum of Modern Art
11 West 53 Street
New York, N.Y. 10019

Printed in the United States of America

Plate 56 is reproduced by permission of the
Paul Strand Foundation © 1981

CONTENTS

PREFACE AND ACKNOWLEDGMENTS

THE COLLECTING OF PHOTOGRAPHS is necessarily a relatively recent activity, since photography itself is no older than two old men, if their lives were laid end to end. Within this brief span, enough photographs have been made, had they survived, to fill all the cabinets and closets of the world. Those few people who have given serious thought to the lasting meanings of this extravagantly fecund species of picture, and who have committed themselves to saving some fragment of its product, have been required to form for themselves some personal definition, intuitive or otherwise, of photography's distinctive values.

What we call the history of photography is in large part an effort to discover or form connections among those pictures that have been preserved by chance or bureaucratic inertia, or by a handful of committed *amateurs* who, in choosing what to save, have proposed the outlines of histories. These proposals have been characteristically subjective, full of vitality and surprise, and of the broad concerns of culture as well as the sharply focused ones of art.

The photography collection of Paul F. Walter is the reflection not only of a love for that medium but of a deep interest in the things and places that photographs describe; one might assume that the former has grown from and been nourished by the latter. Mr. Walter's early acquisitions in photography were often pictures made in Asia, surely in part because these pictures enriched for him the intellectual and cultural context of his collections of objects of traditional Eastern art. Similarly, the subject and spirit of many other photographs in the Walter Collection relate to the places, periods, and ideas that inform his involvement with the larger world. And it is perhaps his sensitivity to these places and periods and ideas that has helped him develop his photographic connoisseurship, the ability to recognize success in a photograph, that has made his collection so rich not only in recognized masterworks but in pictures of extraordinary quality and interest that had previously been overlooked.

It is a special pleasure to exhibit this selection of photographs from the Walter Collection in the knowledge that these superb pictures are pledged to the Museum and will greatly enhance our ability to illuminate the story of photography, both in public exhibitions and in our service to individual scholars. This superb gift exemplifies the traditional process that not only has made the museums of the modern world rich in the quality and depth of their holdings but has helped keep them vital. Our museums are, primarily, collections of collections that were earlier the pride of other collectors, men and women who were captivated by the stories and sensibilities and moral values that had been captured in sequences of objects, and captivated equally by the systems by which these ideas were made flesh.

It is perhaps a special virtue of museums that the meaning of their riches is not wholly coherent—not the perfect expression of a fixed meaning, as a book might be, but rather like a colloquium among a succession of generations, held together by their common love of an idea that is never quite precisely defined, and that forever slowly changes.

*

The essay on private collecting by John Pultz, Beaumont and Nancy Newhall Curatorial Fellow at the Museum from 1981 to 1984, and the notes on the individual plates, have profited from the assistance of scholars and authorities in a remarkable variety of fields, and by two of the photographers whose work is included. We express our gratitude to Milo Beach, Williams College, Williamstown, Mass.; Linda Benbow and David Haberstich, Smithsonian Institution, Washington, D.C.; Ilse Bing; Janet F. Buerger and Joanne Lukitch, International Museum of Photography at George Eastman House, Rochester, N.Y.; Peter C. Bunnell, Prince-

ton University, Princeton, N.J.; Henri Cartier-Bresson; Genevieve Christy; Walter Clark; Douglas Cluett, Croydon Airport Society, Croydon, England; Virginia Dodier; William Roame Frame; Marion Fricke, Edition Marzona, Dusseldorf; Michel Frizot, Centre Nationale de la Photographie, Paris; Helen Gee; Lori Gross and Julie Trachtenberg, Canadian Centre for Architecture, Montreal; L. Fritz Gruber; Maria Morris Hambourg; Mark Haworth-Booth, Victoria and Albert Museum, London; Françoise Heilbrun, Musée d'Orsay, Paris; Jean Humbert, Musée de l'Armée, Paris; André Jammes; Harry H. Lunn, Jr., Lunn Ltd., Washington, D.C.; David H. McAlpin; Barbara McCandless, Humanities Research Center, University of Texas at Austin; Lee Marks, Gilman Paper Company, New York; Michael Meister, University of Pennsylvania, Philadelphia; Marjolaine Mourot-Matikhine, Musée de la Marine, Paris; Marjorie Munsterberg and Theodore Reff, Columbia University, New York; Dorothy Nelhybel, The Burndy Library, Norwalk, Conn.; Beaumont Newhall; Arthur Ollman, Museum of Photographic Arts, San Diego, Calif.; Mary Panzer; Leland Rice; John Rohrbach, Paul Strand Archive and Library, Millerton, N.Y.; Walter Rosenblum; Nancy Ann Roth; Gerd Sander, Sander Gallery, New York; Catherine Scallen; Robert Schoelkopf, Schoelkopf Gallery, New York; Sara F. Stevenson, National Galleries of Scotland, Edinburgh; Marie de Thézy, Bibliothèque Historique de la Ville de Paris; Kirk Varnedoe, Institute of Fine Arts, New York University; Magda Vasilov, City University of New York; Sam Wagstaff; Michael Weaver, Oxford University, Oxford, England; and Susan I. Williams.

The curatorial staff of the Department of Photography, as joint author of this book, expresses its appreciation to Jane Fluegel, editor of the texts, for her essential and gracious work in clarifying and rationalizing the contributions of five authors. The book's design is by Antony Drobinski, and the planning and supervision of its production has been the responsibility of Tim McDonough.

Special thanks are due Terrence Abbott, curator of Mr. Walter's collections, for his patience and precision in assisting us with countless questions, and for facilitating our study of the collection.

Our deepest gratitude goes of course to Paul Walter, for his great generosity to the Museum, and for his important service to the art of photography and its audience.

John Szarkowski
Director, Department of Photography

COLLECTORS OF PHOTOGRAPHY

John Pultz

ANY COLLECTOR OF ART, in choosing to acquire one object rather than another, reflects not only his own taste but also the underlying assumptions and attitudes of his time. Paul F. Walter, the collector of the photographs assembled in this book, has shown a vision of photography at once personal and contemporary.

There have been collectors of photography ever since the announcement of its invention in 1839. The collections they formed have varied over time, linked as they are to changing attitudes toward photography and its status as a means of communication and as art. Among those individuals who have collected photographs, one can distinguish four major attitudes toward the central meaning of photography: documentary, aesthetic, cultural, and modernist. Even though each of these attitudes is specific to a more or less coherent time period, the collectors themselves remain linked by a passion for photography and a will to possess the physical objects the medium has produced.

*

To the nineteenth-century collector, the photograph—be it a portrait, architectural view, landscape, or record of an event—was a means to possess aspects of the visual world. This attitude can be called "documentary." Although today the word has come to denote a style, it is used here to stress a congruence of meaning between the photograph and what has been photographed. The nineteenth-century collector was interested in both the sentiment and the visual information a photograph contained. Art and report were not distinct. In harmony with the artistic conventions of their time, nineteenth-century photographers sought to find sublime and picturesque beauty in the close observation of nature; they did not oppose aesthetics and the natural world but found the source for art in nature.

From the time of its invention, photography was closely linked with the graphic arts and, like them,

served to produce artful documents. The rows of framed photographs that cover the walls of a civil engineer's office at Cornell University (page 12) serve to bring together and organize visual evidence of geographically disparate locations. Collections predicated on this documentary stance were so pervasive that information on specific collectors is sparse. An exception is Chauncy Hare Townshend (1798–1868) of England. Townshend was a Victorian dilettante of poetry, natural history, and the arts.[1] His house in London was designed to display to their best advantage the wide range of objects he collected, including contemporary paintings, Old Master prints, books, gems, fossils, Swiss coins, and photographs. For Townshend, collecting photography was an extension of the Victorian interest in the material world as seen with a careful and, at the same time, aestheticized eye. With the exception of stereographs, which he kept together perhaps for convenience, Townshend's photographs were integrated with the rest of his collection: he stored mounted exhibition photographs in presses with fine prints and shelved photographically illustrated books with other volumes. This organization suggests that Townshend considered the similarities of photographs to the other reproductive media greater than the differences.

Townshend's collection included Crimean War photographs by Roger Fenton, seascapes and tree studies of the Forest of Fontainebleau by Gustave Le Gray, and landscapes by Albert Giroux and Camille Silvy. In Townshend's time these photographs were already discussed in an aesthetic context. A Fenton war photograph, a print of which Townshend owned, was cited in the *Journal of the Photographic Society* of London in 1855 as a "picture of a kind of subject not often attempted ideally by painters." In 1857, when Le Gray's seascapes were exhibited in London, the same journal called one of them the "most successful seizure of water and cloud yet attempted."[2]

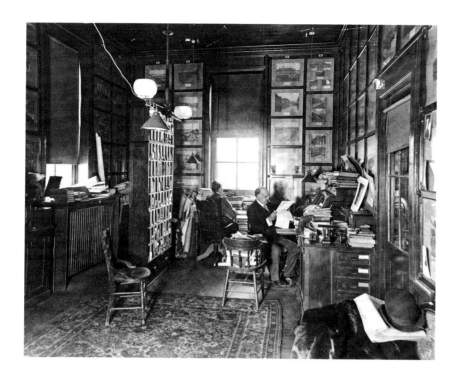

Photographer unknown. Estévan A. Fuertes, director of civil engineering at Cornell University, 1873–1902, in his private office. Courtesy Cornell University

Nineteenth-century photographs were frequently assembled in albums. This was done for ease of handling and to protect fragile albumen prints on thin paper. Those albums that have remained intact are in many ways the best record of nineteenth-century collecting, because the selection and sequencing of the pictures is that of the original collector and reflect the criteria he used.

A very fine example is one from 1865 assembled by the Englishman James Patton and titled by hand on the first leaf, "Nature and Art."[3] It is similar to the albums nineteenth-century travelers assembled after their Grand Tours to the natural wonders and monuments of Europe and the Mediterranean lands. They would buy at the site (or later from a catalogue) photographs of landscapes, city scenes, buildings, monuments, and paintings to keep as souvenirs. Patton extended this model, transforming a record of travel into something at once more poetic and didactic, placing landscapes, architectural views, and reproductions of paintings in a well-thought-out, intellectually rigorous sequence. One section pays homage to Prince Albert, grouping photo-graphs of his German homeland, his wedding to Queen Victoria in 1840, their children, and the mourning of his death in 1861. This lyrical tribute to Albert, himself a great collector and promotor of taste in the Victorian age, suggests that Patton aligned himself aesthetically with the Prince Consort and took seriously his own efforts at collecting as reflected in the album.

Another widespread practice in the nineteenth century was the assembling of cartes de visite in albums. The collection of The Museum of Modern Art contains a commercially manufactured example with slots and windows to hold commercially produced cartes de visite.[4] An unknown collector has organized by profession portraits of many of the nineteenth century's great painters, writers, and composers, as well as royalty and military leaders. The impulse to collect images of contemporary notables can be found as early as 1641, in the *Iconography* of Anthony Van Dyck. *Galerie contemporaine,* a series of seven volumes published in France between 1876 and 1885, brought the practice up to date, reproducing in woodburytype photographic portraits of the day's leading figures.

*

In the 1880s, in reaction to the growing force of industrialization, the Aesthetic Movement in art emerged

under the influence of William Morris and others. This group sought to escape the squalor of urban industrialism through an aesthetic stance toward life and proposed to replace the uniformity of mass-produced goods with well-created handmade objects. Faith in scientific observation as a way of understanding the workings and meaning of the world, strong in the 1860s, '70s, and '80s, gave way to a new openness to mysticism, which prompted artists to give form to the unseen forces and energy of life rather than to the logical causality of the visible world.[5]

Photographers who responded to the Aesthetic Movement gave up the camera's potential as a faithful and expressive witness to produce photographs that drew attention to themselves as objects of great beauty and value. These photographers, calling themselves pictorialists, rejected manufactured papers for hand-coated ones, and sought to counter the commonness of commercial photographs and halftone reproductions with singular prints made of precious metals with richly textured surfaces.

The pictorial photographers formed a small, coherent group. They were amateurs with the economic means to pursue photography full or part time, without making money from it. Most of them knew one another and each other's work through camera clubs, illustrated journals, and local and international exhibitions spawned by the pictorialist movement. Pictorialism, as embodied in these institutions, was strongly polemical, finding its raison d'être in winning recognition for photography as a means of artistic expression. The collectors of pictorial photographs were almost all pictorial photographers themselves, for whom a collection of the best examples of their peers' work would be proof of photography's artistic worth.

As early as 1891, George Timmins (1885–1920) began collecting photographs with this belief. Timmins, the head of the Syracuse (New York) Tube Works and an amateur photographer, acquired between 1891 and 1896 nearly three hundred works by seventy-eight American and European pictorialists in a collection he hoped would further pictorialism's claim to aesthetic acceptance.[6] Timmins said in 1897 that "my collection of photographs has been made in order to ascertain as far as possible what has been accomplished in the art of picture-making by photography. I feel sure that a study of my modest collection is sufficient to convince any candid critic that photography has fairly earned the right to a place among the fine arts."[7]

Other photographers were building collections at this time. By 1898, F. Holland Day (1864–1910) owned some sixty prints. William B. Post (1857–1925), a member of the New York Stock Exchange and an amateur photographer, began to form a collection in that year which one writer suggested could surpass the preeminence of Timmins's.[8] By the turn of the century, collecting by pictorial photographers was common enough that The Camera Club of New York could organize an exhibition drawn exclusively from private holdings.[9]

The collections of Alfred Stieglitz in New York and Ernst Juhl in Hamburg were especially important in the advocacy of pictorialism's goal. Stieglitz (1864–1946) championed pictorialism in his various activities as editor of the prestigious quarterly *Camera Work*, as director of the Photo-Secession gallery "291," and as writer, photographer, and collector.[10] Stieglitz, who first collected photographically illustrated books while in Germany between 1885 and 1889, appears to have acquired

Heinrich Kühn. *Alfred Stieglitz*, 1904. The Museum of Modern Art, New York. Gift of Edward Steichen

his first photograph in London in 1894. He continued to add to his collection into the 1930s, but his period of greatest activity was from 1903 to 1908.[11]

Juhl (1850–1915) similarly promoted pictorialism in Germany. By profession a merchant and engineer, Juhl founded the Amateur-Photographen-Verein Hamburg in 1892, organized ten international exhibitions of pictorial photography in Germany between 1893 and 1903, and edited the journals *Photographische Rundschau* and *Camera-Kunst*. Juhl began to collect in 1893 in conjunction with the organization of his first exhibition. When his collection was shown in 1910 at the Kunstgewerbe Museum in Berlin, it contained work by over sixty photographers from ten countries, including Holland, Russia, and Denmark.[12]

As advocates of a specific style, Stieglitz, Juhl, and others focused their collections on the photographs of their contemporaries. The only exceptions were a few of pictorialism's artistic progenitors, such as Julia Margaret Cameron and the Scottish collaborators David Octavius Hill and Robert Adamson.[13] Works by these earlier masters were used by Stieglitz and Juhl to inspire their fellow workers and establish a historical context for pictorialism. Stieglitz reproduced photographs by Cameron and by Hill and Adamson in *Camera Work*. Juhl included the works of these British photographers, as well as Henry Peach Robinson, in his 1910 exhibition, citing the British as the first to recognize the expressive potential of photography.

Just as many pictorialists defended their claim to photography's status as an art with formal and technical references to the other graphic arts, so Stieglitz borrowed from them a notion of print connoisseurship: "Can we not draw a parallel with the field of engraving and etching, where only the most select and magnificent pieces share the honor of being called 'Artist's Proofs' and reach a corresponding price?" This comes from Stieglitz's most complete statement on collecting and connoisseurship, published in German in 1903 by Juhl's *Camera-Kunst*. Stieglitz suggested that collectors should follow a rule he used for his own collection: to "acquire only pictures of really outstanding artistic worth." For Stieglitz, "artistic worth" implied financial value, and both were inseparable from the quality of the individual print. "Almost always," he wrote, "it is possible to find one print that conveys the intentions and the concepts of the artist more completely than any other."

To acquire that single best print, Stieglitz advised, the potential collector should be willing to pay what might seem to be an excessive price: "What today may seem an exorbitant price can perhaps be thought of tomorrow as cheap." As evidence, Stieglitz said that a print by one of the most famous photographers of the day was bought by a collector in 1895 for $50 and that three years later another print from the same negative went for $110.[14]

What Stieglitz did not say was that artistic worth and financial value were subject to changes in taste. Pictorialism began to lose power as a movement soon after its goal of recognition had been achieved in 1910, when the Albright Art Gallery in Buffalo, New York, turned over its galleries to Stieglitz and other pictorialists for the *International Exhibition of Pictorial Photography*. In the years following, a new notion of the artistic potential of photography began to emerge, paralleling the shift in European art from the languid fin-de-siècle style to the bold geometries of Picasso and others.

This shift from the pictorialist ideal to modernism affected collectors. Stieglitz himself is a dramatic example. The works in his collection from 1915–17 by Paul Strand and Charles Sheeler, as well as his own conversion to straight photography, led Stieglitz to conclude that modernism had rendered most pictorialist prints of "greater historic value than art value."[15] Stieglitz's disaffection with his collection was manifested at this time by his putting it in storage. The collection on which Stieglitz had spent some $15,000 now had little financial value.[16]

By 1921 Stieglitz's own photographs were mostly 4 x 5 contact prints on inexpensive, commercial, gelatin-silver paper (rather than the platinum paper he had used earlier). That year, in contrast to his statement of 1903, Stieglitz said: "My idea is to achieve the ability to produce numberless prints from each negative, prints all significantly alive, yet indistinguishably alike, and to be able to circulate them at a price not higher than that of a popular magazine or even that of a daily paper."[17]

*

Simultaneous with the formation of collections predicated on an aesthetic attitude there emerged collectors who approached photography as a broad cultural phenomenon. They perceived a photograph as at once an

object of aesthetic delectation, a record that evoked the past, and an artifact from photography's evolving history. Whether the focus of their interest was photography's technical evolution, social history, or aesthetic possibilities, such collectors approached the medium not as a simple fact but as a process expressing continuing change.

In 1934, in a eulogy to the French collector Gabriel Cromer, the early French historian of photography Georges Potonniée implicitly compared the invention of photography to that of printing, suggesting that the two shared a revolutionary impact on human knowledge and communication: "To measure the extent of [Cromer's] work, imagine a contemporary of Gutenberg having kept for us the efforts today lost—the ignorant attempts, all the first proofs which preceded, accompanied, or followed the discovery of printing."[18] Cromer was the first person, Potonniée observed, to act on the conviction that photography's impact on the world merited the preservation of its early examples and ephemera.

Potonniée's comparison of photography to printing serves to characterize not just its cultural significance, but the milieu in which Cromer and other Frenchmen collected photographs.[19] Many began as collectors of rare books. Even those who did not do so shared with the bibliophiles their antiquarian tastes and interests, as well as the very locus of their searches. Both plied new and secondhand bookshops, stalls along the Seine, suburban flea markets, and estate auctions at the Hôtel Drouot, Paris. Their finds were similarly embraced. The photography collectors' multifaceted appreciation of a picture as an object and for its content paralleled many bibliophiles' enjoyment of a book for its binding and printing as well as for the written word within.

Cromer (1873–1934) trained for the law but pursued photography instead, becoming an accomplished amateur known for the portraits he exhibited at salons and an ability to print in a wide variety of processes. His collection comprised not only photographs but also documents and artifacts pertinent to the invention and development of photography. It surveyed the evolution of the camera with examples of the prephotographic camera obscura and camera lucida and 170 models of photographic cameras, including the Giroux model of 1839 that L.-J.-M. Daguerre used.[20] According to one visitor's account, Cromer possessed the "original patents of Daguerre and Niépce, the first photographic efforts of these two inventors, and even Daguerre's redingote, decorated with the red rosette King Louis-Philippe awarded him."[21]

In addition to photographs that were themselves examples of technical advances, other works in Cromer's collection documented anecdotal aspects of the medium's history and included a daguerreotype portrait of Daguerre himself, a portrait of one of the first critics of art photography, and a view of a photographer at work.[22] The first Golden Age of French photography, when artists and amateurs experimented with the camera's potential for expressive documentation, was represented with works from the 1850s by Henri Le Secq, Edouard-Denis Baldus, Le Gray, Adolphe Braun, and Charles Marville, whose photograph of Chartres Cathedral is also represented in the Walter Collection (pl. 5).

Cromer used his collection as the basis for research and at least one exhibition. He published the results of his investigations in the *Bulletin de la Société Française de Photographie*[23] and drew heavily from the collection when he organized the first part of the exhibition *Centenaire de l'invention de la photographie* (1925) in Paris.

Cromer's view of photography was perhaps similar to that which guided Henri Jonquières as editor of *La Vieille Photographie depuis Daguerre jusqu'à 1870* (1931), a book of photographs drawn mostly from private collections. Works from Cromer's collection dominate the book, and in the 1935 edition, which appeared the year after the collector's death, Jonquières acknowledges Cromer's collaboration as essential. In the preface Jonquières suggests that the book be looked at as an album of old family photographs, full of humanity and psychological insight: "One is astonished to feel a powerful interest awaken in the course of these pages where disparate things, which seem to us, *a priori*, out of date, are crowded together. An extraordinary impression of life becomes clear, which is moving and profound." Despite the emphasis on the evocative powers of the photographs, the book is not just a picture book. The viewer is reminded that these are not reproductions of randomly selected images but express the interests of individual collectors, whose names appear with each plate and again in the index. The index itself further reflects the context of the works, citing for each photographer nationality and profession (some were amateurs)

and for each photograph the medium of the negative and of the print.

Cromer's collection was followed closely in time and in quality by those of three other Parisians: Georges Sirot, Albert Gilles, and Victor Barthelemy.

Sirot (1898–1977), a romantic in love with the nineteenth century, found in photographs a way to regain the past. Left financially secure by his father, he worked two days a week as an advertising broker. In 1919, while browsing through a book sale, Sirot happened upon a portrait by Nadar of the French writer George Sand. Sirot said later of seeing the photograph: "George Sand was before me, with her beautiful eyes, but also with her masculine traits and her sensual lips. This lifelike image, so far from the Aurore Dupin [Sand's real name] that I had imagined, brutally explained to me Chopin [with whom Sand had an affair that lasted from 1838 to 1847], Musset [with whom she had a stormy liaison from 1833 to 1835], and the rest."[24] With the discovery that photographs could give him access to the past, Sirot began buying photographic portraits of writers, musicians, artists, and other personages of the nineteenth century and soon had over three thousand of these portraits.

Sirot then widened the scope of his collection to include many aspects of French life of the second half of the nineteenth century, especially the 1880s and '90s. There are pictures of tradesmen (a dog clipper, a farrier, bakers, tinkers, and two butchers), artists, and performers. There are groups of people at leisure—in a balloon, in a private garden, on an outing at the foot of Mont-Saint-Michel. There are records of events, such as the preparations for the inauguration of the Suez Canal and an accident at the Gare Montparnasse, Paris, in which a locomotive fell from an elevated platform to the street. There are documents of what was novel—a count on an 1887 steam tricycle—and what was new—the crypt of Sacré Coeur and the buildings for the Exposition Universelle of 1867. Sirot lived through these pictures, many by unknown photographers, and worked hard to reconstruct the history of whatever was contained in each one.[25]

Gilles, a cloth broker, and Barthelemy, a clerk, were of more modest means than Sirot. For them photography afforded an inexpensive way to collect relics of old Paris and the *ancien régime*. With few competitors, prices remained low. Gilles was attracted first to da-

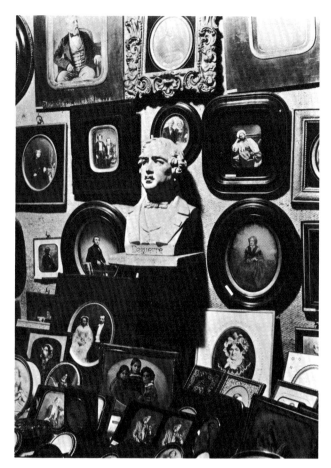

Photographer unknown. The Gilles Collection, Paris, n.d.

guerreotypes (he owned the largest one in the world, according to Sirot) and then went on to collect apparatus, photographic prints, and albums. Barthelemy's line of work—collecting overdue accounts for a store—gave him access to apartments where he often discovered photographs that otherwise would not be for sale. Gilles and Barthelemy lived abstemious lives in order to pursue their passionate interest in photography. According to Sirot, Barthelemy lived in a small apartment with his collection crammed into department store boxes. To conserve his limited storage space, he would sometimes cut a photograph's mount flush with the image. Gilles did without a car so that he could use the garage of his house to store his collection.

Sirot, Gilles, and Barthelemy did not conduct formal research into the history of photography, but their collections were important resources for others. The three were among the chief lenders to the historical section of the *Exposition internationale de la photographie con-*

temporaine (1936), at the Musée des Arts Décoratifs, Paris.[26] The following year the exhibition *Photography 1839–1937*, organized by Beaumont Newhall at The Museum of Modern Art, New York, depended heavily on historical material from the collections of Barthelemy, Gilles, and Sirot. Barthelemy lent over 120 photographs, including portraits by André-Adolphe-Eugène Disdéri, Pierre Petit, and Etienne Carjat; street scenes by Marville; architectural views by Baldus, Fenton, Le Secq, and Charles Nègre; a battle scene from Balaklava by Fenton; and a still life by Braun. Gilles lent some sixty daguerreotypes, mostly portraits by unidentified practitioners, as well as miscellaneous apparatus. Sirot lent eleven portraits, including a daguerreotype attributed to Mathew Brady and two prints by Nadar: one of the lithographer Honoré Daumier and the other of the critic Théophile Gautier.

In Austria and Germany two major collectors emerged during the late nineteenth century. Like the French collectors, they embraced photography in broad cultural terms, although their concern was inflected by professional involvement with photochemistry and graphic-arts technology.

Josef Maria Eder (1855–1944), Professor of Photochemistry at the Vienna Technische Hochschule (Technical College) and founding director of the Graphische Lehr- und Versuchsantal (Institute for Teaching and Research in Graphic Arts), also in Vienna, began in 1890 to build a collection that centered on the history of photography and the graphic arts.[27] His collection and the institute he founded exhibited a very broad view of photography, both in terms of its possible uses and the forms the medium could take. Types of photographs that seemed mutually exclusive to some collectors—unique prints, multiples, photomechanical facsimiles—were not so to Eder. For him, each had a place in a private collection formed to enhance the study of the "entire field of photography, in its application to portraiture, landscape, and scientific photography as well as its use in the photomechanical processes (heliogravure, photolithography, line etching, halftone, and both hand photogravure and rotogravure, etc.)."[28] The collection was unified by an interest in optical laws and chemical processes rather than by judgments as to the content or artistic worth of specific examples. Procedure, rather than artistic success, defined for Eder what to collect, a principle that informed as well his *History*

of Photography (1905), which is an unfolding of inventors, inventions, and applications of inventions.

Erich Stenger (1875–1957) was a friend of Eder's and formed a collection in Germany from a similar perspective.[29] A professor of photographic chemistry and director of the photochemical laboratory at the Berlin Technische Hochschule, Stenger collected, between 1900 and 1955, examples of photographic processes as well as more than four thousand books on photography and the graphic arts. "At the time of World War II [Stenger's] collection was said to be the largest in private hands anywhere in the world," wrote Beaumont Newhall in 1958.[30]

The cultural role of photography is stressed in Stenger's *History of Photography: Its Relation to Civilization and Practice.* "What the invention of the art of printing contributed to the dissemination of thought and the spoken word," his preface begins, "was fortunately supplemented in pictorial presentation by the invention of photography.... We are now seldom conscious of how largely this light-writing has contributed to our cultural progress."[31]

Stenger not only collected but also was active in the exhibitions in Germany in the 1920s that promoted a "new vision" of photography. The broad definition of the medium that informed Stenger's collection encompassed many of the same forms and uses of photography that interested László Moholy-Nagy and other artists of the avant-garde. In the influential exhibition *Film und Foto* (1929), in Stuttgart, contemporary photographers were represented not only by photochemical prints but also by posters, advertisements, and other products of the graphic arts. Moholy-Nagy borrowed from Stenger's broad collection for the introductory room, in which he attempted "to group photographs in the exhibition according to their various domains of employment."[32]

In the years following World War II, collections were begun by André and Marie-Thérèse Jammes and Helmut and Alison Gernsheim. While continuing to view photography as a cultural phenomenon, these collectors also saw photographs as objects that could be studied as works of art. This position was inevitably affected by modernist attitudes of the 1930s, especially the growing acceptance of photography as an art and as inherently modern. Their view of photography as art suggested to these individuals that one could write a

history of photography modeled on art history, for which a collection of photographic prints and books would be essential. Modernist theory supported the position that neither the evocation of the past nor technology alone should define a collection.

André Jammes articulated this view in an article on a 1961 photography auction held in Geneva by the dealer Nicolas Rauch. Jammes wrote that the auction's success had been assured by the "historical and aesthetic value of the collection and not by its anecdotal interest."[33] Fascination with the nineteenth century did not motivate the purchasers, for "this collection of pictures included practically no pictorial works such as portraits of celebrities, family groups, old street scenes, topographical or documentary miscellanies which, to the public eye at least, provide the only real interest in 'old photographs.'"

Jammes (born 1927), a rare-book dealer in Paris, had come to collect photographs through an interest in the history of printing and bookmaking. Along with his wife Marie-Thérèse, André Jammes formed a collection especially rich in the first century of French photography, from Joseph-Nicéphore Niépce to Eugène Atget, and assembled a library of documents with the conviction that these "would be fundamental to the writing of histories of photography and of the illustrated book."[34]

Jammes saw his work as a continuation of the preservation of photography's heritage begun by earlier collectors and dealers and has written with appreciation of their early recognition of the medium's value. Jammes acquired works from French collections that had been formed between the wars, especially those of Cromer, Sirot, and Gilles. In addition, Jammes acquired the stock of booksellers who had tried unsuccessfully to establish a market for photography in the 1930s, such as E. P. Goldschmidt and Ernst Weil in London, Nicolas Rauch in Geneva, and Pierre Lambert in Paris. To secure photographs directly from the families and estates of nineteenth-century masters, Jammes traveled throughout France, Germany, and the United States.

Jammes's recognition that preservation of original photographs and documents was the essential step preceding research and writing history echoes Potonniée's characterization of Cromer. André and Marie-Thérèse Jammes have written that "one of the most obvious [feelings of collectors] is the desire to procure a work of art in order to preserve it from abandonment, disgrace,

or destruction. A collection is often the result of the activity of one who has realized that a certain form of artistic creation might fall into oblivion unless he, personally, were to save it from perishing."[35]

André and Marie-Thérèse Jammes have characterized their collection as a "choice which represents a particular taste," but they also acknowledge its function as an archive: "thousands of documents of uneven aesthetic value were [preserved] in order to establish the framework in which the masters evolved." The knowledge garnered from the collection in turn allowed the Jammeses to make historical judgments on the collection itself. "With the passage of time, the evolution of taste and changes in points of view," they have written, "photographs, which formerly we had saved through intuition or compassion, have become extremely important to our concerns."

Helmut Gernsheim (born 1913), trained in Germany as an art historian.[36] In 1934, sensing the ominous political situation in Germany, Gernsheim took up the practice of photography so that he would have a transportable skill if he should need to emigrate. Although by 1944 Gernsheim, now settled in London, had already begun to collect African art and German Expressionist woodcuts, Beaumont Newhall persuaded him to collect photographs, arguing that the writing on photography Gernsheim had begun with *New Photo Vision* (1942) would retain meaning only if someone accepted the responsibility to save for posterity those photographs that had not already been lost or destroyed in the war. Although Gernsheim at first accepted Newhall's charge with reluctance, he and his wife Alison (1911–1969) soon became assiduous collectors. In 1956 Newhall wrote of the Gernsheims: "Within a decade they not only built the largest and most selective collection [of photographs] in private hands, but they also produced [four books] and innumerable magazine articles."[37]

The Gernsheims were initially interested in the "aesthetic side of photography, and British photography in particular." As their work progressed, they realized that the "proper understanding of the evolution of photography" also required acquaintance with its history in other countries, as well as knowledge of changing equipment and processes.[38] Still, the strongest area of the collection remained nineteenth-century Britain, with large holdings of work by Julia Margaret Cam-

eron, Lewis Carroll, Roger Fenton, Oscar G. Rejlander, and the partners Hill and Adamson. Among the books the Gernsheims produced, several resulted directly from these acquisitions. The discovery and attribution of an album assembled by Lewis Carroll of his own photographs led to Helmut Gernsheim's 1949 monograph on Carroll as a photographer. The purchase of Roger Fenton's own set of his 360 Crimean War pictures, as well as an album of letters he wrote to his family and to his publisher, provided the foundation for the 1954 book by Helmut and Alison Gernsheim on Fenton's work in the Crimea.[39] The Gernsheims, in their activities of preservation and monographic research, form a transition between cultural and modernist collecting.

*

Within the documentary, aesthetic, and cultural modes of collecting, the individual photograph had been valued as, respectively, a document, a singular aesthetic object, and a cultural artifact; within the modernist mode it was viewed as the consequence of the artist's heroic struggle for expression. The artistic personality of the photographer, rather than particular photographs, formed the core of modernist collecting.

Beginning in the 1920s many of the best photographers rejected Stieglitz's demand that photography be practiced as a pure art, independent of utility, and made photographs on commission for the printed page. Photographers came to support themselves through the sale of reproduction rights to an image rather than through sale of the print itself. In 1923 Edward Steichen, the leading pictorialist before World War I, became chief photographer for Condé Nast publications. That same year Charles Sheeler went to work for Steichen at *Vogue* and *Vanity Fair,* breaking a close friendship with Paul Strand, who insisted that an artist-photographer should not seek commercial employment. Photographers such as Strand and Edward Weston, who followed Stieglitz's call for artistic purity and did not pursue commercial reproduction as the outlet of their work, became increasingly isolated.

Those who would collect contemporary photographs after the demise of pictorialism were thwarted by two stylistic developments within photography. One was commercially oriented and found expression primarily on the printed page with little concern for original prints. The other was avant-garde; it insisted on the purity of art and refused to offer the public the documentary congruence between art and life that had motivated nineteenth-century collectors. Not surprisingly, only a few individuals actively collected contemporary photographs in the period between the 1920s and the 1960s.

An early collector with the modernist attitude was David H. McAlpin (born 1897).[40] For McAlpin, to purchase photographs was to support financially and morally those photographers he believed in. He established a form of patronage for artist-photographers at a time when sales through conventional outlets were next to impossible. In addition, McAlpin was instrumental in the establishment of institutional support for contemporary photography. He subsidized The Museum of Modern Art's 1937 exhibition *Photography 1839–1937* and in the following years assisted in the founding, along with Ansel Adams and Beaumont Newhall, of the museum's Department of Photography.

An amateur photographer from the age of ten, a

Edward Weston. *David H. McAlpin, New York,* 1941. The Museum of Modern Art, New York. Gift of T. J. Maloney

lawyer by training, and an investment banker by profession, McAlpin first collected Old Master prints as a university student in the 1930s. In 1933 he became acquainted with Ansel Adams through the painter Georgia O'Keeffe. In 1936 McAlpin bought six prints out of Adams's solo exhibition at Stieglitz's gallery An American Place. The sequence of this acquisition —coming to know the photographer first as a friend and then acquiring work—became the pattern for McAlpin's collecting. With the exception of his initial purchases from Stieglitz of works by Adams and Eliot Porter, McAlpin bought directly from photographers he knew, such as Edward and Brett Weston, Sheeler, Paul Outerbridge, and William Garnett.

McAlpin was deeply committed to the photographers whose work he collected. He has written that the collection reflects his and his wife's personal taste and their identification with "the concerns and aspirations of the artists whose work it represents. First among these shared concerns," he continued, "has been an interest in the unspoiled natural scene of this country's unique wilderness area—which photography has done so much to record and interpret, and hopefully preserve."[41] And yet personal relationships remained dominant over this strong conservationist feeling; Outerbridge's abstractions could be fitted into a collection strong in the work of Adams, the Westons, and other photographers of the Western landscape because Outerbridge, like the others, was a friend of McAlpin's.

McAlpin remained one of the few collectors of modern photography until the 1960s. In the intervening decades, museums increased their involvement with the medium, and dealers attempted to interest the public in collecting. However, the printed page continued to attract photographers, especially with the emergence in the late 1930s and in the '40s of picture magazines such as the *Berliner illustrierte Zeitung* in Germany, *Vu* in France, and *Life* in the United States. Nancy Newhall observed in 1953 that the photographic print for most European photojournalists "is just a transition between the seeing and the publication. It is something to toss by the dozen into the laps of editors; it is nothing by itself."[42] American photojournalists, she continued, even though better technicians, were as reproduction-oriented as their European counterparts.

In the 1960s, the aesthetic of reproduction loosened its hold on photography. As picture magazines fell victim to the speed and immediacy of television, many photographers turned away from the ideals of mass communication and began to see photography as a personally expressive, object-oriented medium. Meanwhile, the generation coming of age in the '60s embraced photography as it sought an identity of its own. The powerfully romantic image of the photographer in the '60s was captured and propagated in the characterization of the fashion photographer of Michelangelo Antonioni's film *Blow-Up* (1966).[43]

This new image of the photographer revised subsequent collecting. Whereas McAlpin had focused on the artistic personalities of photographers who were contemporary, collectors of the '60s and '70s extended the modernist concern for the artist as heroic individual to the earlier history of the medium.

The heroizing of the artist fused with confidence in the collector's own aesthetic intuition when Arnold Crane (born 1932) began to assemble a collection in the mid-1960s.[44] It included strong holdings of a handful of major masters such as Hippolyte Bayard, Man Ray, Moholy-Nagy, and Walker Evans and idiosyncratic choices of work by unidentified and unknown photographers.

Crane began to photograph professionally at sixteen in Chicago and continued to work commercially to put himself through college and law school. To buy the work of living photographers, Crane would visit them, establish a friendship, and purchase all the photographs he could that were still in their hands. A desire to identify with these photographers is suggested by Crane's practice of photographing them in their studios and darkrooms. Crane's goal in collecting—to show the aesthetic breadth and depth of photography—and his trust in his own zeal and passion, has made his collection strong in widely varied periods and styles of photography.

Many of the accepted masters of twentieth-century photography are absent from the collection formed by Sam Wagstaff (born 1921), who has found other photographers with the modernist spirit of the heroic individual. Wagstaff first collected Pop and Minimal art. In 1973, after seeing *The Painterly Photograph,* an exhibition of pictorial photographs at The Metropolitan Museum of Art, New York, he sold his collection in order to devote himself to photography.

Wagstaff's education as an art historian and earlier

professional experience as a curator of modern art infuses his collecting with contentious didacticism. He disputes the historical perspective that traces modernism through a series of masters beginning with Paul Strand in the teens and continuing with such photographers as Brassaï and Harry Callahan. His collection has no works by these photographers. Instead, he has discovered others, many of them previously unknown or undocumented, who he feels are equally important to photographic modernism.

Wagstaff considers photography broadly and, like the collectors who view the medium as a cultural phenomenon, does not limit himself to photographs made as art. Whether they worked in an artistic or vernacular context, only those photographers in whose work Wagstaff perceives a coherent and individual artistic personality are represented in his collection.

For Wagstaff the departure from the established history of photography is a welcome challenge. While admitting that buying works by famous names keeps the collection on bedrock, he finds that "it's more fun to be where you're floating outside your knowledge, where only your stomach tells you, or your groin, that a photograph is good."[45]

A Book of Photographs from the Collection of Sam Wagstaff (1978), which Wagstaff edited to accompany an exhibition of works from his collection, offers the viewer pictures, and juxtapositions of pictures, that challenge conventional, canonical notions of what is of value in photography. The highly personal spirit behind the collection is suggested by Wagstaff's two-sentence introduction to the book: "This book is about pleasure, the pleasure of looking and the pleasure of seeing, like watching people dancing through an open window. They seem a little mad at first, until you realize they hear the song that you are watching."[46]

Aspects of earlier attitudes toward photography reappear in the collecting of Paul F. Walter. The chief executive of an electronics manufacturing firm, Walter began to collect art as a college student, buying prints when he came to New York from Ohio for vacations.[47] Before he first purchased photographs in 1975, his collection included architectural drawings, Indian miniatures, Whistler prints, and contemporary paintings and sculptures.

Two areas Walter explored in the collection led him to acquire photographs. Within the scope of Indian art, Walter included European views of India. Because photographs came in the 1860s and '70s to supplant drawings and prints as the dominant medium for such views, they too belonged within the collection. For Walter, the continuous tradition of picture-making unified photographs with prints and drawings and prevailed over formal distinctions between media. An interest in Whistler and his influence on other artists and printmakers led Walter to acquire works by late nineteenth- and early twentieth-century photographers such as Steichen, Heinrich Kühn, and Robert Demachy, who as pictorialists were artistically aligned with Whistler's aestheticism. Within a year of the acquisition of his first photographs, Walter widened the scope of his collecting. Although he has concentrated on nineteenth-century photographs because of what he sees as their impending disappearance from the market, he has collected pictures from all periods of the medium's history, including the current work of young photographers.

One might see in Walter's collection a recapitulation of the various attitudes—documentary, aesthetic, cultural, modernist—that have characterized photographic collecting. His first pictures of India presented to Walter, as they did to nineteenth-century Europeans, documentary reports about life in the subcontinent. Pictorialist photographs entered the collection for their affinity with contemporaneous printmaking, a judgment within the spirit with which they were made. These two specific interests brought Walter to an appreciation of the medium as a whole and to the work of individual photographers. In 1977 Walter wrote of his attraction to photography: "It is one of the few areas left in art—maybe the only area—where you can still put together a major collection of major works by major artists. In other areas this is no longer possible, even with unlimited funds; the material just isn't available."[48]

*

A universal aspect of private collections is their transient nature. One writer has compared collecting to building sand castles at the seaside, where the next rain—or even sooner, the next high tide—will destroy the edifice and return the millions of grains of sand to the unformed expanse of the beach.[49] Few private collections remain intact beyond the lifetime of the collector. Taxes and inheritance often require their sale, but perhaps more

importantly, collections are so contoured to the taste of those who formed them that they, like shoes, seldom fit a second owner.

Few of these photography collections have been broken up, however. Most have been given or sold to major institutions, completing preservation efforts begun by the collector. Many collectors acquired photographs with the intention that their collections would find permanent homes in museums. Jammes and Cromer, in France, and Gernsheim, in Great Britain, hoped their collections would be the foundations of national museums of photography in their respective countries. Although they were unsuccessful in this goal, their collections have remained nearly intact in public institutions.

The Victoria and Albert Museum, London, pursued Townshend for his gemstone collection. He bequeathed the museum not only his gems but also his photographs and other collections. In 1933, Stieglitz gave the bulk of his collection to The Metropolitan Museum of Art, New York. Most of Cromer's collection did not remain in France, as he had wished, but was acquired from his widow by Eastman Kodak and shipped on the last freighter to leave France at the start of World War II. It was later placed in the George Eastman House, Rochester, New York, as part of its historical collection. Eder's collection also ended up at the Eastman House; Eder sold it in 1920 to Kodak to raise funds to support his teaching and research institute. Stenger's collection was acquired in 1955 by Agfa-Gevaert, a European producer of photographic material and equipment, to form the basis of what became the Foto-Historama, Leverkusen, Germany. The Gernsheims were unsuccessful in finding a satisfactory home for their collection within Britain; the requisite funds and space were not available. It is now in the Humanities Research Center of the University of Texas at Austin. McAlpin collected with museums in mind, seeking always to make museum-quality acquisitions. He has presented major gifts from his collection to The Metropolitan Museum of Art, the Art Museum, Princeton University, and The Museum of Modern Art.

In 1984 the J. Paul Getty Museum, Malibu, California, drew on its impressive financial resources to enter the field of photography through the acquisition of several private collections, including those of Crane and Wagstaff and part of Jammes's. Relying on the efforts of private collectors, the museum was quickly able to build a collection covering the entire history of photography.

To preserve all the photographs ever made would be at once impossible and meaningless. One hopes instead for the preservation of those that are most significant. However, there is no a priori, universal truth that identifies such works. Rather, in the process of collecting, through the interaction of knowledge and speculation with photographs themselves, an individual works out his own hypothesis of what is significant in photography. In this way, each of these private collections—begun as an individual vision of photography—has come to play a major role in developing our collective view of photography and its history.

NOTES

1. Townshend's life and collecting are described in Mark Haworth-Booth, "The Dawning of an Age: Chauncy Hare Townshend, Eyewitness," in *The Golden Age of British Photography, 1839–1900*, Mark Haworth-Booth, ed. (Millerton, N.Y.: Aperture, 1984), pp. 11–21. Haworth-Booth generously provided me with a draft of his essay prior to publication. An informal model for this essay is William W. Robinson, "'This Passion for Prints': Collecting and Connoisseurship in Northern Europe during the Seventeenth Century," in *Printmaking in the Age of Rembrandt*, Clifford S. Ackley, ed. (Boston: Museum of Fine Arts/New York Graphic Society, 1981).

2. Both are cited by Haworth-Booth, p. 17.

3. The album was formerly in the collection of Sam Wagstaff, who kindly brought it to my attention and shared his ideas about it with me. The album is now in the collection of the J. Paul Getty Museum, Malibu, Calif.

4. The album contains 117 cartes de visite by various French photographers and was purchased as the gift of Shirley C. Burden.

5. This interpretation was suggested by Kirk Varnedoe in lecture, Institute of Fine Arts, New York University, September 24, 1984.

6. For information on Timmins, see Christian A. Peterson,

"George Timmins' Early Collection of Pictorial Photography," *History of Photography*, vol. 6, no. 1 (January 1982), pp. 21–27. Peterson provides useful information on collecting throughout the period.

7. "With the Artists," *Syracuse Herald*, June 27, 1897, p. 16; cited by Peterson, p. 26.

8. "The Post Collection of Pictorial Photographs," *Camera Notes,* vol. 2, no. 3 (January 1899), p. 96. "[I]t is only a question of time when the Post collection will be the most notable in the country."

9. J[oseph] T. K[eiley], "Loan Exhibition," *Camera Notes*, vol. 3, no. 4 (April 1900), pp. 214–15. Keiley begins the review: "A few years ago, and even less remotely, no better means could have been devised for calling an incredulous smile to the lips and a chaffing word to the tongue of the majority of one's friends than seriously to have asserted that there existed persons sufficiently interested in the pictorial achievements of photography as to engage themselves in making private collections of photographs after the manner that paintings and other objects of art are collected...."

10. The volume by Weston J. Naef, *The Collection of Alfred Stieglitz: Fifty Pioneers of Modern Photography* (New York: The Metropolitan Museum of Art/Viking, 1978), is a valuable resource for information not only on Stieglitz but on other collectors of the period as well. Much of the unattributed information that follows in this section comes from Naef.

11. According to Naef, around 1900 Stieglitz's collection contained about two dozen prints; in 1910, over 500; in 1933, around 700.

12. On Juhl, see his text in *Sonderausstellung Sammlung Ernst Juhl in Hamburg: Zur Geschichte der künstlerischen Photographie* (Berlin: Kunstgewerbe Museum, 1910); and *Photographie zwischen Daguerreotype und Künstphotographie* (Hamburg: Museum für Kunst und Gewerbe, 1977).

13. Although Stieglitz emphasized print quality in the work of his contemporaries, little of the historical material in his collection was vintage. Of Hill and Adamson, for example, he owned one vintage calotype; eight photogravures, all but one hand-printed by J. Craig Annan; and eleven carbon prints, probably made in 1916 by Jesse Bertram. The Cameron prints were made from copy negatives by the Autotype Fine Art Co., London, between 1902 and 1905. See Naef, pp. 375–80, 293–94.

14. Alfred Stieglitz, "Sammler und Verzugsdrucke," *Camera-Kunst* (Berlin: Gustav Schmidt, 1903); trans. Beaumont Newhall, "The Collector and Fine Prints," in *Print Collectors' Newsletter*, vol. 9, no. 6 (January–February 1979), p. 179.

15. Alfred Stieglitz to R. Child Bayley, October 9, 1919, Stieglitz Archive, Collection of American Literature, Beinecke Rare Book and Manuscript Library, Yale University, New Haven, Conn.; reprinted in Sarah Greenough and Juan Hamilton, *Alfred Stieglitz, Photographs and Writings* (Washington, D.C.: National Gallery of Art, 1983), p. 203.

16. Naef, p. 226.

17. Quoted by Dorothy Norman, untitled contribution to "The Controversial Family of Man," *Aperture*, vol. 3, no. 2 (1955), p. 13.

18. Georges Potonniée, "Gabriel Cromer," *Bulletin de la Société Française de Photographie*, no. 12 (December 1934), p. 248.

19. Eliette Bation-Cabaud, "Georges Sirot, 1898–1977: Un Collection de photographies anciennes," *Photogenesis*, no. 3 (October 1983), has been an invaluable source of information on the French collectors Sirot, Cromer, Barthelemy, and Gilles. Much of the unattributed information that follows is indebted to Bation-Cabaud.

20. See Walter Clark, "George Eastman House: Its Technology Collections," *Image*, vol. 24, no. 2 (December 1981), pp. 1–3. Clark discusses the collections of Cromer, Eder, Alden Scott Boyer, and Louis Walton Sipley. Boyer (1887–1953), a Chicago manufacturer of industrial chemicals and cosmetics, voraciously collected a wide variety of artifacts, including tobacco tags, perfume bottles, and baby ribbons. Between 1938 and 1950 he collected photographs. (See also "The Boyer Collection," *Image*, vol. 2, no. 7 [October 1953], pp. 41–48.) Sipley (1897–1968) collected photographic prints, books, equipment, and especially American daguerreotypes. From his collection he founded the American Museum of Photography, Philadelphia, in 1940. These collections are now at the International Museum of Photography at George Eastman House, Rochester, N.Y.

21. Georges Sirot, quoted in Bation-Cabaud, n.p.

22. These and the subsequently cited works from Cromer's collection are reproduced in Henri Jonquières, ed., *La Vieille Photographie depuis Daguerre jusqu'à 1870* (Paris, 1935). The daguerreotype portrait of Daguerre (1844) is by Jean-Baptiste Sabatier-Blot; the critic is Francis Wey, identified in the book as "one of the first, if not the first chronicler and critic of art photography" and shown in a portrait by Victor Laisné (c. 1852); the picture by an unknown French photographer and labeled "Group fantaisiste chez un photographe" (c. 1860) shows a photographer standing beside his view camera and a man and a woman on each side watching as prints develop in printing frames.

23. For example, Josef Maria Eder, *History of Photography*, trans. Edward Epstean (New York: Columbia University Press, 1945), p. 753, n.9, and p. 754, n.5, cites Cromer's reproduction in facsimile of an 1826 letter from Niépce to his son Isidore, *Bulletin de la Société Française de Photographie*, 1922, p. 71, and Cromer's documentation of Daguerre's pre-photographic work with dioramas, *BSFS*, 1924, p. 52.

24. Bation-Cabaud, n.p. The photographs cited from Sirot's collection are reproduced in Bation-Cabaud.

25. Bation-Cabaud, n.p.

26. See Beaumont Newhall, "A Chronology for the Years 1900–1940 of Certain Publications, Collections, Museums and Exhibitions Pertaining to the History of Photography," *Antique Book Monthly Review* (December 1978), pp. 544–45. Newhall distributed this chronology when he lectured on the history of

collecting photographs at the International Museum of Photography at George Eastman House, Rochester, N.Y., October 17, 1978. A similar lecture, "The Historiography of Photography," was presented at the School of the Art Institute of Chicago, January 26, 1979. Newhall kindly provided The Museum of Modern Art with tapes of both lectures.

27. See Hinricus Lüppo-Cramer, "Biography of Josef Maria Eder," in Eder, *History of Photography*, pp. 720–28.

28. Lüppo-Cramer, in Eder, p. 723.

29. See Beaumont Newhall, "The Late Erich Stenger," *Image*, vol. 7, no. 1 (January 1958), p. 4.

30. Ibid.

31. Erich Stenger, *The History of Photography: Its Relation to Civilization and Practice*, trans. Edward Epstean (Easton, Pa.: Mack Printing Co., 1939; reprinted New York: Arno, 1979), p. vii.

32. *Internationale Ausstellung des deutschen Werkbunds Film und Foto* (Stuttgart: Deutscher Werkbund, 1929), p. 49.

33. André Jammes, "Photographic Incunabula: A Review of the Geneva Auction Sale of June 1961," *Camera*, no. 12 (December 1961), p. 25. Jammes and his wife Marie-Thérèse were the authors of the catalogue for the auction *(La Photographie des origines au début du XXe siècle* [Geneva: Nicolas Rauch, 1961]). The former wrote the introduction and the latter prepared the entries.

34. André Jammes and Eugenia Parry Janis, *The Art of French Calotype* (Princeton, N.J.: Princeton University Press, 1983), p. ix. See also André and Marie-Thérèse Jammes, "On Collecting Photographs," in *Niépce to Atget: The First Century of Photography from the Collection of André Jammes* (Chicago: The Art Institute of Chicago, 1977).

35. This and subsequent comments are from André and Marie-Thérèse Jammes, pp. 10, 13.

36. See Helmut Gernsheim, "Gernsheim on Gernsheim," *Image,* vol. 27, no. 4 (December 1984), pp. 2–8; and interview with Helmut Gernsheim in Paul Hill and Thomas Cooper,

Dialogue with Photography (New York: Farrar, Straus, Giroux, 1979), pp. 160–210.

37. Beaumont Newhall, review of Helmut Gernsheim, *History of Photography*, in *Image*, vol. 5, no. 3 (March 1956), p. 68.

38. Helmut and Alison Gernsheim, Foreword, *History of Photography* (London: Oxford University Press, 1955), p. vii.

39. Helmut Gernsheim, *Lewis Carroll: Photographer* (London: Max Parrish & Co. Limited, 1949); Helmut and Alison Gernsheim, *Roger Fenton: Photographer of the Crimean War* (London: Secker & Warburg, 1954).

40. Much of this information comes from an interview with David McAlpin, New York City, October 19, 1983.

41. David McAlpin, Introductory Wall Label for the exhibition *From the McAlpin Collection*, The Museum of Modern Art, New York, December 14, 1966–February 12, 1967.

42. Nancy Newhall, "Controversy and the Creative Concepts," *Aperture*, vol. 2, no. 2 (1953), p. 5.

43. Some of these ideas were suggested by Lee Witkin in a conversation with the author, New York City, June 13, 1984.

44. On Crane's collection, see Lauren Shakely, "Passion for Genius," *Aperture*, no. 90, pp. 48–59. See also Arnold Crane, "Advice from a Photograph Collector," *New York Times*, October 12, 1975, sec. D., p. 31.

45. Quoted by Ben Lifson in "Sam Wagstaff's Pleasures," *Village Voice*, July 17, 1978, p. 71.

46. See *A Book of Photographs from the Collection of Sam Wagstaff* (New York: Gray Press, 1978).

47. Much of this information comes from a telephone interview with the author, December 17, 1984.

48. Paul Walter, untitled contribution to "On Collecting Nineteenth-Century Photographs, Part II," *19c Nineteenth Century,* vol. 3, no. 4 (Winter 1977), p. 76.

49. Anatole France, *Le Jardin d'Epicure* (1895); cited by Sir James Yoxall in *The ABC about Collecting* (London: Stanley Paul & Co., [1910]), p. 8.

PLATES

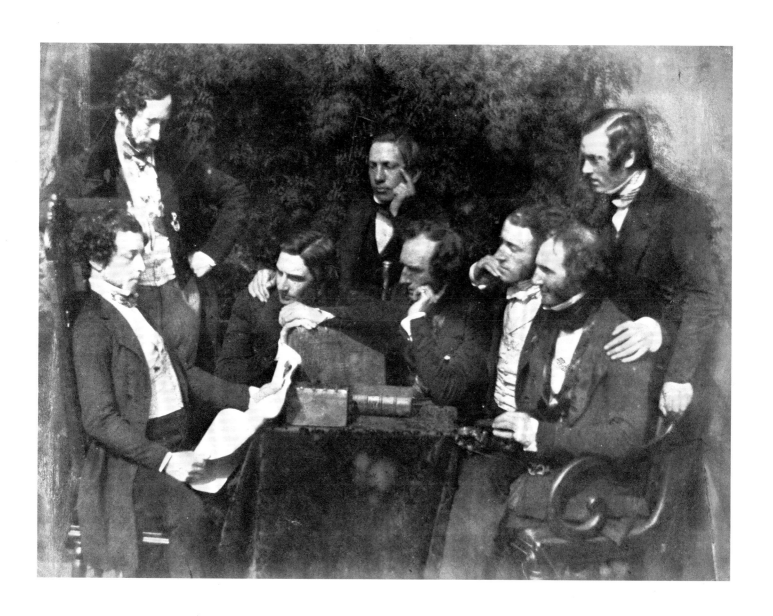

Plate 1 · David Octavius Hill and Robert Adamson
Untitled, 1843–47

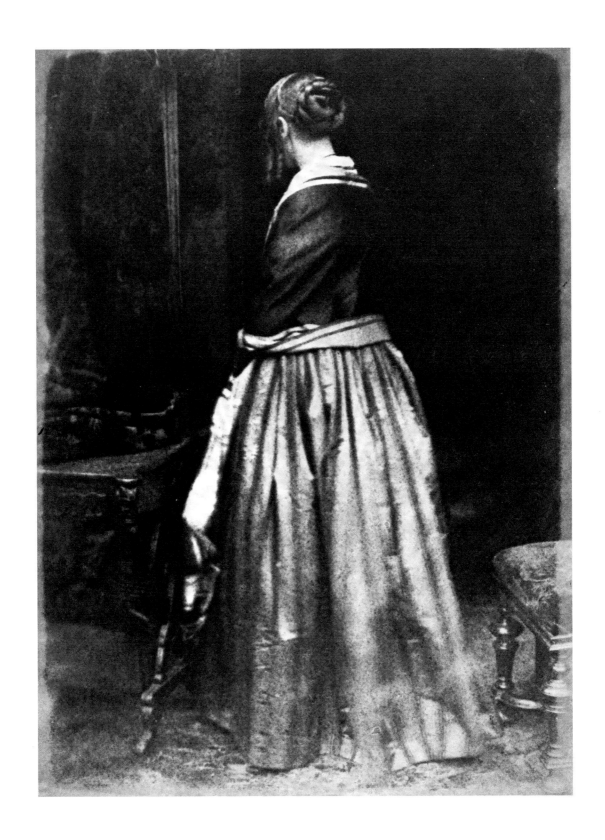

Plate 2 · David Octavius Hill and Robert Adamson
Mrs. Murray, 1847

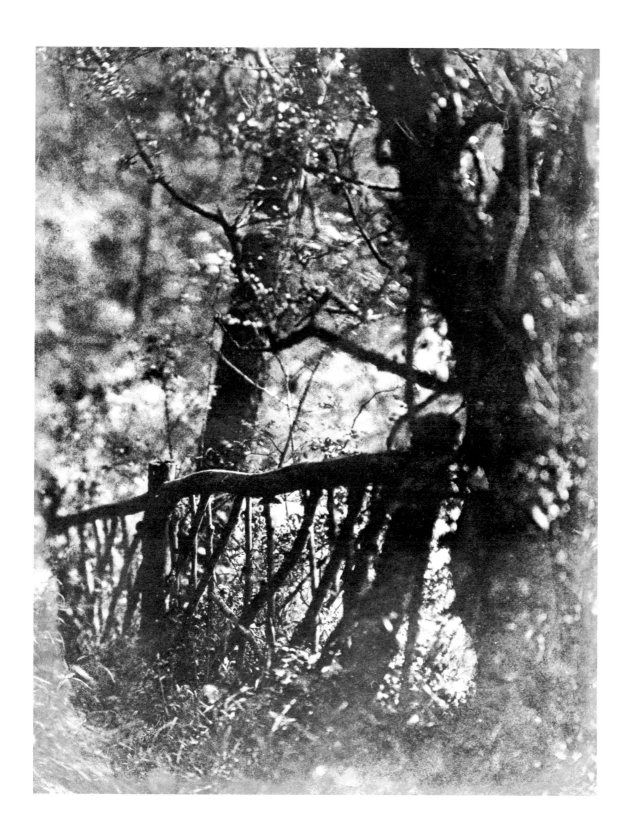

Plate 3 · David Octavius Hill and Robert Adamson
Colinton Wood, 1843–47

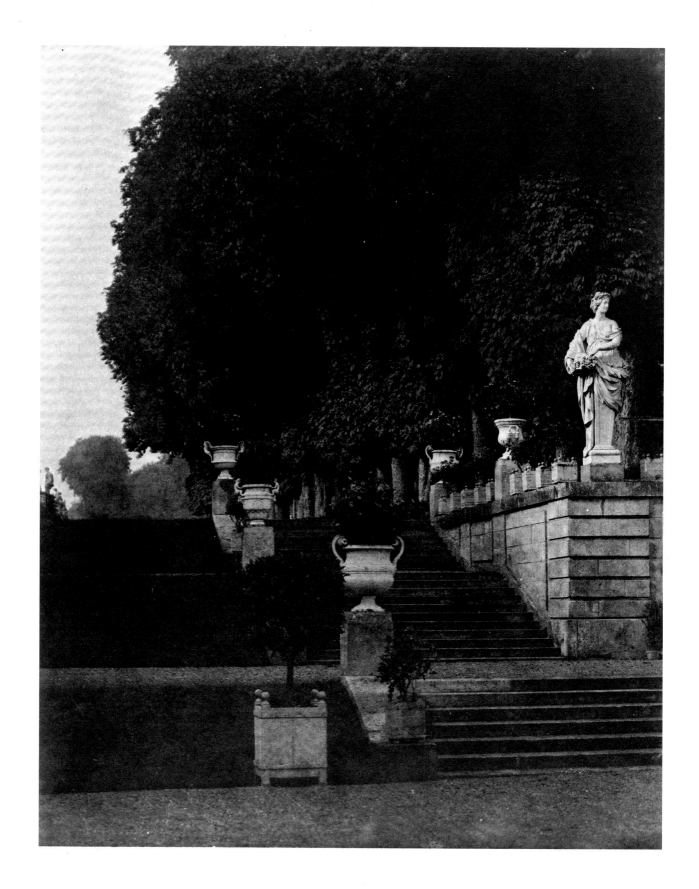

Plate 4 · Louis-Rémy Robert
The Park of Saint-Cloud, c. 1853?

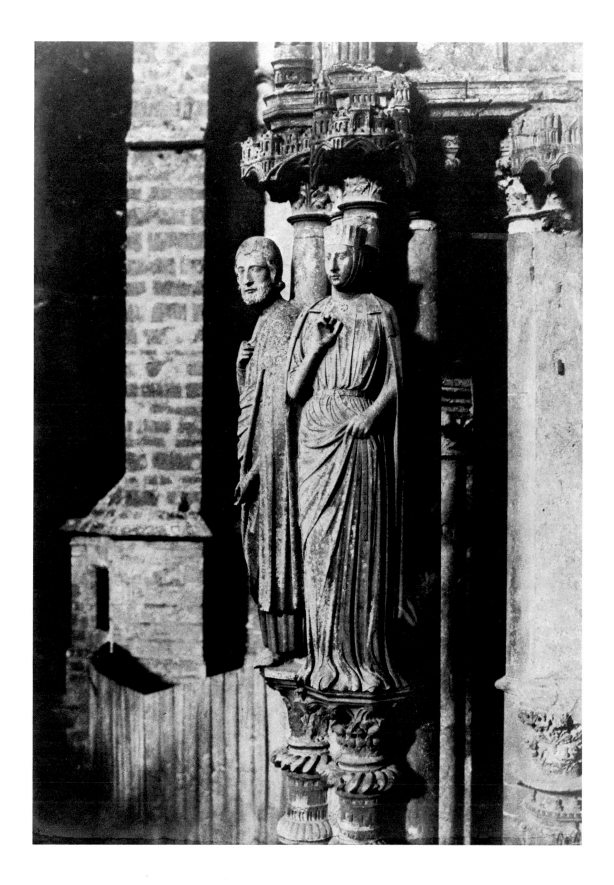

Plate 5 · Charles Marville
Columnar Figures of the North Porch, Chartres Cathedral, 1853–54

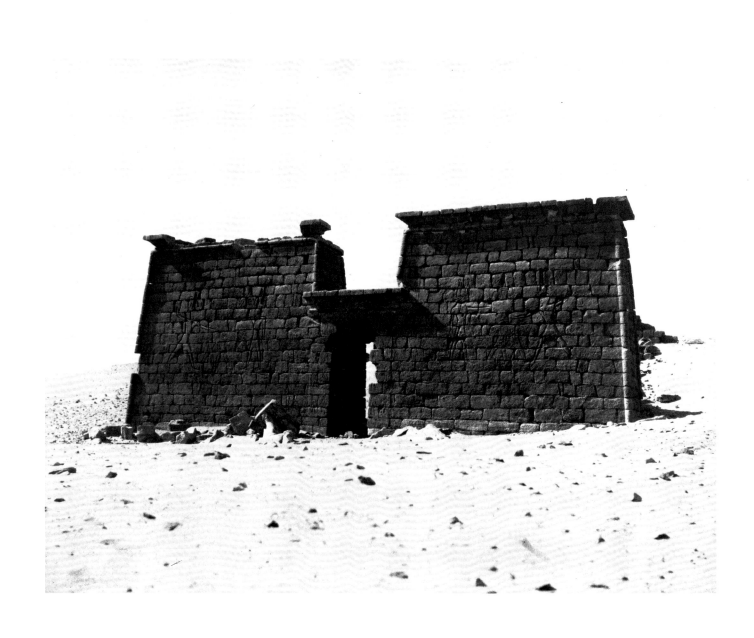

Plate 6 · Félix Teynard
General View of the Pylon, Temple of Sebou'ah, Nubia, 1851–52

Plate 7 · Auguste Salzmann
Tomb of Zachary, Valley of Jehosaphat, 1854

Plate 8 · Attributed to Charles Simart
Untitled, 1850s?

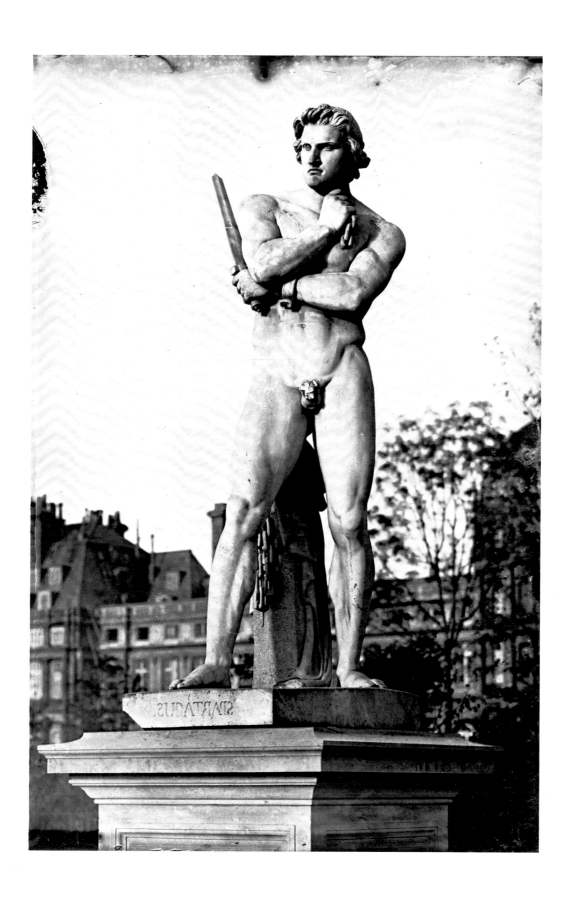

Plate 9 · Charles Nègre
Spartacus, Tuileries Gardens, Paris, 1859

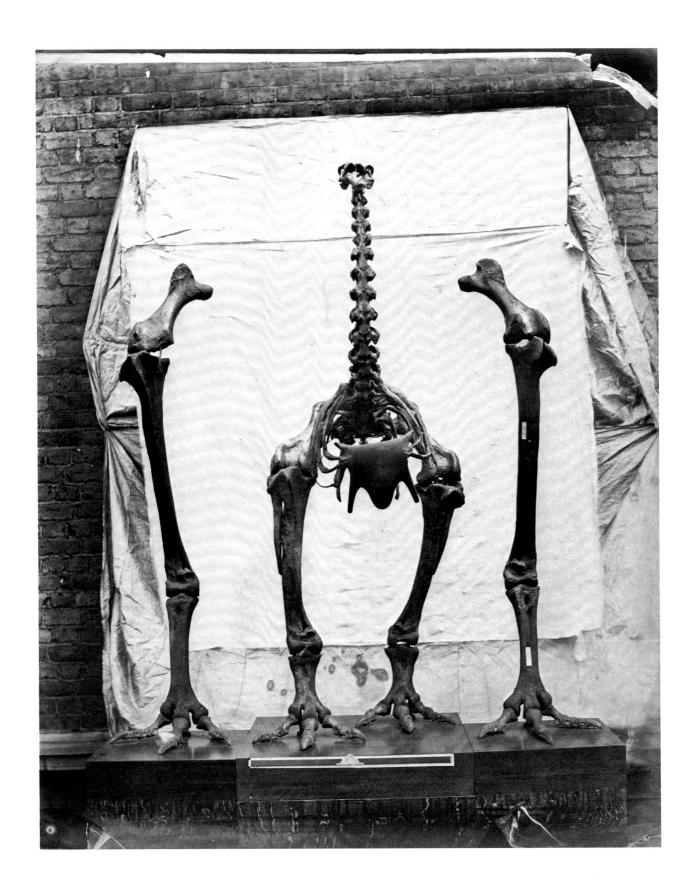

Plate 10 · Roger Fenton
Dinornis Elephantopus, 1858?

Plate 11 · Attributed to Charles Marville
Untitled, 1860s?

Plate 12 · Charles Nègre
Imperial Asylum, Vincennes, 1858–59?

Plate 13 · Oscar Gustave Rejlander
Joseph Wilson Foster, c. 1860

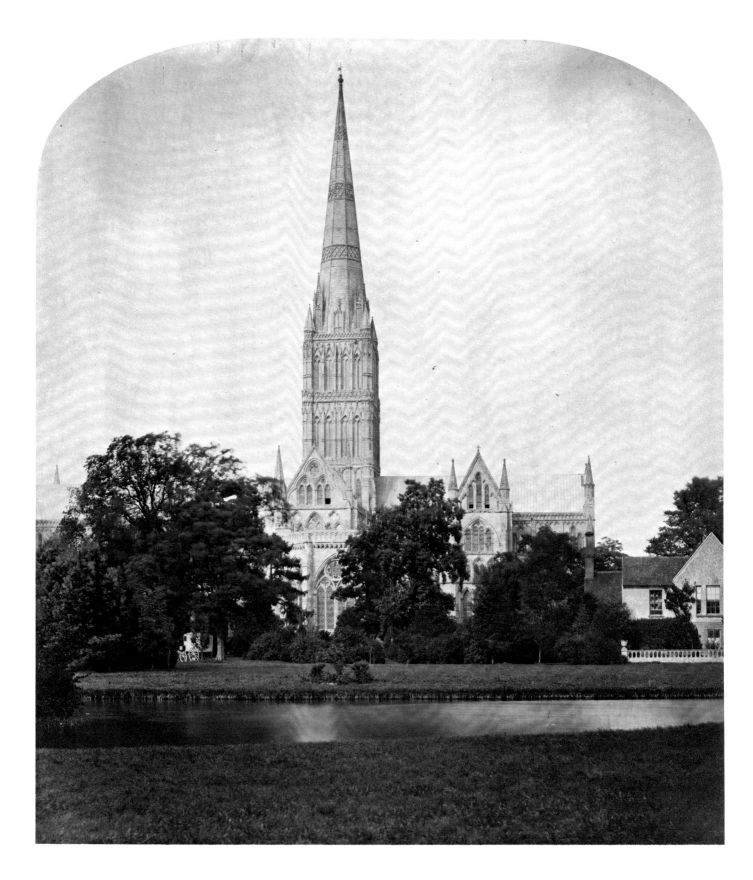

Plate 14 · Roger Fenton
Salisbury Cathedral: The Spire, c. 1860

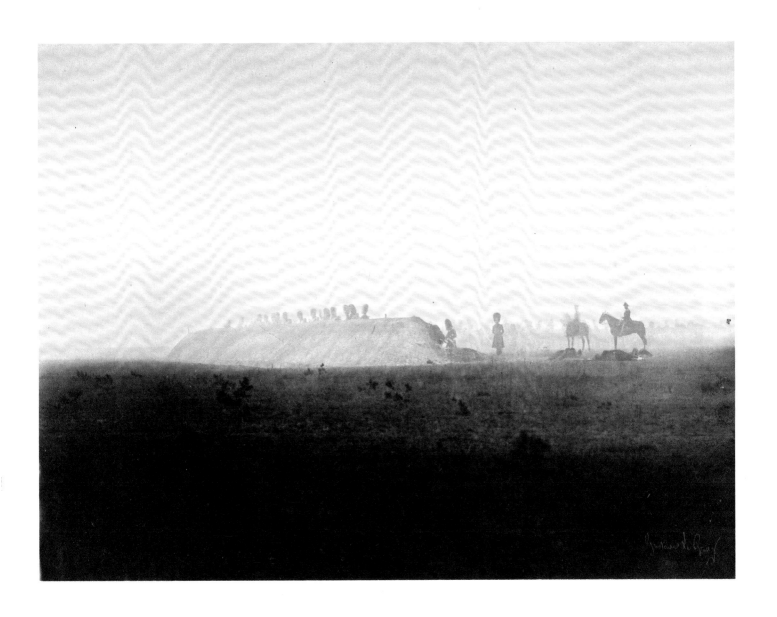

Plate 15 · Gustave Le Gray
The Camp at Châlons, Maneuvers of October 3, 1857

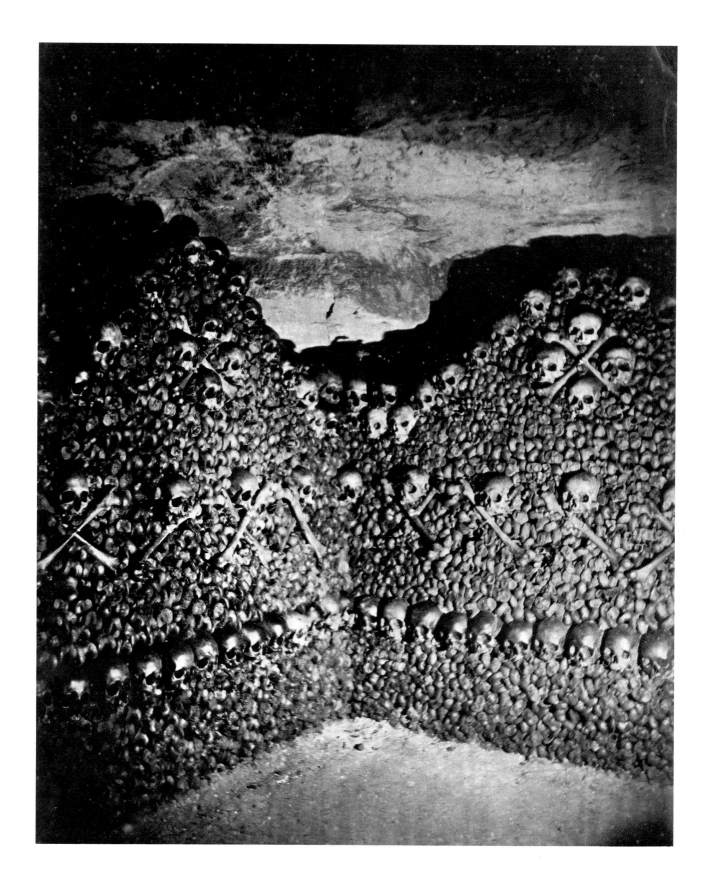

Plate 16 · Nadar (Gaspard Félix Tournachon)
Catacombs, Paris, 1861

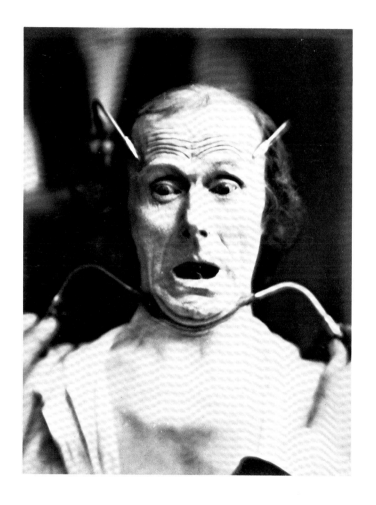

Plate 17 · Guillaume-Benjamin-Amand Duchenne de Boulogne
Fright, 1862

Plate 18 · Edouard-Denis Baldus
La Ciotat, before 1859

Plate 19 · Louis-Auguste Bisson and Auguste-Rosalie Bisson
Ice Pinnacles of the Giant, Mont Blanc, 1860

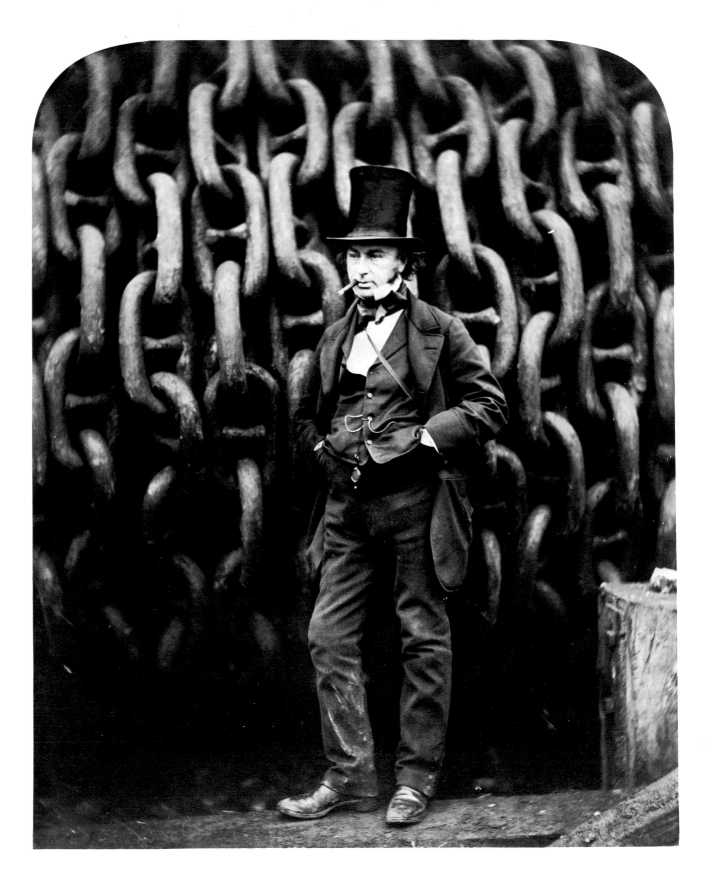

Plate 20 · Robert Howlett
Isambard Kingdom Brunel and the Launching Chains of the Great Eastern, 1857

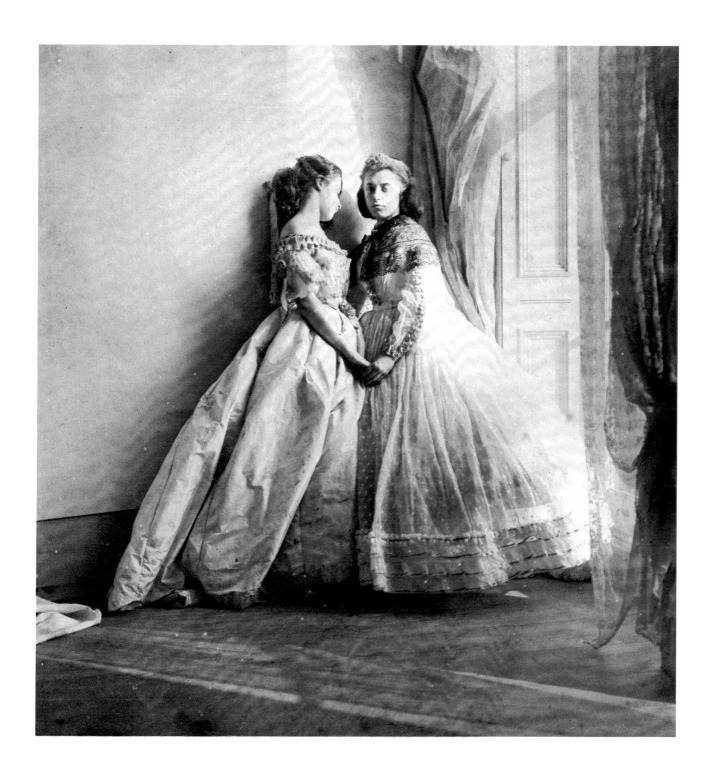

Plate 21 · Clementina, Lady Hawarden
Grace Maude and Clementina Maude, c. 1863–64

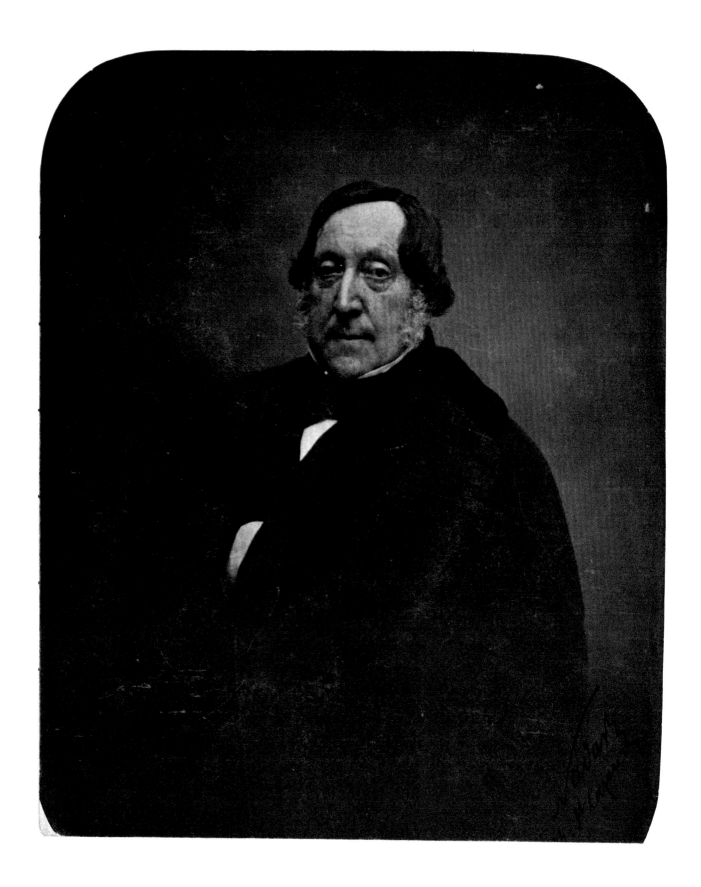

Plate 22 · Nadar (Gaspard Félix Tournachon)
Rossini, before May 1856

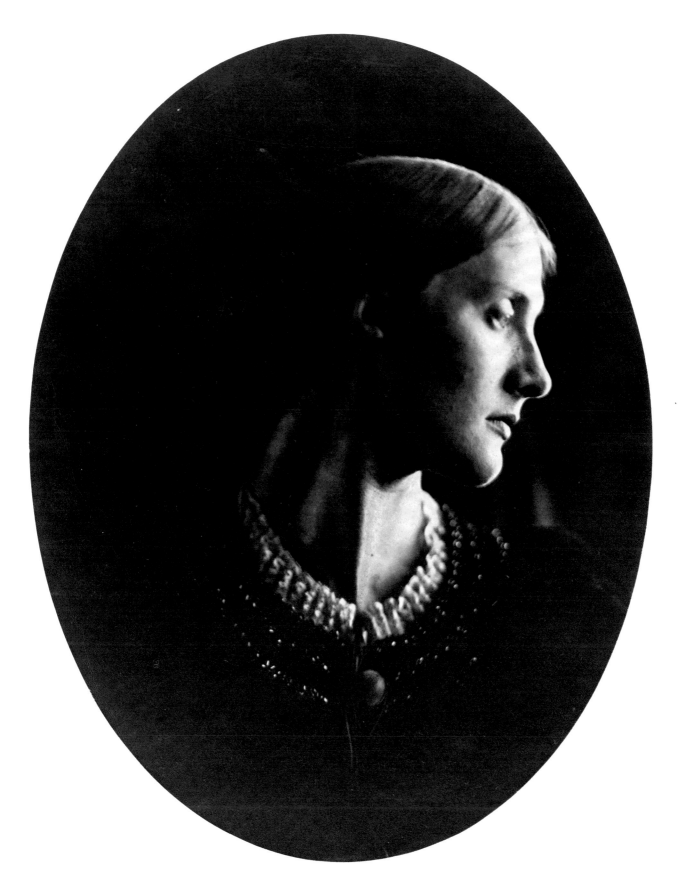

Plate 23 · Julia Margaret Cameron
Mrs. Duckworth, 1867

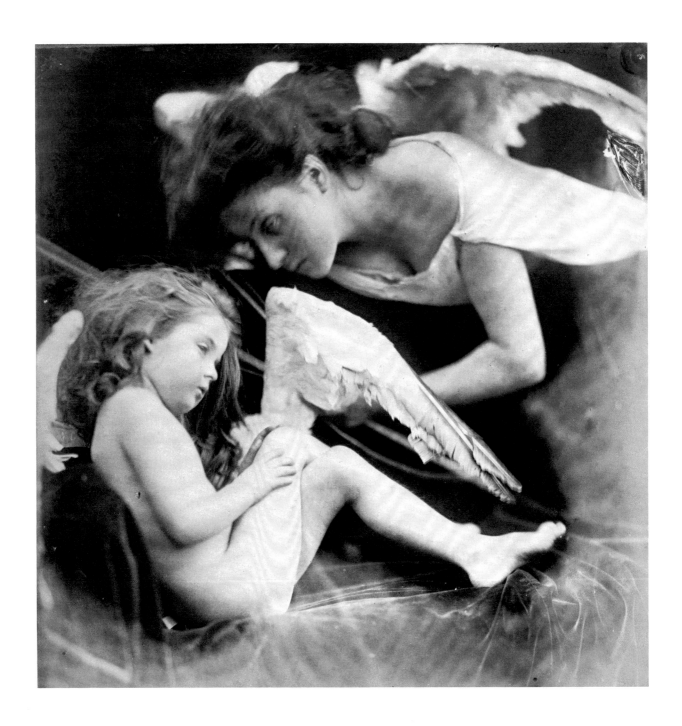

Plate 24 · Julia Margaret Cameron
Venus Chiding Cupid and Removing His Wings, 1872

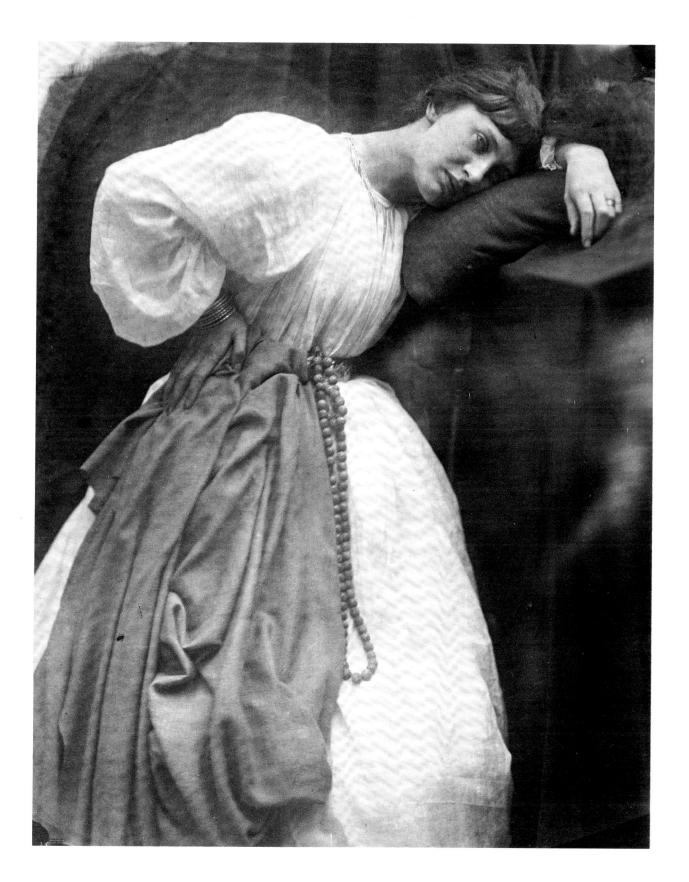

Plate 25 · Julia Margaret Cameron
Pre-Raphaelite Study, 1870

Plate 26 · Henry White
Untitled, n.d.

Plate 27 · Louis-Emile Durandelle
Ornamental Sculpture of the New Paris Opera, 1865–72

Plate 28 · C. Famin
Untitled, 1860s or 1870s

Plate 29 · Théophile Jaquen
Batteries on the Point, Entrance to the Port of Brest, 1860s

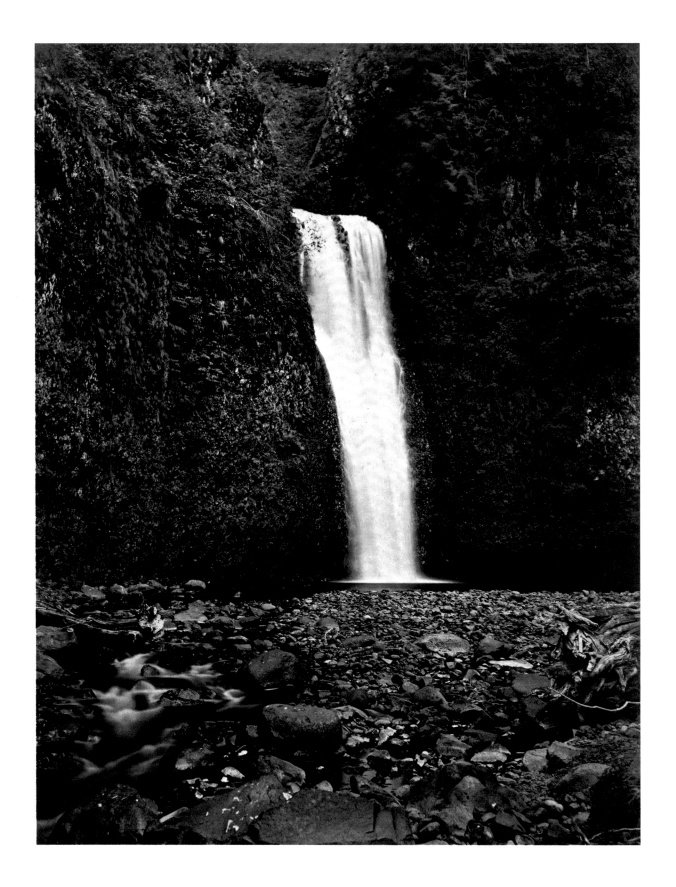

Plate 30 · Carleton E. Watkins
Lower Multnomah Falls, Columbia River, Oregon, 1867

Plate 31 · Eadweard Muybridge
Valley of the Yosemite from Mosquito Camp, 1872

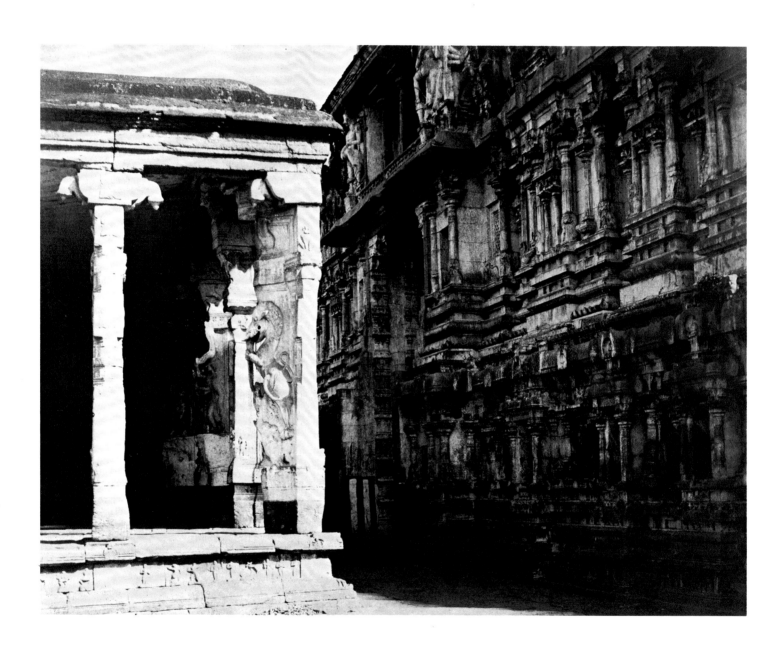

Plate 32 · Linnaeus Tripe
The Inner Façade of the Gateway of the East Gopuram, Great Pagoda, Madura, India, 1856–58

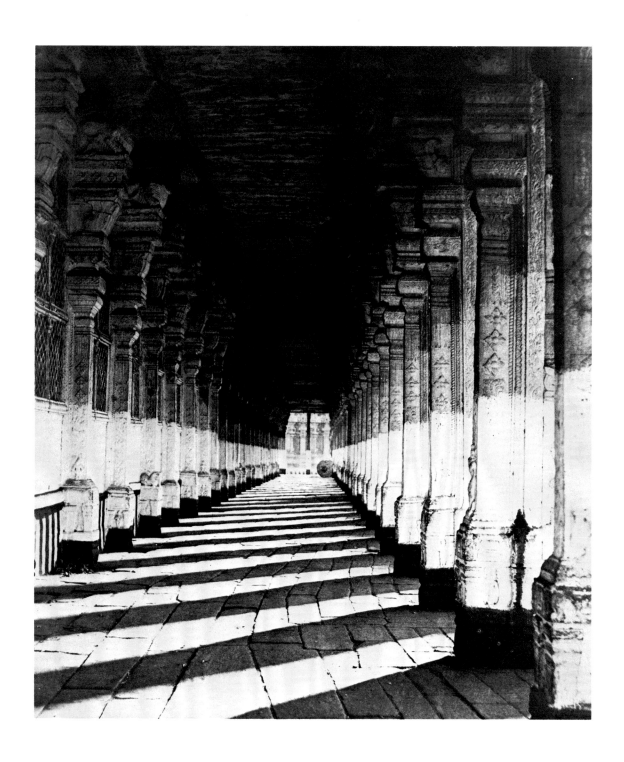

Plate 33 · Linnaeus Tripe
Aisle on the South Side of the Puthu Mundapum, from the Western Portico, Madura, India, 1856–58

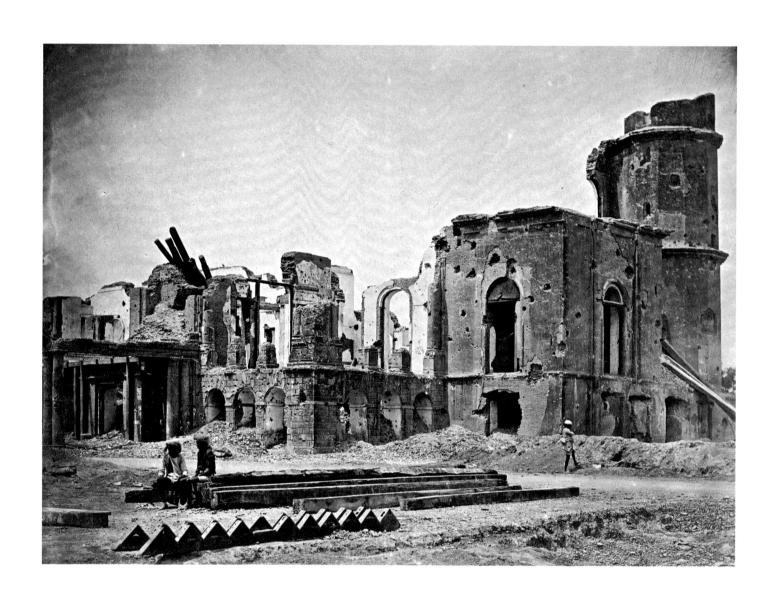

Plate 34 · Felice or Felix Beato
Lucknow, India: View of the Residency in Front, Showing the Room in which Sir H. Lawrence Was Killed, 1858

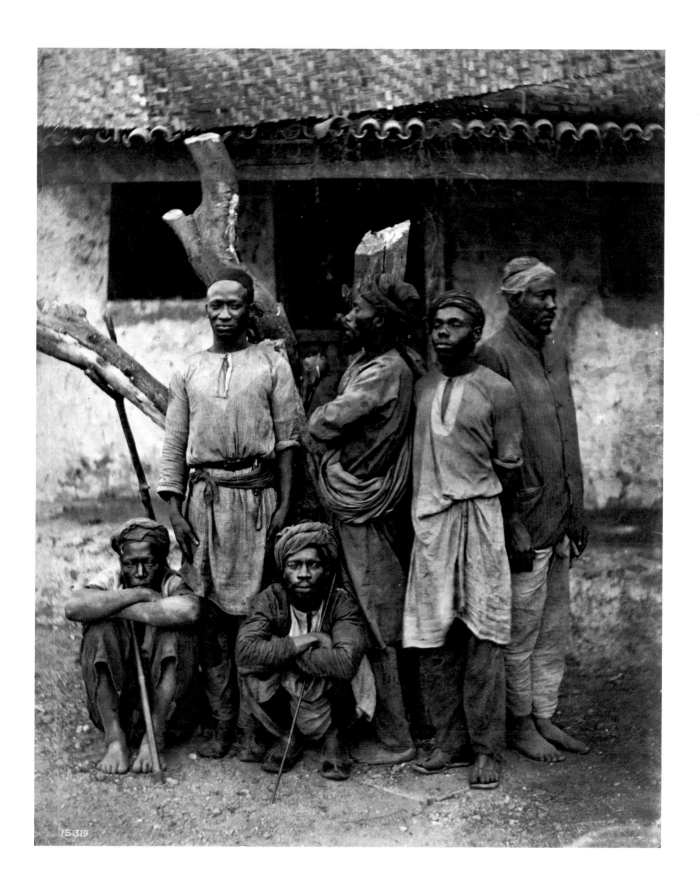

Plate 35 · Francis Frith and Company
Mangalore(?), *India,* 1860s?

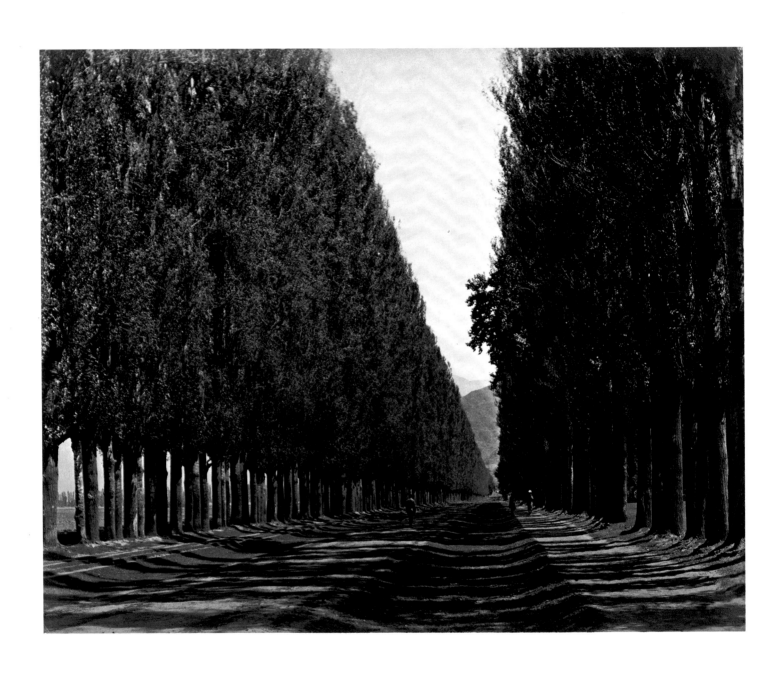

Plate 36 · Samuel Bourne
Poplar Avenue, from the Middle, Kashmir, 1864

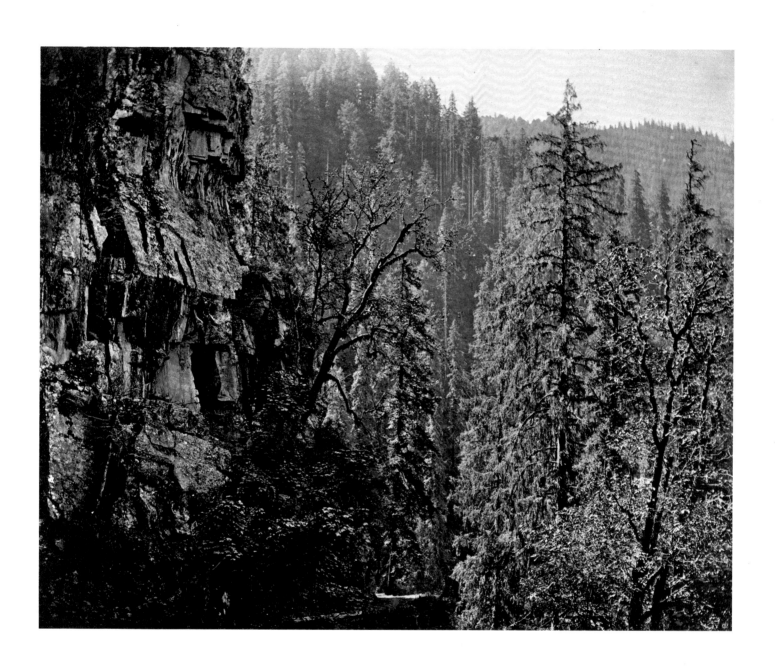

Plate 37 · Samuel Bourne
View in Narkunda Forest, Chini Valley, Himalayas, 1863

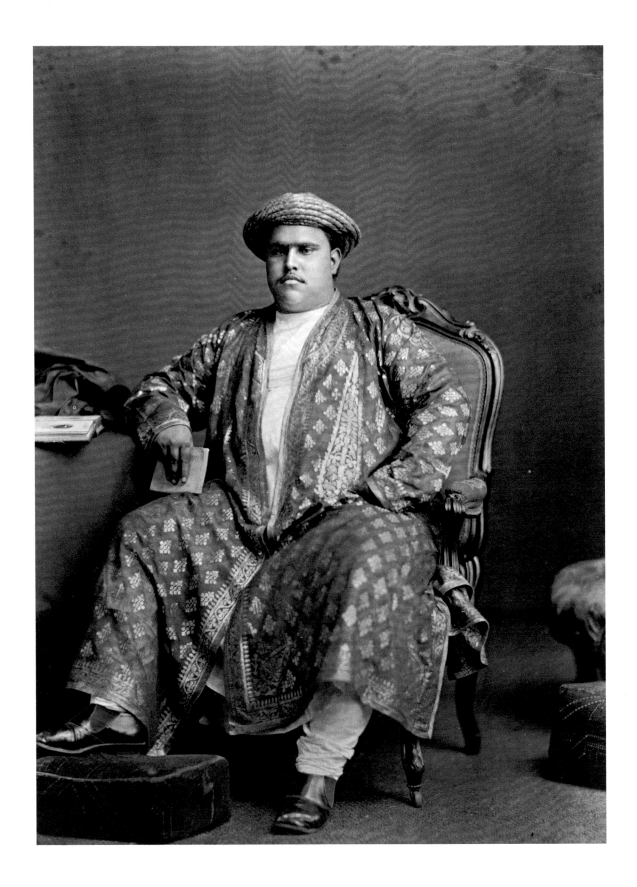

Plate 38 · Photographer unknown
Untitled, n.d.

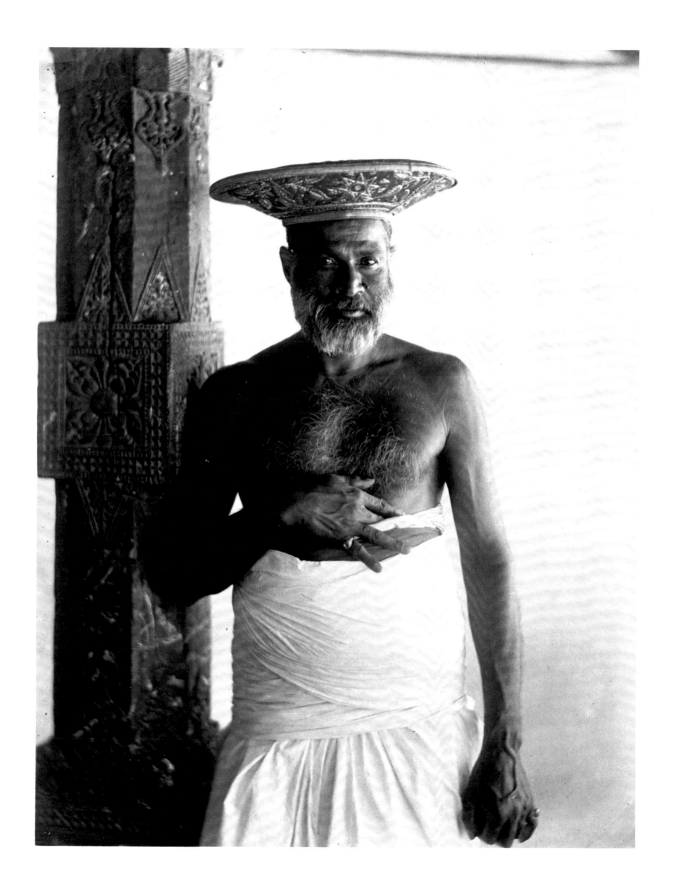

Plate 39 · W. L. H. Skeen and Company
Kandyan Chief, c. 1890

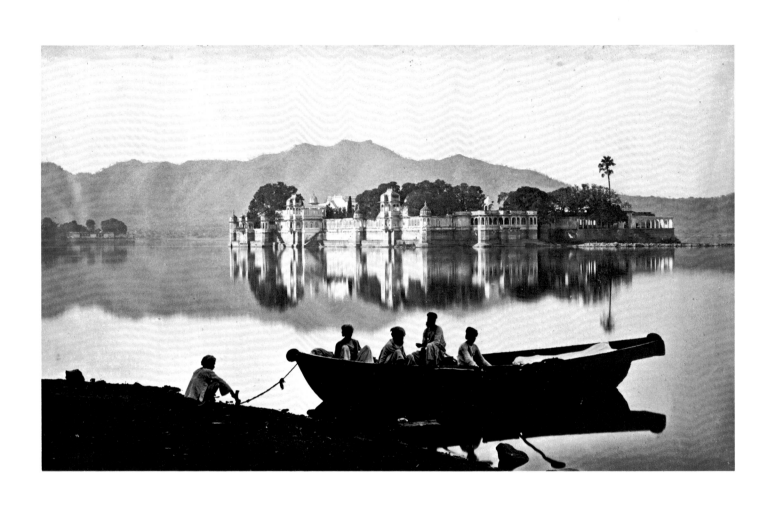

Plate 40 · Colin Murray
Jagmandar: Water Palace at Udaipur, 1872–73

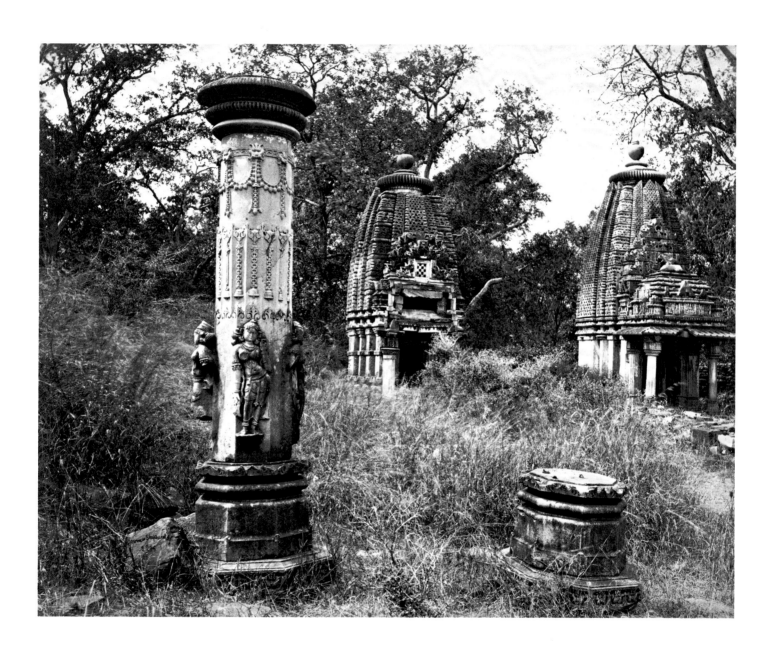

Plate 41 · Colin Murray
Stone Column at Baroli, Udaipur, 1872–73

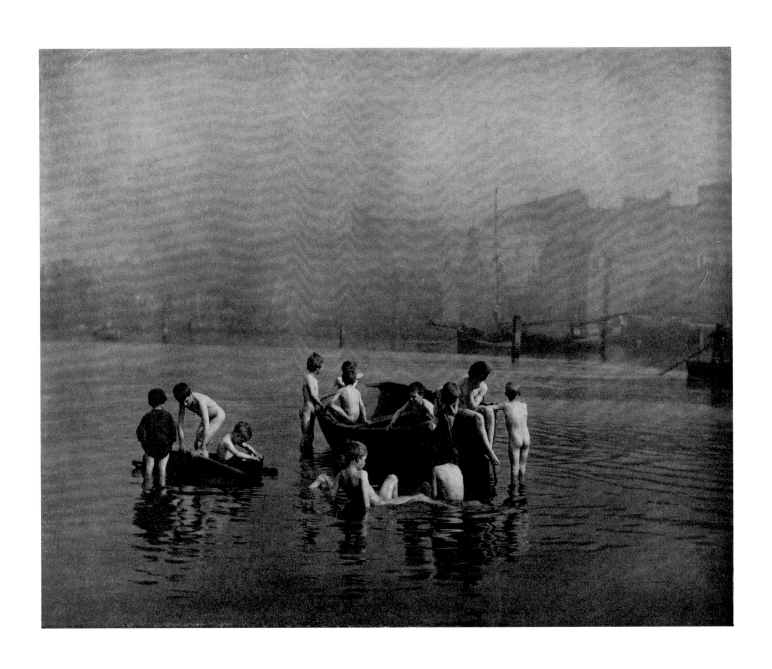

Plate 42 · Frank Meadow Sutcliffe
The Water Rats, 1886

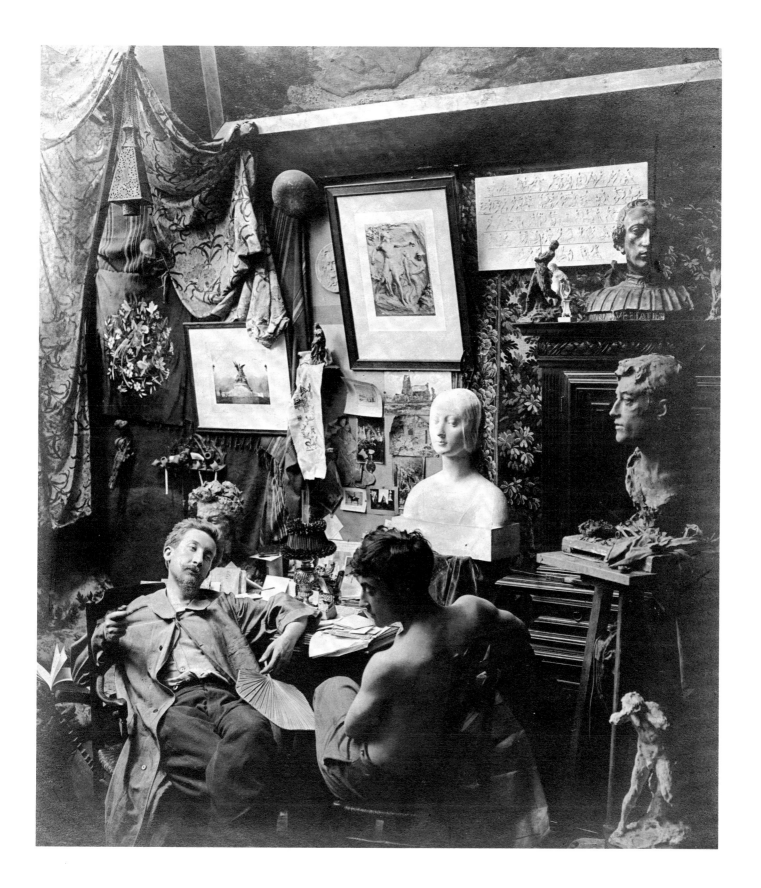

Plate 43 · Photographer unknown
Untitled, 1890s?

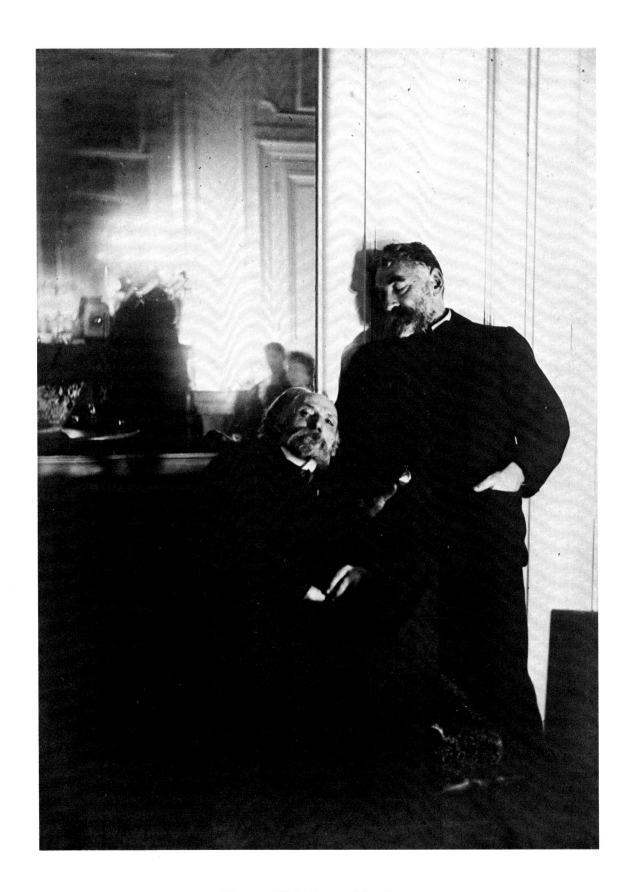

Plate 44 · Hilaire Germain Edgar Degas
Pierre Auguste Renoir and Stéphane Mallarmé, 1895

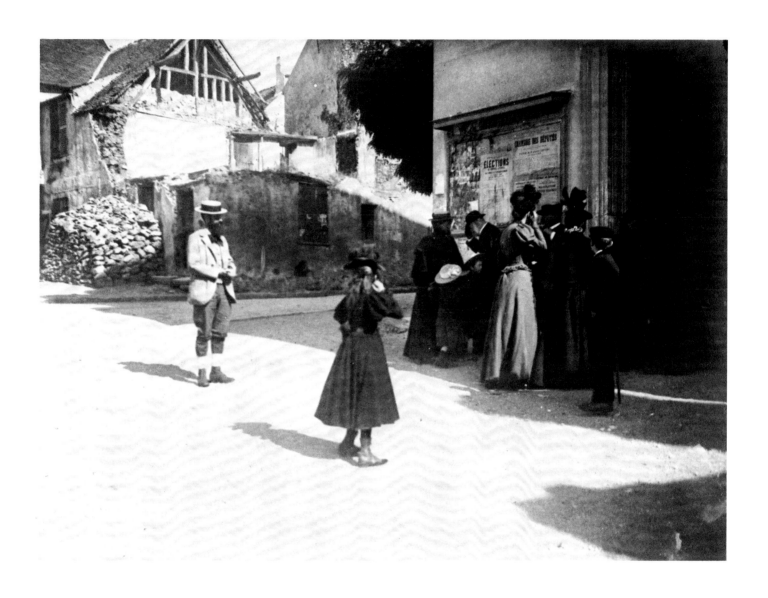

Plate 45 · Hilaire Germain Edgar Degas
Untitled, c. 1900?

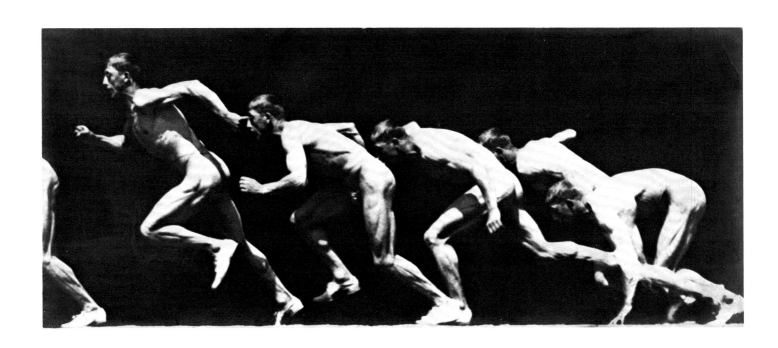

Plate 46 · Etienne-Jules Marey or Georges Demenÿ
Untitled, c. 1890–1900

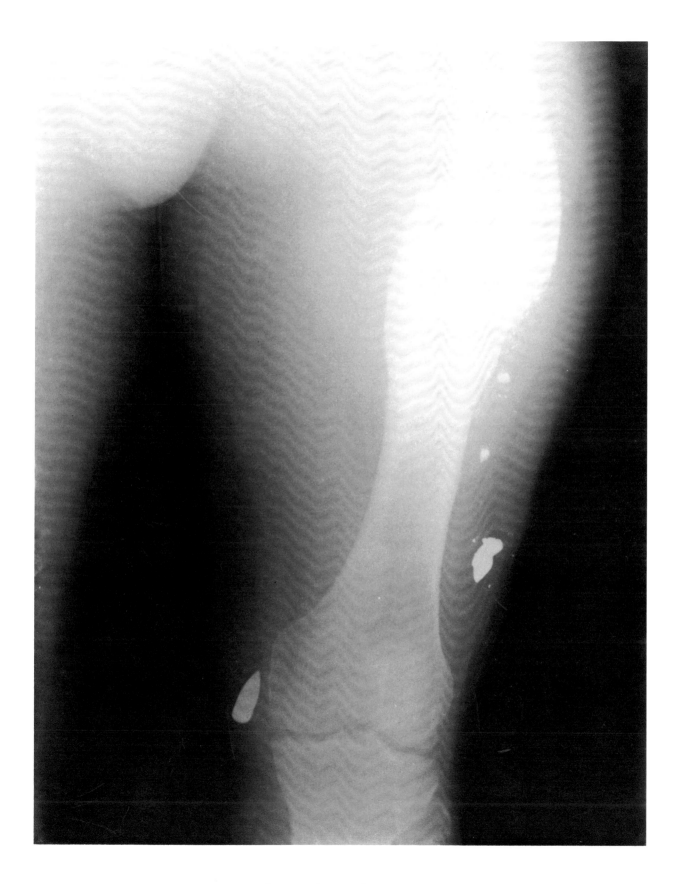

Plate 47 · Photographer unknown
X ray, 1917

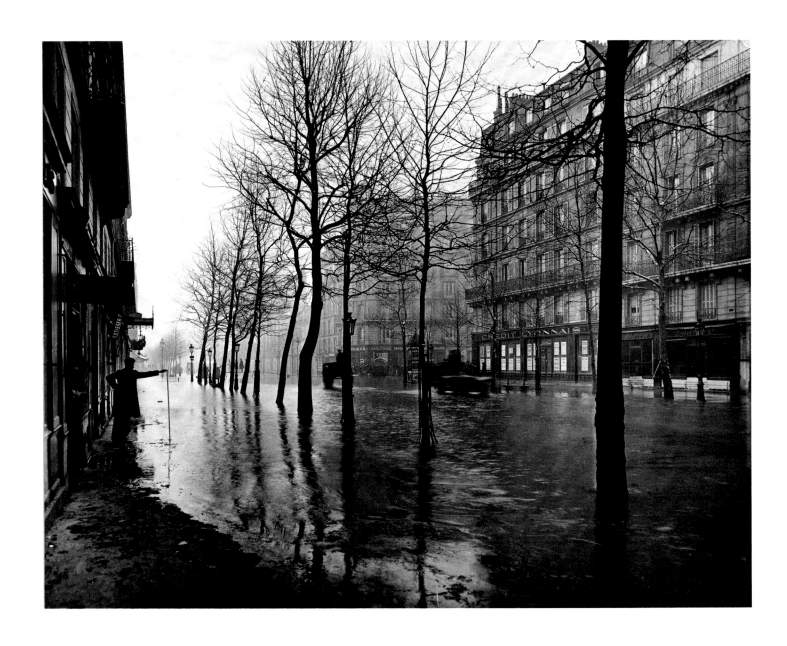

Plate 48 · Photographer unknown
Flood of the Seine, Avenue Ledru-Rollin, Paris, January 27, 1910

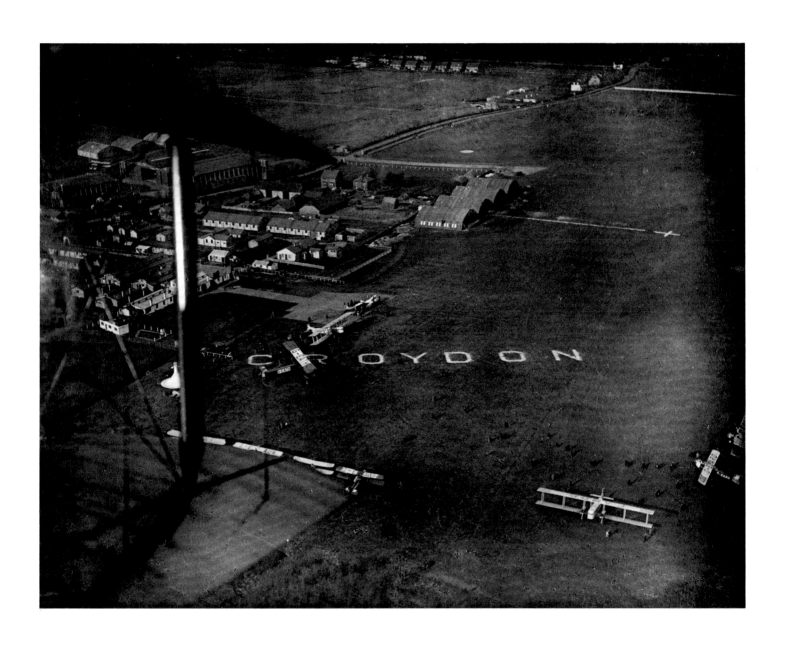

Plate 49 · Photographer unknown
London Terminal Aerodrome (Croydon), 1921–22

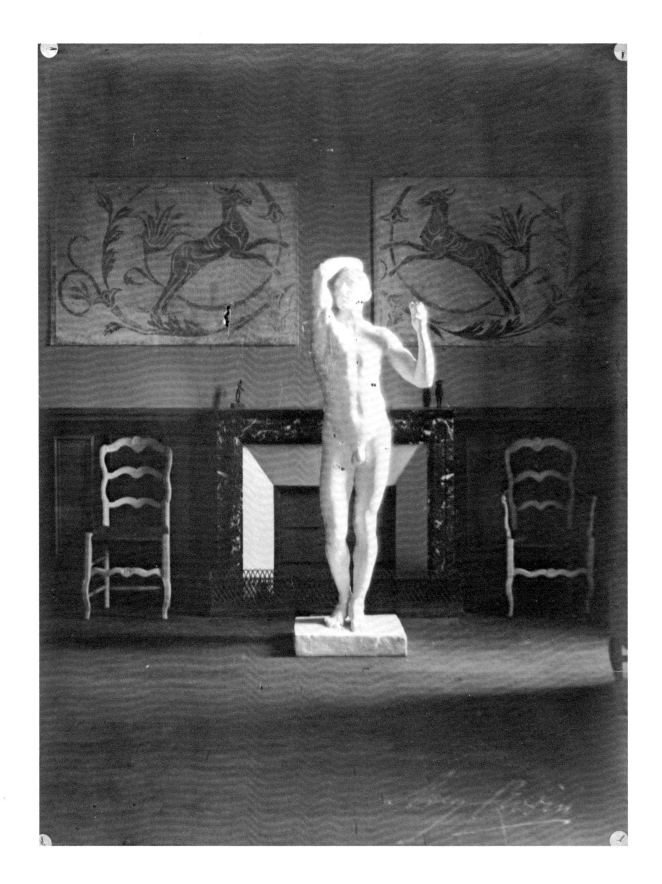

Plate 50 · Eugène Druet
Rodin's Age of Bronze, c. 1898–1900

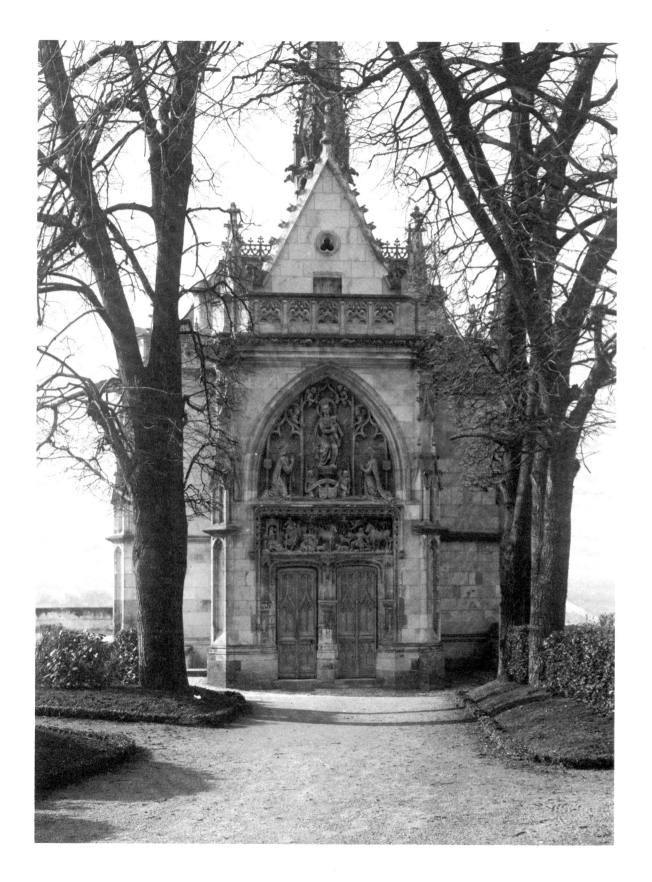

Plate 51 · Frederick H. Evans
Château d'Amboise, Chapel, 1907

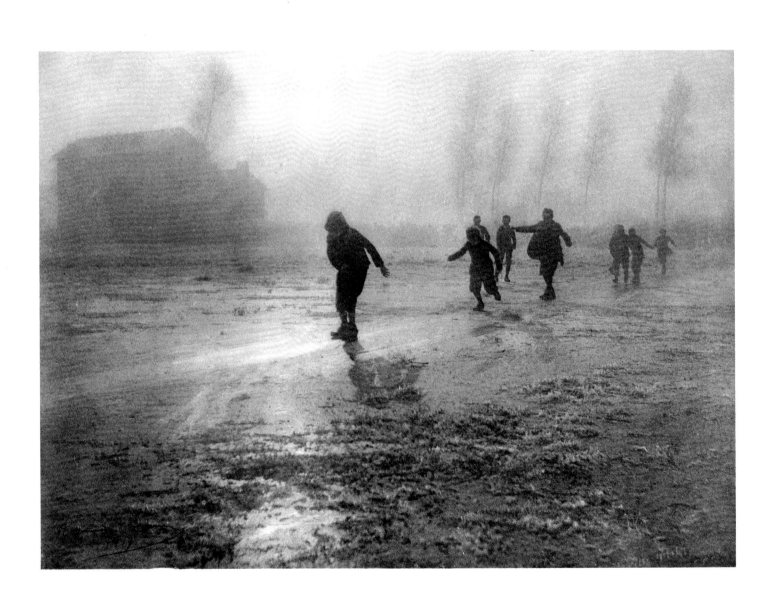

Plate 52 · Léonard Misonne
Untitled, 1919

Plate 53 · Drahomír Josef Růžička
Untitled, early 1920s?

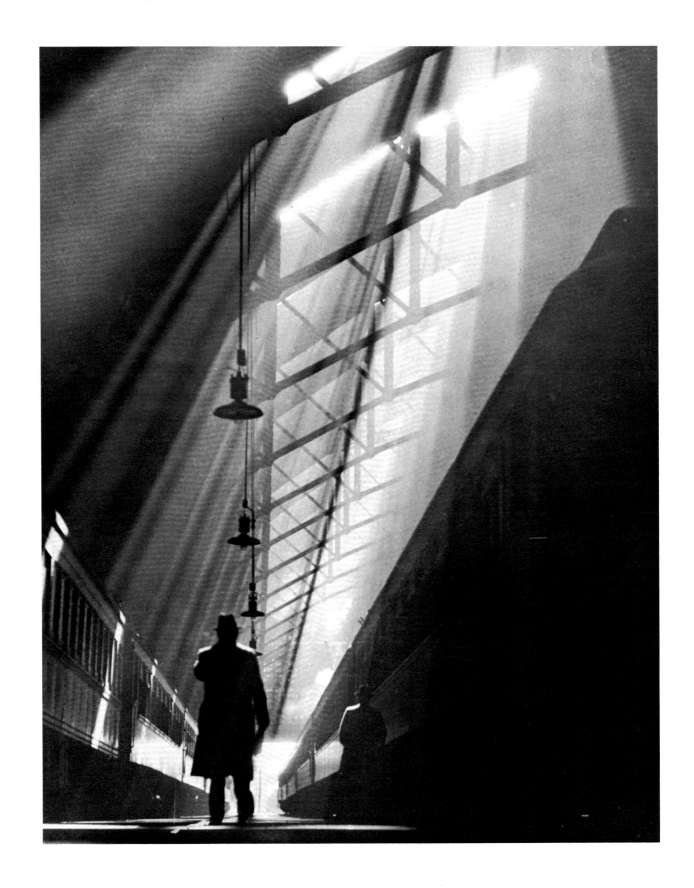

Plate 54 · William M. Rittase
Light Rays on Trains, La Salle Street Station, Chicago, 1931

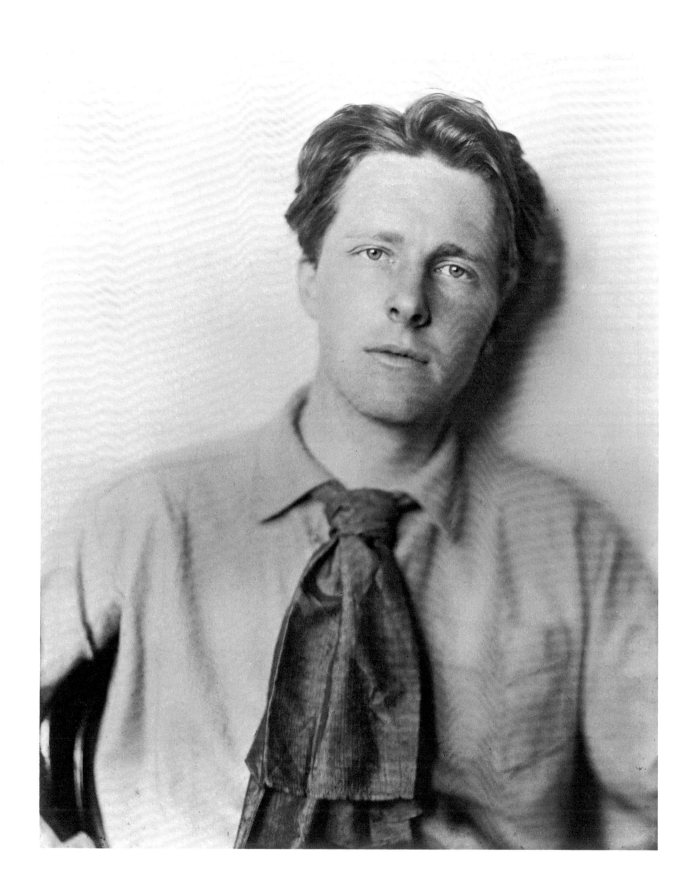

Plate 55 · Sherril Schell
Rupert Brooke, 1913

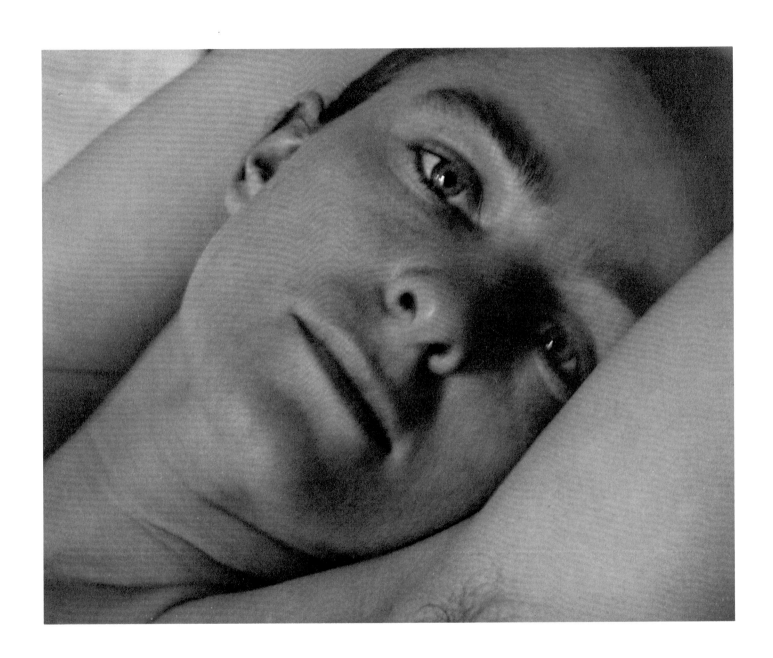

Plate 56 · Paul Strand
Rebecca Strand, New York, 1923

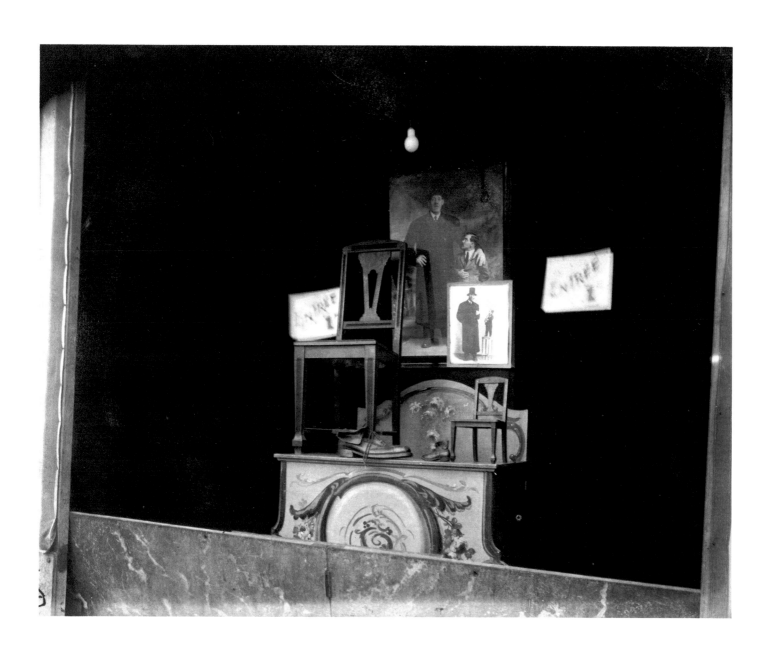

Plate 57 · Eugène Atget
Fête du Trône, 1925

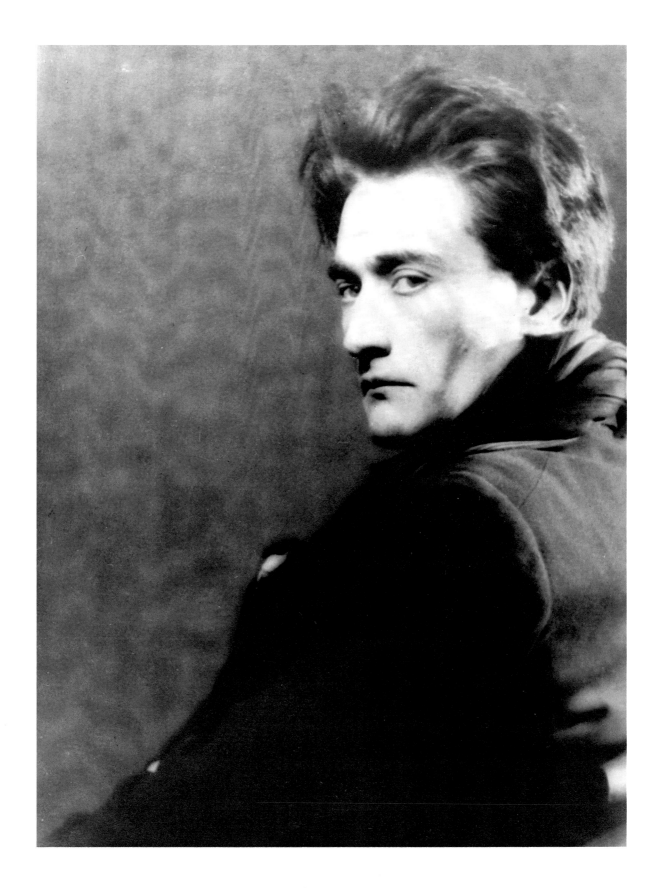

Plate 58 · Man Ray
Antonin Artaud, 1926

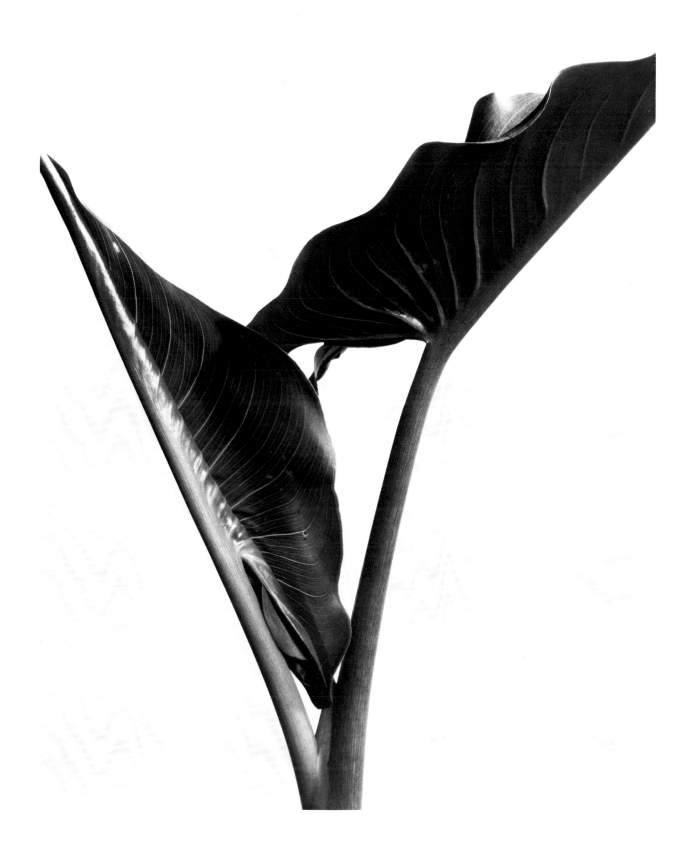

Plate 59 · Imogen Cunningham
Cala Leaves, 1932

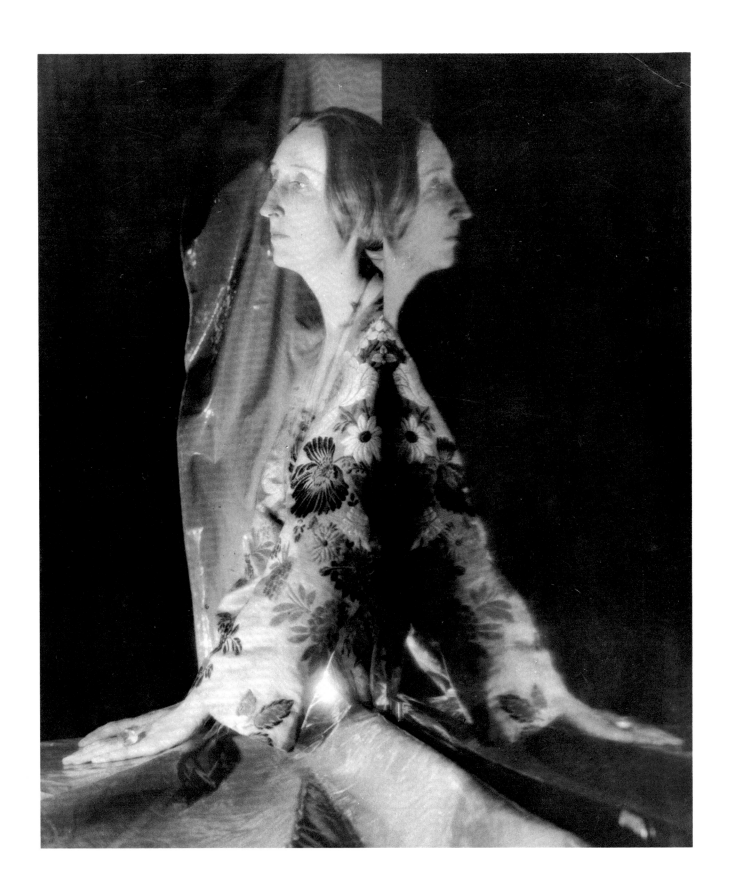

Plate 60 · Cecil Beaton
Edith Sitwell, 1927

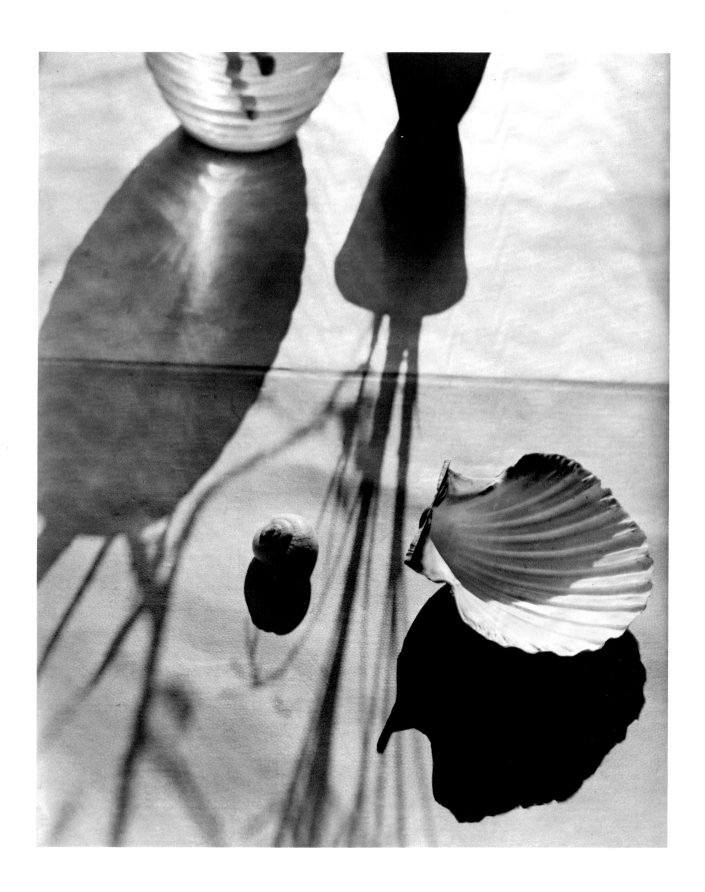

Plate 61 · Florence Henri
Untitled, c. 1931

Plate 62 · Attributed to Tim Gidal
Beer Hall, Munich, 1931

Plate 63 · Ilse Bing
French Cancan, Moulin Rouge, Paris, 1931

Plate 64 · August Kreyenkamp
Untitled, 1930s?

Plate 65 · Brassaï (Gyula Halász)
"Juan-les-Pins," Folies-Bergère, Paris, 1932

Plate 66 · Henri Cartier-Bresson
Untitled, 1929–30

Plate 67 · Henri Cartier-Bresson
Untitled, 1933

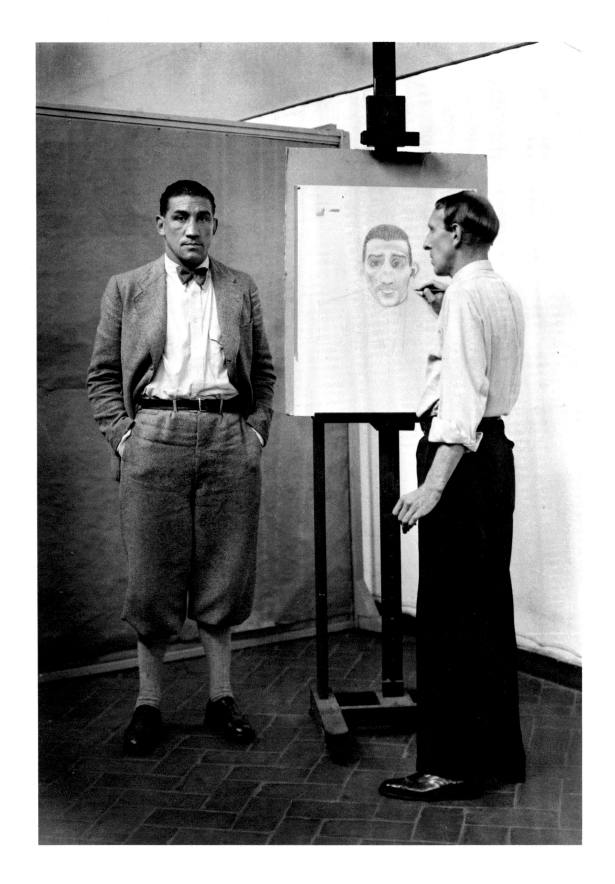

Plate 68 · August Sander
The Painter Heinrich Hoerle Drawing the Boxer Hein Domgörgen, c. 1927–31

Plate 69 · Josef Sudek
My Studio, 1956

CATALOGUE

The catalogue follows the order of the plates. An index of photographers represented in the book appears on page 133. The following members of the Department of Photography have written the notes:

CE	Catherine Evans	JP	John Pultz
PG	Peter Galassi	JS	John Szarkowski
SK	Susan Kismaric		

Photographer unknown
British?

Frontispiece. *The Great Temple, Madura, India.* n.d.
Albumen-silver print from glass (?) negative
8¾ × 10¾″ (22.1 × 27.2 cm)

Madura, located in southern India, is the largest and most ancient city in Tamil Nadu (the former state of Madras) and is considered an authentic center of the Dravidian culture. It is renowned for its Hindu temple built in the seventeenth century by the ruler Tirumala Nayak.

This room is a hall for public audiences and is known as the Mandapa of a Thousand Pillars or Hall of Saharathamba. At least one other nineteenth-century photograph of this interior space has been published.[1] The Walter picture provides a somewhat unconventional view; rather than describing the general meeting area, it depicts the corridor along one of the sides. The use of a very wide-angle lens and the play of light and shadow afford the photograph a curiously modern appearance.

Photographs by Linnaeus Tripe (pls. 32, 33) describe buildings that are a part of the same complex in Madura. CE

1. P. A. Johnston, *Tirumala Nayak's Palace* [sic], *Madura*, in Richard Pare et al, *Photography and Architecture 1839–1939* (Montreal: Canadian Centre for Architecture, 1982), pl. 89.

David Octavius Hill
British, 1802–1870

Robert Adamson
British, 1821–1848

1 Untitled, 1843–47
Salt print from paper negative
8¼ × 11⅛″ (21.2 × 28.2 cm)

2 *Mrs. Murray,* 1847
Salt print from paper negative
8 × 5⅞″ (20.2 × 14.9 cm)

3 *Colinton Wood,* 1843–47
Salt print from paper negative
7⅞ × 6⅛″ (20 × 15.5 cm)

The Hill and Adamson partnership arose out of a historic occasion in Scotland. In 1843 the General Assembly of the newly founded Free Church of Scotland held its first meeting,

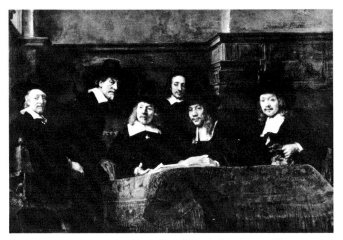

Fig. 1. Rembrandt van Rijn. *The Syndics of the Clothmakers Guild,* 1662. Oil on canvas. Rijksmuseum, Amsterdam

and the painter David Octavius Hill chose to commemorate the event in a large-scale history painting. The work, known as "The Disruption Painting," required gathering the likenesses of 474 members of the Free Church. Sir David Brewster, the chemist and friend of William Fox Talbot who was responsible for introducing photography to Scotland, suggested to Hill that he use the calotype (paper negative) process as a means of obtaining portraits for preliminary studies. Brewster introduced Hill to Robert Adamson, a young photographer who had opened a studio in Edinburgh, in 1843. This meeting precipitated a fecund partnership that enjoyed great success but ended with Adamson's premature death in January 1848. Although the collaboration began with studies for the painting, other portraits, as well as landscapes and architectural studies, soon drew Hill and Adamson's interest.

The portrait of eight men (pl. 1) is not related to the Disruption painting, nor are the sitters clergymen, judging by the variety of their neckwear. They appear to be businessmen[1] who are gathered around a table bearing emblems of their trade, recalling Rembrandt's *The Syndics of the Clothmakers Guild* (fig. 1). Contemporaries of Hill and Adamson often compared their work to Rembrandt's,[2] and although no specific paintings were mentioned, *The Syndics* might have served as a precedent for the photograph. In both cases the composition is compact, the background detail is minimal, and the atmosphere is one of created informality; in the photograph the seeming spontaneity is heightened because of the hand gestures and the lack of eye contact with the viewer.

Although most of Hill and Adamson's work cannot be dated more precisely than the period of the partnership, 1843–47, the picture of Mrs. Murray (pl. 2) was probably made in 1847, the year she married John Murray, the eminent publisher.[3] Roy Strong suggests that "portraits such as the back views of Mrs. Murray and Lady Ruthven are records of clothes and not primarily of personalities" and goes on to cite contemporary fashion prints as source material for the poses.[4] Other known prints from the same negative are reversed.[5]

The landscape of the fence and tree (pl. 3) is one of at least five views made in Colinton Wood that are listed in the National Galleries of Scotland catalogue. The title in an album in the British Library reads "At Lord Dunfermline's, Colinton."[6] The town of Dunfermline is outside Edinburgh to the north across the Firth of Forth, en route to Saint Andrews. Hill and Adamson photographed frequently in this area, and certainly this subject would have appealed to Hill, who had been a landscape painter. CE

1. Letter from Sara Stevenson, National Galleries of Scotland, Portrait Gallery, November 29, 1984.

2. The painters John Harden and Clarkson Stanfield, cited by Sara Stevenson in *David Octavius Hill and Robert Adamson* (Edinburgh: National Galleries of Scotland, 1981), p. 21.

3. Colin Ford and Roy Strong, *An Early Victorian Album* (New York: Knopf, 1976), p. 127.

4. Ibid., p. 63.

5. Ibid., p. 127, and Stevenson, p. 141.

6. Stevenson, p. 212.

Louis-Rémy Robert
French, 1811–1882

4 *The Park of Saint-Cloud,* c. 1853?
Albumen-silver print from paper negative
12⅝ × 10⅛″ (32.2 × 25.9 cm)

During the 1850s Louis Robert was in charge of the painters and decorators of the historic porcelain factory at Sèvres, while his fellow calotypist Victor Regnault was in overall charge of the establishment. A substantial body of opinion in that day and this views the output of the factory during this period with unmodified dismay;[1] if this judgment is correct, it might be in part because Robert, Regnault, and the artist-in-chief, Jules-Pierre-Michel Diéterle, spent so much of their attention and energy on making photographs. The enthusiasm of the early French amateurs of paper-negative photography was unmeasured. Jules Ziegler wrote in 1855 of eminent men of the time who gave to the new art "not a little energy and money, but their fortunes and their lifetimes."[2]

Robert may have learned photography from his friend Regnault as early as 1848; he used the calotype system until 1855, when he switched to glass negatives. In 1853 Blanquart-Evrard published a series of Robert's views of Versailles under the title "Souvenirs de Versailles."[3]

The stairway in Robert's picture does not match precisely the one that Eugène Atget photographed repeatedly two generations later (fig. 2).[4] Even without reference to the sculptures and vases, which were movable and moved for a variety of reasons, the architecture of the stairway itself is different. It may nevertheless be the same site. When the Château at Saint-Cloud was destroyed at the end of the Franco-Prussian War (1870–71), the gardens also suffered extensive damage; even after their renovation, further changes would be necessary as the gardens

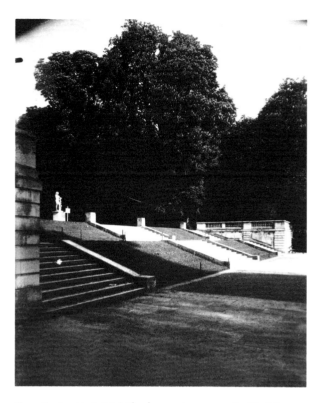

Fig. 2. Eugène Atget. *Saint-Cloud,* 1924. Arrowroot print. The Museum of Modern Art, New York. Abbott-Levy Collection. Partial gift of Shirley C. Burden

became progressively important as a public park. It will be noted that Robert made his picture with a lens of long focal length (the virtual height of the stair risers decreases very slowly with distance), while Atget's picture encompasses a wider field of view from a closer vantage point. JS

1. André Jammes and Eugenia Parry Janis, *The Art of French Calotype* (Princeton, N.J.: Princeton University Press, 1983), p. 238.

2. Ibid., p. 138.

3. Isabelle Jammes, *Blanquart-Evrard et les origines de l'édition photographique française* (Geneva: Droz, 1981), pp. 283–87.

4. For variant views by Atget, see *The Work of Atget,* vol. 3, *The Ancien Régime* (New York: The Museum of Modern Art, 1983), pls. 62, 63, and related figures.

Charles Marville
French, 1816–1879?

5 *Columnar Figures of the North Porch, Chartres Cathedral,* 1853–54
Salt print from paper negative
14 3/16 × 10⅛″ (36 × 25.6 cm)
Printed on mount: "NEGATIF DE CH. MARVILLE, PHOTOGRAPHIÉ ET ÉDITÉ PAR BLANQUART-ÉVRARD./ CATHÉDRALE DE CHARTRES./GRANDES FIGURES DES

Although Charles Marville is known primarily for his glass-plate views of Paris in the 1860s, his first photographs were calotypes made between 1851 and 1855 for the photographic printing establishment of Blanquart-Evrard. This picture is from *L'Art Religieux: Architecture–Sculpture–Peinture,* an album conceived by Blanquart-Evrard and issued in fascicles in 1853 and 1854.[1] The album was divided into two series: the first was devoted to architectural monuments and sculpture; the second, to Old Master paintings. Each series was further divided chronologically, with one hundred plate numbers reserved for each century. Only sixty-nine plates appear to have been produced: forty-one of architecture and sculpture and twenty-eight of painting.

Here Marville photographs two unidentified Old Testament figures on columns of the foreportal of the north transept of Chartres Cathedral. The vantage point is unusual. He has

Fig. 3. Henri Le Secq. *Columnar Figures, North Porch, Chartres Cathedral,* 1852. Photolithograph, printed late 1870s. Centre Canadien d'Architecture/Canadian Centre for Architecture, Montreal

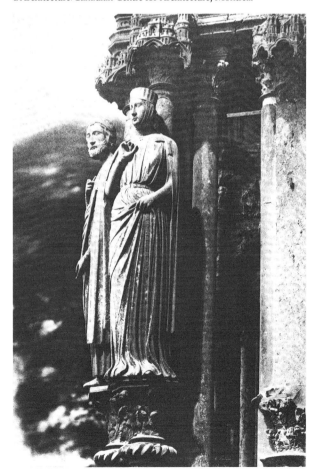

placed his camera within the splayed entranceway of the fore-portal, directing it at an angle away from the portal itself. He silhouettes the front of the male figure against the deep shadow of a buttress, giving graphic clarity to the figure's contour. Especially evident is the lifelike attitude of the figure's head, one of the few on the north transept not attached by a stone strut to the corresponding column.

At the same time that Marville made this view, Henri Le Secq photographed Chartres as part of a French-government project in which five photographers were commissioned to document endangered architectural monuments.[2] Le Secq photographed the same two figures from almost the same vantage point but placed his camera at a lower angle, to the right (fig. 3). In Marville's photograph the two figures, although fused into an intimate pair, clearly remain part of the architectural setting of the cathedral. In Le Secq's, they seem removed from the exigencies of architecture and animated with psychological realism. JP

1. See Isabelle Jammes, *Blanquart-Evrard et les origines de l'édition photographique française* (Geneva: Droz, 1981), p. 148 and cat. no. 58.

2. See Janet E. Buerger, "Le Secq's 'Monuments' and the Chartres Cathedral Portfolio," *Image,* vol. 23, no. 1 (June 1981), pp. 1–5; and Eugenia Parry Janis, "Man on the Tower of Notre Dame: New Light on Henri Le Secq," *Image,* vol. 19, no. 4 (December 1976), pp. 13–25.

Félix Teynard
French, 1817–1892

6 *General View of the Pylon, Temple of Sebou'ah, Nubia,* 1851–52
Salt print from paper negative
9⅜ × 12⅛″ (23.8 × 30.4 cm)
Printed on mount: "NUBIE/Félix Teynard, phot. Publié par Goupil et Cie éditeurs, Paris, Londres, Berlin, New-York./ SEBOÛAH/TEMPLE—VUE GÉNÉRALE DU PYLÔNE/Pl. 132"

Félix Teynard, a civil engineer, had not had any artistic training when he took up photography. Like his contemporaries Felice Beato, Louis De Clercq, Maxime Du Camp, Francis Frith, John B. Greene, and Auguste Salzmann, he made a photographic expedition to Egypt in the 1850s. During his trip, in 1851–52, he produced negatives for the two-volume *Egypte et Nubie: Sites et monuments les plus intéressants pour l'étude de l'art et de l'histoire. Atlas photographique accompagné de plans et d'une table explicative servant de complément à la Grande Description de l'Egypte* (Paris: Goupil et Cie; London: E. Gambart et Co., 1858). Although it is not known who sponsored the trip, the paper negatives were printed by the firm of H. de Fonteny and the resulting 160 salt prints were issued in thirty-two fascicles of five plates each in 1853 and 1854.[1] The *Description de l'Egypte* referred to in the extended title is the name of an enormously ambitious publication on which Teynard's volumes were based. After his occupation of Egypt in 1798, Napoleon I commissioned an account, and it was pub-

lished in twenty-three volumes that appeared between 1809 and 1828 as *Description de l'Egypte, ou Recueil des observations et des recherches qui ont été faites en Egypte pendant l'expédition de l'armée française.* As the ultimate example of the nineteenth-century assumption that knowledge is power, it served as the prototype for all future attempts at linking Europe to the Orient.[2] Obviously less all-encompassing than its antecedent, *Egypte et Nubie* nevertheless contains lengthy texts that describe the history of the monuments, plate by plate. In addition, Teynard's introduction discusses history, geography, population, archaeology, and architecture. With regard to the making of negatives, he mentions the difficulties of working in the desert and apologizes for the lack of interior views, citing windowless Egyptian tombs as the reason.[3]

This picture was reproduced as plate 132 in *Egypte et Nubie* and belongs to the second volume. In general, the photographs are distinguished from those of his contemporaries by their emphasis on clearly defined patterns created by light and shadow. Although the same subject matter occupied De Clercq, Du Camp, Frith, Greene, Salzmann, and Teynard, each developed a singular, recognizable, and remarkably consistent style. CE

1. André Jammes and Eugenia Parry Janis, *The Art of French Calotype* (Princeton, N.J.: Princeton University Press, 1983), p. 249.

2. Edward W. Said, *Orientalism* (New York: Pantheon, 1978), p. 87.

3. Félix Teynard, *Egypte et Nubie* (Paris: Goupil et Cie; London: E. Gambart et Co., 1858), introduction. A nearly complete version of the volumes is in The Metropolitan Museum of Art, New York.

Auguste Salzmann
French, 1824–1872

7 *Tomb of Zachary, Valley of Jehosaphat,* 1854
Salt print from paper negative
9¼ × 12⅜" (23.5 × 31.4 cm)
Printed on mount: "Aug. Salzmann/JÉRUSALEM/VALLÉE DE JOSAPHAT/Tombeau de Zacharie"; "Gide et Baudry, éditeurs"; "Imp. Photogr. de Blanquart-Evrard, à Lille"

The painter Auguste Salzmann traveled to Algeria in 1847, a trip which aroused his interest in archaeology.[1] In 1851 he went to Egypt in search of antiquities for possible acquisition by the Colmar museum in his native Alsace. By 1854 he had turned to photography, for in that year, the Ministry of Public Instruction commissioned him to amass archaeological data and to photograph monuments in the path of the Crusades in Egypt, Syria, Palestine, and on the Greek islands.[2] However, Jerusalem became the destination of the tour; the archaeologist Félicien Caignart de Saulcy instructed Salzmann to photograph its ancient monuments in order to give credence to de Saulcy's dating theories, then under lively debate.[3] Salzmann's efforts resulted in *Jérusalem: Etude et reproduction photographique des monument de la Ville Sainte, depuis l'époque judaïque jusqu'à nos jours* (1856), published in Paris by Gide et Baudry.

The two volumes include 174 photographs printed by Blanquart-Evrard and a separate text of ninety pages, which Salzmann dedicated to de Saulcy.

This photograph falls in the first volume within a section called "Monuments judaïques" and is the fourth of ten pictures on the Valley of Jehosaphat. The three preceding views locate the Hellenistic tomb in the landscape, and those that follow picture two other important sites in the valley, the tombs of St. James and of Absalom. Although modern taste has prized the "eccentricities of design and composition"[4] of the architectural details in the book, Salzmann's systematic approach to the Valley of Jehosaphat suggests that he was following the path of documentarian. CE

1. For a biographical account of Salzmann and a descriptive catalogue of *Jérusalem*, see Françoise Heilbrun, "Auguste Salzmann, Photographe malgré lui," in *F. de Saulcy (1807–1880) et la Terre Sainte* (Paris: Editions de la Réunion des Musées Nationaux, 1982), pp. 114–82. See also Isabelle Jammes, *Blanquart-Evrard et les origines de l'édition photographique française* (Geneva: Droz, 1981), pp. 92–103.

2. André Jammes and Eugenia Parry Janis. *The Art of French Calotype* (Princeton, N.J.: Princeton University Press, 1983), p. 246.

3. According to Jammes and Janis, de Saulcy believed that certain architectural fragments in Jerusalem dated back to the time of King Solomon and possibly even to King David and thus were much earlier than had been previously thought. This theory, as published in *Voyage autour de la Mer Morte dans les terres bibliques* (1852–54, 2 vols.), aroused much controversy among contemporary archaeologists.

4. Jammes and Janis, p. 72.

Attributed to Charles Simart
French, 1806–1857

8 Untitled, 1850s?
Albumen-silver print from wet-collodion glass negative
9¼ × 6⅛" (23.4 × 15.5 cm)

The photograph has been tentatively attributed to the sculptor Charles Simart on the somewhat slender evidence that another print from the same negative came from an album, apparently by one hand, that also reproduced a drawing for one of Simart's bas-reliefs.[1] Simart is perhaps best remembered for his extended series of relief sculptures for Napoleon's Tomb in the Invalides, Paris. Perhaps the figure in the photograph will be discovered, in a more highly idealized state, as a figure in one of those works. The large picture on the right would appear to be a tapestry, the left edge of which is perhaps obscured by a movable white flat that stands behind the model.

The photographer, of whatever name, was a pioneer in the technique of photographic enlarging. A cropped version from the same negative, in which the image has been enlarged about four diameters, and other examples of enlarged images exist as salt prints in the André Jammes Collection.[2] JS

1. David Travis, ed., *Niépce to Atget: The First Century of Photography*

from the Collection of André Jammes (Chicago: The Art Institute of Chicago, 1977), p. 64.

2. Ibid., pls. 80–83.

Charles Nègre
French, 1820–1880

9 *Spartacus, Tuileries Gardens, Paris,* 1859
Albumen-silver print from wet-collodion glass negative
16¹⁵⁄₁₆ × 11¼″ (43.1 × 28.6 cm)

Charles Nègre, like Gustave Le Gray, Henri Le Secq, and Roger Fenton, studied painting in Paris under Paul Delaroche and made his debut as a history painter in the Salon of 1843 at the age of twenty-three.[1] He exhibited regularly at the Salon, where his paintings drew the attention of his contemporaries and the future Napoleon III.[2] In 1844 he became interested in photography as a way of producing sketches for his painting. The recognition he received in the Salons, as well as his remarkable ability as a photographer, led to a series of photographic commissions in the 1850s under the auspices of Napoleon III.

Nègre photographed *Spartacus* in June 1859 for a monograph on the sculpture in the Tuileries Gardens.[3] This project was meant to be a part of a more ambitious plan Nègre presented to Napoleon III in a memorandum of 1858. He proposed to photograph objects in the Louvre in order to produce a history of civilization. Instead of supporting this complex proposal, the Emperor commissioned Nègre to make the Tuileries series. Fifty heliographic plates were to be published in an edition of one hundred. Nègre made a total of thirty photographs for approval by the Beaux-Arts division of the Louvre. However, the director of the department died, and the project was not pursued by his successor. Of the thirty photographs, fifteen prints, including *Spartacus,* remain with the Nègre family.[4]

The marble sculpture *Spartacus,* by Denis Foyatier, probably dates from 1831, when it was installed in the Tuileries. A plaster version had appeared at the Salon of 1827. Although the marble sculpture was moved to the Louvre in 1877,[5] the buildings in the background confirm the sculpture's location in the Tuileries at the time the photograph was made.

Nègre had experimented with photogravure as early as 1854, believing that permanent photographs could be achieved only by printing them in ink.[6] He intended to print *Spartacus* as a gravure, which required that an intermediate transparent positive (on glass) be prepared from the original negative.[7] In the positive, the image would be reversed, as demonstrated in plate 9 by the lettering at the base of the sculpture, since it would again be laterally inverted by the printing process. The reversal of the image here is puzzling. If the print had been exposed through the back of the glass plate, the image would not be as sharp as it is, suggesting that the reversal was achieved in the original negative, possibly by reversing the plate in its holder so that the sensitized emulsion faced away from the lens, or possibly by photographing the image inverted in a mirror.
CE

1. See James Borcoman, *Charles Nègre* (Ottawa: The National Gallery of Canada, 1976).

2. Ibid., p. 13.

3. See the comprehensive description of this project by Françoise Heilbrun in *Charles Nègre, Photographe* (Paris: Les Editions des Musées Nationaux de France, 1980).

4. Ibid., p. 373.

5. *Inventaire général des richesses d'art de la France: Monuments civils,* vol 4 (Paris: Plon, 1913), p. 248, issued by the Ministère de l'Instruction Publique et des Beaux-Arts.

6. Borcoman, p. 39.

7. For another example of this series, see Richard Pare et al, *Photography and Architecture 1839–1939* (Montreal: Canadian Centre for Architecture, 1982), pl. 24 and p. 228.

Roger Fenton
British, 1819–1869

10 *Dinornis Elephantopus,* 1858?
Salt print from wet-collodion glass negative
15 × 10¹⁄₁₆″ (38.1 × 30.6 cm)

Like many of the most important photographers of the first generation, Roger Fenton was a man of affairs and of substantial culture. Trained as a painter (under Paul Delaroche, like Charles Nègre, Henri Le Secq, and Gustave Le Gray) and as a solicitor, he devoted most of his energies to photography, both as an outstanding practitioner and as a force in the formation (1853) and in the early achievements of the London Photographic Society. In 1862, for reasons which he did not explain, he gave up photography, and late in that year over one thousand of his negatives were sold at auction. Some of these were later reprinted by Francis Frith and Company at Reigate.

In a photographic career that spanned a dozen years, Fenton photographed the Crimean War, served as the first photographer of the British Museum, and produced extensive series of genre pictures and still lifes; but his highest achievement was his landscapes and architectural studies, which possess a grandeur and simplicity of conception that place them among photography's masterworks (see pl. 14).

The British Museum established a photographic unit in 1853 to record and facilitate the study of certain objects in its collection. Fenton was selected as photographer, and served in this capacity for over seven years. The first pictures he made in this role, in 1854, were apparently of a number of the Museum's Assyrian tablets; a report of the Museum proposed that twenty prints be made from each negative and "sent to such scholars as are known to be engaged in their translation and interpretation."[1] Fenton photographed stuffed animals and skeletons for the Museum in 1858,[2] and the picture shown here is probably of that series. Two other photographs by Fenton[3] show the central skeleton of plate 10, and identify the

creature as *Dinornis Elephantopus,* presumably a member of the genera *Dinornithidae Elephantopus,* large flightless birds native to Australia.

Hans Friedrich Gadow of Cambridge University, writing in 1910,[4] noted that much had been expected of the study of fossil birds, but that they had in the main proved a source of perplexities. He added that if every bird, extant and extinct, were known to science, all differences would be connected by subtle and continuous gradations, and that no method of classification would be possible, a thought that has also occurred to art historians. Dr. Gadow also stated that the proper study of fossil birds might be said to have begun with the work of A. Milne-Edwards, published between 1867 and 1871, in which case no highly rigorous scientific function need be demanded of Fenton's marvelous earlier photograph of the crazy bones. J S

1. John Hannavy, *Roger Fenton of Crimble Hall* (Boston: Godine, 1979), p. 34.

2. Ibid., p. 42.

3. See Hannavy, p. 37, and *Photographies,* no. 2 (September 1983), p. 4.

4. "Birds," *Encyclopaedia Britannica,* 11th ed. (1910–11), vol. 3, p. 970.

Attributed to Charles Marville

11 Untitled, 1860s?
Albumen-silver print from wet-collodion glass negative
7⁹⁄₁₆ × 9¾" (19.3 × 24.9 cm)

The picture is from an album that contained about thirty photographs by Marville, who in at least one other case is known to have photographed dogs.[1] The same dog is the subject of a daguerreotype (private collection, England), originally in the same collection as the album. The picture, a portrait, probably was made on commission, but the circumstances are not known; perhaps the dog belonged to a member of the Court of Napoleon III. P G

1. Sale catalogue, Sotheby's Belgravia, London, March 14, 1979, lot 281.

Charles Nègre

12 *Imperial Asylum, Vincennes,* 1858–59?
Albumen-silver print from wet-collodion glass negative
6¾" (17.1 cm) diameter
Signed in ink on print: "ch. Nègre"

Among the commissions Nègre received from Napoleon III (see also pl. 9) was one that involved photographing the new Imperial Asylum of Vincennes, an institution for disabled workmen and one of the Emperor's many projects aimed at treating social issues. It is believed that Nègre began the documentation in 1858 or 1859, not long after the first convalescents entered the asylum in September 1857, and completed it sometime before November 1860, when an album was presented to the Duke of Padua.[1] Here we see the linen storage area attended by two nuns. The quality of arrested motion may have been achieved by a procedure Nègre developed in 1851, combining lenses to minimize exposure time.[2] The tondo format was probably used here to avoid squaring off and thereby further reducing the already relatively small image area. C E

1. Françoise Heilbrun, *Charles Nègre, Photographe* (Paris: Les Editions des Musées Nationaux de France, 1980), p. 259 and notes 21 and 22, pp. 329–30.

2. James Borcoman, *Charles Nègre* (Ottawa: The National Gallery of Canada, 1976), pp. 24–25.

Oscar Gustave Rejlander
British, born Sweden. 1813–1875

13 *Joseph Wilson Foster,* c. 1860
Albumen-silver print from wet-collodion glass negative
7¹³⁄₁₆ × 5⅞" (19.7 × 15 cm)
Inscribed in pencil on mount: "Wilson Foster"

O. G. Rejlander studied painting in Rome, perhaps also in Spain, then moved to England. By 1841 he had established himself as a painter in Lincoln; then by 1846 in Wolverhampton. He moved to London only in 1862, after he had gained a reputation as a photographer. He had learned photography in 1853, ostensibly as an aid to painting, which he soon gave up.[1]

Rejlander often is linked to his contemporary Henry Peach Robinson (1830–1901). In the late 1850s both used "combination printing," a technique in which individual figures and sections of the background are photographed on separate negatives, then carefully pieced together in the finished print to create the illusion of a seamless image. As a method for producing artistic tableaux, the technique was peculiar to England. Rejlander adopted it in 1857 for an elaborate multifigured allegory called *The Two Ways of Life.* Within a few years, however, his work took a new direction. Unlike Robinson, who continued to make combination prints, Rejlander virtually abandoned the technique and henceforth concentrated on "photographic art studies and portraits," as the backs of his picture mounts stated. The art studies generally include one or two figures in poses designed to illustrate types ("The Wayfarer"), episodes of daily life ("She's Looking at Me, the Dear Creature"), and states of mind ("The Dream"). Some of these now strike us as hopelessly artificial, but the best are still affecting. Abandoning the grandiose for the modest, Rejlander repeated a pattern familiar in English art at least since Joshua Reynolds, who had preached the high ideals of Michelangelo but did his best work as a portraitist. Rejlander's special sympathy for children and success with them as subjects also may be compared to Reynolds's.

Rejlander was a pioneer: the first photographer, perhaps, to take the life of the mind and the emotions as his central subject.[2] It is no surprise, then, that both Lewis Carroll and Julia Margaret Cameron (pls. 23–25) admired and learned from his pictures.[3] As in their photographs, it often is difficult

in Rejlander's work to draw the line between portraiture and allegory, fact and fantasy. The picture here is a case in point. It bears the sitter's name rather than a title, and is doubtless a commissioned portrait; but it would serve equally well as an illustration of "The Guileless Enthusiasm of Youth."

The apparent spontaneity of the portrait was a technical as well as artistic achievement. In 1860 exposures were still long—even in sunlight at least a second—and a headbrace often was used to steady the sitter. Here this function is performed by the boy's left arm. It is an ingenious pose, transforming a technical liability into a gesture of candor. PG

1. The essential source for Rejlander's life is the obituary in *The British Journal of Photography*, January 29, 1875. The basic study of his life and work is Edgar Yoxall Jones, *Father of Art Photography: O. G. Rejlander, 1813–1875* (Greenwich, Conn.: New York Graphic Society, 1973). For Jones's interpretation of the pose of our picture, see p. 77.

2. It was probably Rejlander's reputation for this sort of work that led Charles Darwin to hire him to make photographic illustrations for *On the Expression of Emotions in Man and Animals* (1872).

3. Rejlander's admirers also included Peter Henry Emerson, the archrival of Robinson. Emerson cited Rejlander (with the French portraitist Adam-Salomon) as one of two "masters" of photography. See *Naturalistic Photography for Students of the Art* (London, 1889), p. 290.

Roger Fenton

14 *Salisbury Cathedral: The Spire*, c. 1860
Albumen-silver print from wet-collodion glass negative
16¼ × 14⅜″ (41.4 × 36.5 cm)
Printed on mount: "Photographed by R. Fenton."; printed label affixed to mount: "68 Salisbury Cathedral, the Spire"

Contemporary critics commented more than once on Fenton's mastery of aerial perspective.[1] His technique was superb, and perhaps no other photographer achieved a more delicately responsive scale of values from the wet-collodion plate and the albumen print. Nevertheless, much of what his contemporaries might have thought a question of chemistry was rather a matter of knowing where to stand, and when. Many of his Cathedral pictures are characterized by the same low, opalescent sunlight that is evident in the Salisbury print. This light sacrifices sculptural emphasis in favor of a buoyant radiance that describes masonry as an ephemeral idea. Against the insubstantial stone Fenton patterned the dark trees and solid earth. Even before Constable, the scheme had been understood by the Dutch painters of the seventeenth century. JS

1. See Valerie Lloyd, "Roger Fenton and the Making of a Photographic Establishment," in Mark Haworth-Booth, ed., *The Golden Age of British Photography: 1839–1900* (Millerton, N.Y.: Aperture, 1984), p. 75.

Gustave Le Gray
French, 1820–1882

15 *The Camp at Châlons, Maneuvers of October 3, 1857*, from *Souvenirs du Camp de Châlons au General Decaën, 1857*

Albumen-silver print from wet-collodion negative
10¾ × 14¼″ (27.3 × 36.2 cm)
Stamped on print: "Gustave Le Gray"

The regime of Napoleon III (1852–70) was perhaps the first to use photography in a sustained program of propaganda. Except for the numerous portraits of the Emperor and his family, this program was not directed at a mass audience. Rather, it took the form of lavish albums documenting notable works of the Second Empire, commissioned for presentation to a small elite and intended to inspire admiration for and loyalty to the Emperor. Baldus's photographs of the new railway lines (pl. 18), Nègre's document of the Imperial Asylum at Vincennes (pl. 12), and Le Gray's views of the Camp at Châlons (an album of which is in the Walter Collection) are outstanding examples of such commissions. The albums, like the Emperor's personal library, were bound uniformly in green morocco with gold lettering and the Imperial monogram, an unmistakable reference to the ubiquitous "N" of Napoleon I.

In 1856, as a preparation for later military adventures, Napoleon III ordered the creation of a camp at which up to 100,000 soldiers could practice maneuvers. He chose a site near Châlons-sur-Marne, east of Paris, where the flat, nearly barren terrain offered few obstacles to the exercises. The camp opened on August 25, 1857, and remained in operation until the demise of the Second Empire in 1870. Each August Napoleon and his family visited the camp, receiving dignitaries, dining with the officers, observing the maneuvers, and celebrating the birthday of Empress Eugenie. The first series of military exercises, involving 21,365 men and 5,871 horses, began on August 31, 1857, and culminated in the *grande manoeuvre* of October 3.[1]

Le Gray appears to have worked throughout this period, photographing the maneuvers, the imperial pavilions, scenes of camp life (especially among the Zouaves), and the final Sunday Mass on October 4, for which all the troops assembled in parade dress.[2] The Walter album contains twenty-five photographs, including two copies of drawings of the camp at night by Benedict Masson (1820–1893), an artist who, like Le Gray, was working on commission. The album was presented by the Emperor to General Claude Théodore Decaën (1811–1870), commandant of the second brigade of the second infantry division of the Garde Impériale. At least five other albums are known.[3] A series of stereo views by Le Gray, possibly intended for a popular audience, also survives.[4]

The exercises, interrupted periodically by days of rest and the weekly Mass, included maneuvers by brigade and by division, firing practice for the artillery and the infantry, and ten *grandes manoeuvres*. Each of the latter was a hypothetical battle against an imaginary enemy, whose position and movements, like those of the actual army, were precisely choreographed in advance. The scenario for October 3 called for a carefully designed earthen breastwork, which during the course of the battle protected first the light infantry, then the grenadiers, from an invisible enemy.[5] Le Gray's picture shows the breastwork from the side and slightly from behind. It is

occupied by grenadiers (identifiable by their headgear) and is partially obscured by a haze of dust raised by the recent advance of the light infantry.

Le Gray's work at Châlons involved an unusual pictorial problem. Unable to stop motion or to work at close range, he photographed the maneuvers from a great distance over the barren terrain. The result was a stark image of bright sky and dark earth divided by a narrow band of detail—the army—at the horizon. In a series of seascapes made a year or two earlier, Le Gray had mastered the radical simplicity of the image. Perhaps this preparation contributed to his success at Châlons, to the elegance and grandeur of his views of the maneuvers.

Here Le Gray was able to get closer than usual, and the dust provided an aura of mystery. Early war photographs of the Crimea and the American Civil War rightly have been credited with unveiling the banality and brutality of war. However, this picture belongs to an earlier world, when battles were planned (if not actually fought) by gentlemen's rules and war was conceived as a noble, romantic adventure. PG

1. The official account of the maneuvers is *Journal du Camp de Châlons-sur-Marne en 1857 publié par ordre de l'Empereur* (Paris: Imprimerie Impériale, 1858). See also Charles Bousquet, *La Garde impériale au Camp de Châlons, 1857* (Paris: Blot, 1858), p. 246, where Le Gray and his commission are mentioned; and Comte Emile Félix Fleury, *Souvenirs du général cte. Fleury*, vol. 1 (Paris: Plon, Nourrit, 1897), pp. 392–96.

2. See Bernard Marbot, "Souvenirs photographiques du camp de Châlons en 1857 par Gustave Le Gray: Album Montebello," *Bulletin de la Bibliothèque Nationale*, 3e année, no. 3 (September 1978), pp. 136–41.

3. Two in the Musée de l'Armée, Paris (one containing fifty-two, the other twenty-eight photographs); one in the Bibliothèque Nationale, Paris (sixty-six photographs, including twenty-five portraits); one in the André Jammes Collection, Paris (sixty-two photographs), and one dispersed in the New York art market in 1983. The photographs in the Walter album do not appear to form a coherent sequence; certainly they do not follow the chronology of the maneuvers. However, with the exception of one addition and three transpositions, the photographs in the Walter album follow the order of the Bibliothèque Nationale album.

4. Thirteen stereo views are in the Division of Photographic History, Smithsonian Institution, Washington, D.C. Several show popular or amusing subjects (e.g., the regimental dog).

5. The exercise is described precisely in the *Journal*, pp. 81–85, and plates XII and XIII.

Nadar (Gaspard Félix Tournachon)
French, 1820–1910

16 *Catacombs, Paris*, 1861
Albumen-silver print from wet-collodion glass negative
9½ × 7¹³⁄₁₆″ (24 × 19.8 cm)
Inscribed in ink on mount: "Epreuve obtenue aux catacombes/de Paris à l'aide du Régulateur/Serrin. Avril 1862./Nadar"

The catacombs of Paris were originally underground quarries, dating from Roman times. Although the soft limestone hard-ened on exposure to the air, in 1774 portions of the Left Bank nevertheless showed signs of sinking, and the huge cave was shored and buttressed. A little later part of the area was converted to an ossuary, when the Cemetery of the Innocents and other graveyards were reclaimed for other uses. Many of those executed during the Revolution were also interred there, and it is estimated that the catacombs hold the bones of six million Frenchmen.

Nadar made approximately one hundred plates in the catacombs and in the sewers of Paris during a three-month period in 1861. He had first developed the technique of photographing with artificial light by doing portraits of his staff, finally solving the problem of extreme contrast by using white reflective screens to add light to the shadow area. After two years of experiment, he decided that the catacombs were the perfect subject for the new technique, and he took his lights and fifty-cell Bunsen battery underground.[1] His exposures there ran eighteen minutes. The "Régulateur Serrin" in the inscription refers to Victor Serrin's invention, a device for controlling the intensity of the arc lamp. The year 1862 probably refers to the date of the inscription itself. JS

1. Nadar, "Quand j'étais photographe" (1899), in *Le Paris Souterrain de Félix Nadar 1861: Des os et des eaux* (Paris: Caisse Nationale des Monuments Historiques et des Sites, 1982), pp. 30–33.

Guillaume-Benjamin-Amand Duchenne de Boulogne
French, 1806–1875

17 *Fright (Effroi)*, from *Mécanisme de la physionomie humaine*, 1862
Albumen-silver print from wet-collodion glass negative
4¾ × 3¹¹⁄₁₆″ (12.2 × 9.4 cm)
Printed on mount: "MÉCANISME DE LA PHYSIONOMIE HUMAINE/FIG. 61/DUCHENNE (de Boulogne), phot./PUBLIÉ PAR J.-B. BALLIÈRE ET FILS"

Duchenne, a physician, was the first to analyze the specific functions of individual muscles of the human body by precisely located electrical stimulation. The fruit of his research, published in 1855, contributed substantially to the study of muscular physiology and pathology.[1] This work made no use of photography. In 1862 Duchenne published a second book, *Mécanisme de la physionomie humaine*, illustrated with seventy-one photographs made with the assistance of Adrien Tournachon, Nadar's brother.[2] Here Duchenne extended his investigation from physiology to physiognomy —the study of facial features and expressions as a universal language of character and emotion. Throughout its long history, physiognomy had been as much an art as a science; Duchenne sought to place it on a firm empirical and systematic footing. He aimed to prove that each expression, the unique sign of a given emotion, is effected by the action of a single muscle, or at the most two or three. To demonstrate this thesis, Duchenne photographed the muscular con-

tractions caused by specially designed electrodes placed in a series of chosen locations on the faces of his models. In his description of the picture here, Duchenne wrote: "...this man is frozen by fright, struck with stupor; his face expresses fear mixed with horror...."

As a visual dictionary intended for both artists and scientists, the *Mécanisme* may be compared to Eadweard Muybridge's *Animal Locomotion* (1887). Unlike Muybridge's work, however, Duchenne's book never achieved widespread influence and except for its photographs would long have been forgotten. Among the few to respond sympathetically at the time was Charles Darwin, who used a number of Duchenne's photographs to illustrate *On the Expression of the Emotions in Man and Animals* (1872).[3] Darwin also commissioned illustrations from O. G. Rejlander (see pl. 13), whose intuitive and theatrical approach to the problem contrasts sharply with Duchenne's clinical work. Darwin and Duchenne viewed their work as the basis of a new scientific classification of expression. In fact their studies mark the end of physiognomy as an active field of scientific study, perhaps even hastening its demise by unintentionally suggesting that facial expression is too complex and fluid to be reduced to a system. Nevertheless, although a failure on their own terms, Duchenne's photographs are curiously affecting. PG

1. The standard professional biography is Paul Guilly, *Duchenne de Boulogne* (Paris: J. B. Ballière et Fils, 1939).

2. See André Jammes, "Duchenne de Boulogne, la Grimace provoquée et Nadar," *Gazette des Beaux-Arts*, ser. 6, vol. 92 (December 1978), pp. 214–20, and Nancy Ann Roth, "Electrical Expressions: The Photographs of Duchenne de Boulogne," an excellent new study, which in 1984 won a Reva and David Logan Grant in support of New Writing on Photography, and which I have read before publication by kind permission of the author.

3. An engraving after this picture appears on p. 299 of Darwin's book.

Edouard-Denis Baldus
French, born Prussia. 1813–c. 1890

18 *La Ciotat,* before 1859
Albumen-silver print from paper(?) negative
11⅞ × 16⅛" (30.2 × 41 cm)
Printed on mount: "LA CIOTAT"

Among French photographers of the 1850s, Edouard-Denis Baldus was one of the most successful in obtaining commissions from the government and private enterprises. His graphically monumental style was well suited to exalting the products of Second Empire expansionism, perhaps most of all those of the civil engineer. On commission Baldus produced two albums on railway lines: *Chemin de fer du Nord: Ligne de Paris à Boulogne* (1855), on the occasion of Queen Victoria's trip by that line to Paris for the Exposition Universelle, and *L'Album des Chemins de fer de Paris à Lyon et à la Méditer-*

ranée (1859), to celebrate the extension of the southern line from Marseilles to Toulon.[1] In some seventy plates, the latter album represents not only bridges, tunnels, and viaducts of the railway itself, but also monuments and landscapes along the route. Baldus had worked in this area of Southern France previously, and in the album he included earlier pictures with ones made in 1859. The precise date of this picture is not known.

La Ciotat, on the Mediterranean coast between Marseilles and Toulon, had been a center of shipbuilding since the 1840s. The coastline at La Ciotat is marked by a rock formation which, when seen from a certain angle, reveals an eagle in profile and is known as the Eagle's Beak. There are two views of La Ciotat in the album.[2] This one shows a pebbly beach, the water of the cove, and the irregular silhouette of the Eagle's Beak against the sky. The second view is closer to the Eagle's Beak; while it offers a fuller description of the craggy slopes, it lacks the sweeping elegance of this view.

In a watercolor of 1880 the Dutch artist Johan Barthold Jongkind painted the same subject but from a closer viewpoint, leaving out the grand curve of the beach. In a painting of 1907 by Georges Braque (private collection, France), the rock formation and nearby buildings and trees are compressed in a proto-Cubist composition. JP

1. See Philippe Néagu and Françoise Heilbrun, "Baldus: Paysages, Architectures," *Photographies*, no. 1 (Spring 1983), pp. 56–77; and André Jammes and Eugenia Parry Janis, *The Art of French Calotype* (Princeton, N.J.: Princeton University Press, 1983), pp. 139–41.

2. I have consulted the copy in the collection of the Canadian Centre for Architecture, Montreal.

Louis-Auguste Bisson
French, 1814–1876

Auguste-Rosalie Bisson
French, 1826–1900

19 *Ice Pinnacles of the Giant, Mont Blanc,* 1860
Albumen-silver print from wet-collodion glass negative
9½ × 15⅞" (24.1 × 40.3 cm)
Stamped on mount: "Bisson frères"; photographers' blindstamp on print; inscribed in pencil in unidentified hand on mount: "Savoie 8—Séracs du Géant"

After a successful venture as daguerreotype portraitists in Paris, the Bisson brothers took up the wet-collodion negative and albumen processes in 1851.[1] They published photographic reproductions of etchings by Rembrandt and Dürer, and made photographs of architectural and scientific subjects to great acclaim. In 1854 they were among the founding members of the Société Française de Photographie. In 1860, the Bissons were appointed official photographers to Napoleon III, and, continuing a series begun in 1855, they photographed the Alps periodically during the next eight years.

This picture is from the body of work made in 1860 by the

Bissons when they accompanied Napoleon III and the Empress Eugenie on an unsuccessful expedition to scale Mont Blanc, the highest point in France, measuring 15,781 feet. The trip was made to celebrate the annexation of Nice and Savoy, and although the attempt to scale the Massif failed owing to bad weather, a celebrated album of twenty-four mammoth-plate albumen prints was published: *Haute-Savoie: Le Mont Blanc et ses glaciers; Souvenirs du voyage de LL. MM. l'Empereur et l'Impératrice.* The epic scale of the Alps, like the grandeur of their architectural subjects, suited the Bissons's preference for printing their plates in large dimensions.

The pictures are impressive for their dazzling revelation of the harsh Alpine landscape and for the physical courage and patience it took to achieve them. An account of the 1860 expedition also underscores the adventurous spirit of the Emperor and Empress:

After a third of the journey they came to a great wall of ice, where all of the retinue grouped to pose, and the photographer, to the cry of 'Vive l'Empereur, vive l'Impératrice' began his work which lasted long enough for the Empress to ask if it would not soon be finished. At last the objective was achieved....Some guides carrying axes to cut the ice into steps at difficult places, were told by the Empress to do no such thing. Her gracious majesty is daring, and set off, each one following her as best he could: one of them fell on his head, the other on his bottom and everyone laughed. The Empress arrived at the summit of one of the highest ridges which was so precipitous that the Emperor could not stand there at the same time.[2]

In the next year, Auguste-Rosalie Bisson made his first successful scaling of Mont Blanc with the aid of twenty-five porters, who carried his equipment for the cumbersome wet-plate process. Despite almost ceaseless storms and the excessive cold, which crystallized the silver on the plates, Bisson returned with the first photographs from the summit. SK

1. This note is based on the following sources: *After Daguerre: Masterworks of French Photography (1848–1900) from the Bibliothèque Nationale* (New York: The Metropolitan Museum of Art, 1980); *The Photograph as Object, 1843–1969* (Ottawa: The Art Gallery of Ontario, 1969); and *Photography: The First Eighty Years* (London: P. and D. Colnaghi, 1976), p. 62.

2. Auguste Marc, *The Journey of Their Imperial Majesties in the South East of France, Corsica, and Algeria (1860)*, quoted in Richard Hough, *Mid-19th Century French Photography* (Edinburgh: The Scottish Photography Group Gallery, 1979), p. 43.

Robert Howlett
British, 1831–1858

20 *Isambard Kingdom Brunel and the Launching Chains of the Great Eastern*, 1857
Albumen-silver print from wet-collodion glass negative
11⁵⁄₁₆ × 9¼" (28.6 × 23.6 cm)
Indecipherable inscription in ink on mount; inscribed in pencil on mount: "Isambard Kingdom Brunel, Civil Engineer. He designed the G[reat] W[estern] R[ailway], Clifton

Suspension Bridge,/The Thames Tunnel &c &c. He was a great friend of N. [?] H. Hyatt and often stayed/in Panis[?]wick House"

Robert Howlett was a successful professional photographer and a partner in the firm of Cundall and Downs in London during the 1850s. Among his commissions, which ranged from Crimean War portraits to interiors at Buckingham Palace, was a series of fifteen stereoscopic views of the launching of the steamship *Great Eastern*.[1] At the same time, Howlett made many photographs of the ship and portraits of its designer, Isambard Kingdom Brunel. Here Brunel poses during one of several launching attempts between November 3, 1857, and January 7, 1858. Engravings after these photographs (the majority by Howlett with some by Cundall), including the portrait (fig. 4), were published in a comprehensive article in *The Illustrated Times*. The report, after a brief mention of Cundall, also noted that the photographs of Howlett were currently for sale in London print shops.[2]

The ship's popular name, *Leviathan*, from the biblical term for aquatic monster, probably alludes to *Great Eastern*'s tremendous size; it was 692 feet long, 83 feet wide, and could accommodate 4,000 passengers. A contemporary writer notes: "Neither Grosvenor nor Belgrave Square could take the 'Great

Fig. 4. *Isambard Kingdom Brunel*. Engraving after photograph by Howlett, from *The Illustrated Times* (London), January 16, 1858

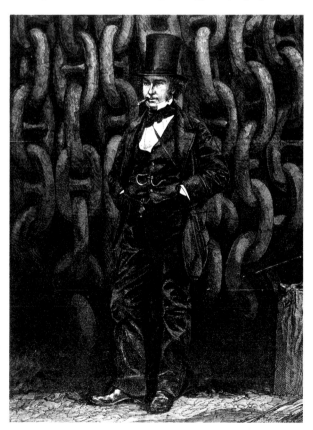

Eastern' in; Berkeley Square would barely admit her in its long dimension."[3] Named for the Eastern Navigation Company, the firm that built it, the ship began construction in 1854 based on Brunel's design; upon completion in 1857, it was considered the crowning achievement of British naval architecture. Brunel was also known for his design in 1837 of the *Great Western*, the first steamship engaged in regular transatlantic travel. Steady improvements had been made in steamship design, but the *Great Eastern* was the first vessel that could carry enough coal to fuel its long passages, thereby eliminating the need for costly fleets of colliers (coal-bearing ships), which preceded earlier boats and deposited fuel at stops along the way. The *Great Eastern* was also distinguished from previous ships by its two sets of engines and propellers. The ship never flourished as a passenger carrier but was used for laying underwater cables; it was scrapped in 1888.[4] CE

1. Jonathan Steel, "Isambard Kingdom Brunel," *The Photographic Collector*, vol. 3, no. 2 (Autumn 1982), pp. 213–16.

2. "The Leviathan," *The Illustrated Times*, vol. 6 (January 16, 1858), p. 67.

3. "The Triton and the Minnows," *Quarterly Review*, vol. 98, no. 196 (December 1855 and March 1856), p. 348.

4. Steel, p. 213.

Clementina, Lady Hawarden
British, 1822–1865

21 *Grace Maude and Clementina Maude*, c. 1863–64
Albumen-silver print from wet-collodion glass negative
9⅛ × 9″ (23.2 × 22.8 cm)
Inscribed in pencil, verso: "Grace Maude/Clementina Maude/No. 8"

The eldest daughter and co-heir of an aristocratic and eminent father, Clementina Elphinstone-Fleming in 1845 married Cornwallis Maude, the fourth viscount Hawarden, who eventually became deputy speaker of the British House of Lords.[1] Her privileged position gave her the time and resources to photograph and, in addition, provided the ambiance in which her photographic style would evolve. This picture of Grace Maude and Clementina Maude, two of her nine children,[2] is exemplary of her mature work.

Lady Hawarden's favorite subjects were her daughters, whom she frequently photographed indoors in natural light, positioning them near a window; this photograph was most probably taken at the family house in South Kensington, London. As here, the carefully costumed women are often seen in pairs, in which they appear as reflections of each other, seemingly bound by a sorrow only they experience. The pictures are rich in a Victorian sensibility of languor. Although obviously theatrical, Lady Hawarden's photographs, through their simplicity, grace of construction, and perfected use of natural light, avoid the heavy symbolism and allegorical content of the work of her pictorialist contemporaries Julia Margaret Cameron (pls. 23–25) and Henry Peach Robinson.

During Lady Hawarden's life, some examples of her work were shown in the 1863 and 1864 exhibitions of the Photographic Society of London (later to become the Royal Photographic Society), where she won medals for the "best amateur contribution" and the "best composition from a single negative." In 1864 Lewis Carroll attended an exhibition for the "benefit of Female Artists at the Kensington Museum" (now the Victoria and Albert Museum). There he purchased five of Lady Hawarden's photographs, placing them in his 1860s album "Professional and Other Photographs," which also contained work by Oscar G. Rejlander and Julia Margaret Cameron. This album was crucial in bringing Lady Hawarden's work to public attention. Helmut Gernsheim acquired it sometime before 1949 and included it in the exhibition *Masterpieces of Victorian Photography, 1840–1900, from the Gernsheim Collection* at the Victoria and Albert Museum in 1951. In addition to the album itself, Gernsheim showed his own reproductions of several of its plates, including a Hawarden that he misattributed to Rejlander. He subsequently learned, possibly from Lady Tottenham, Hawarden's granddaughter, that the picture was, in fact, by Hawarden. The unaltered Carroll album is in the Gernsheim Collection, Humanities Research Center, The University of Texas at Austin. There are 775 photographs by Clementina, Lady Hawarden, in the collection of the Victoria and Albert Museum, to which they were donated by Lady Tottenham in the 1940s. SK

1. Graham Ovenden, ed., *Clementina, Lady Hawarden* (New York: St. Martin's Press, 1974), p. 5.

2. This and subsequent facts about the work of Lady Hawarden were generously provided by Virginia Dodier, a "student attachment" in the Photograph Collection, Victoria and Albert Museum, London. Ms. Dodier recently catalogued the Museum's holdings of photographs by Lady Hawarden and is currently at work on an M.A. report on her life and work.

Nadar (Gaspard Félix Tournachon)

22 *Rossini*, before May 1856
Salt print(?) from wet-collodion glass negative
Inscribed in ink on print: "Nadar/[ru]e St. Lazare"

Nadar was a caricaturist and a journalist, a biographer of his close friend Charles Baudelaire, a famous balloonist who pursued that popular technique in order to support his truer interest in heavier-than-air flight, a friend of the advanced painters of his day, the author of a marvelously lively autobiography, and, chiefly, a photographer—perhaps the greatest portraitist the medium has known. From an age when all those we remember seem remarkable, Nadar was extraordinary. Baudelaire called him "an astonishing expression of vitality," and Théodore de Banville saw him as "a giant drunk with happiness."[1]

Gioacchino Rossini (1792–1868) wrote his last opera, *William Tell*, in 1829, when he was thirty-seven. Nadar photographed him at least twice, in 1851 and five years later, when he

made this portrait and a close variant.[2] Although Rossini had attempted no new major works in a quarter-century, he was secure and lionized, and it has been suggested that he had come to prefer this condition to the hard work of composing. As old age approached he may also have become a little vague, but no one questioned the sweetness or generosity of his character.

In the year he made this portrait, Nadar took his brother to court to prevent him from using his pseudonym. He testified:

The theory of photography can be learned in an hour and the elements of practising it in a day.... What cannot be learned is the sense of light, an artistic feeling for the effects of varying luminosity.... What can be learned even less is the moral grasp of the subject—that instant understanding which puts you in touch with the model, helps you sum him up, guides you to his habits, his ideas and his character and enables you to produce not an indifferent reproduction [but] an intimate portrait.[3] J S

1. Nigel Gosling, *Nadar* (New York: Knopf, 1976), p. 11.

2. Philippe Néagu and J.-J. Poulet-Allamagny, *Nadar,* vol. 1 (Paris: Hubschmid, 1979), p. 513.

3. Gosling, p. 37.

Julia Margaret Cameron
British, 1815–1879

23 *Mrs. Duckworth,* 1867
Albumen-silver print from wet-collodion glass negative
13¾ × 10¾" (35 × 27.1 cm) (oval)

24 *Venus Chiding Cupid and Removing His Wings,* 1872
Albumen-silver print from wet-collodion glass negative
11¾ × 11⅜" (30 × 29 cm)
Inscribed in ink on mount: "From life Registered Photograph Copyright/Julia Margaret Cameron Freshwater Nov. 1872/ Venus chiding Cupid and removing his Wings/A gift to my beloved friend Emma Gilford/from Julia Margaret Cameron. June 1873"; blindstamp of the Messrs. Colnaghi on mount

25 *Pre-Raphaelite Study,* 1870
Albumen-silver print from wet-collodion glass negative
13⅞" × 11" (35.4 × 28 cm)
Blindstamp of the Messrs. Colnaghi on mount

Julia Margaret Cameron, an amateur only in the sense that her social position did not oblige her to live from her work, took up photography in 1863 as a diversion and soon adopted it as a passion. The range and character of her work are well represented by the three pictures here.

Mrs. Herbert Duckworth, born Julia Jackson, was a niece of the photographer. This photograph (pl. 23) was made in 1867, just prior to Jackson's marriage at the age of twenty-one to Duckworth, an English barrister.[1] In 1878, after Duckworth's death, Julia Jackson married Leslie Stephen, critic, writer, and first editor of the *Dictionary of National Biography.* Their children included Virginia Woolf, Vanessa Bell, and Adrian Stephen, all members of the Bloomsbury group. In Virginia Woolf's novel *To the Lighthouse* (1927), the character Mrs. Ramsey, based on Woolf's mother, is described as possessing

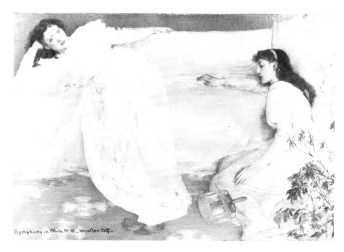

Fig. 5. James McNeill Whistler. *Symphony in White, No. 3,* 1865–67. Oil on canvas. The Barber Institute of Fine Arts, Birmingham, England

great beauty: "The Graces assembling seemed to have joined hands in meadows of Asphodel to compose the face."[2] Roger Fry, another member of the Bloomsbury group, wrote of Cameron's portrait of Mrs. Duckworth that "the transitions of tone in the cheek and the delicate suggestions of reflected light, no less than the beautiful 'drawing' of the profile, are perfectly satisfying."[3] This print of the famous portrait once belonged to Virginia Woolf.

Venus Chiding Cupid and Removing His Wings (pl. 24) suggests three possible readings—pagan, Christian, and secular—which converge within the sensibility of Victorian aestheticism. The first and most obvious is defined by the title: Venus disarms Cupid by removing his wings, illustrating the victory of sacred over profane love, a motif originating in antiquity. At the same time Cameron has provided Venus herself with wings, suggesting that both she and Cupid may be taken as Christian angels. In a letter to a friend whose young son recently had died, Cameron described the deceased child as a "Cherub and Seraph Babe.... We did not see his Angel wings but [they] were there...."[4] The pagan and Christian interpretations merge with a third, secular reading in which Venus, mother of Cupid, repeats a protective, motherly gesture found in other photographs by Cameron. In one series, for example, Cameron presents her grandchild as himself and again as the Christ child under the loving gaze of Mary.[5]

The figure in *Pre-Raphaelite Study* (pl. 25) is May Prinsep, another niece of the photographer and, in her second marriage, wife of Hallam, Lord Tennyson, son of the poet. Cameron often used her as a model in allegorical pictures, and this photograph is one of the most sympathetic treatments. The pose, common in painting of the period, may be derived from Whistler's *Symphony in White, No. 3*[6] (fig. 5). The emotion effecting the pose had been described in 1835 by Charles Hay Cameron, the photographer's future husband: "The effect of sorrow on the human frame is to prevent all muscular exertion, consequently every part which in ordinary circumstances is

sustained by such exertion alone, droops and collapses under the influence of that depressing passion. Every thing, therefore, which droops...has a sorrowful and beautiful expression."[7]
J P

1. See Anita Ventura Mozley, *Mrs. Cameron's Photographs from the Life* (Palo Alto: Stanford University Museum of Art, 1974), cat. no. 23.

2. Quoted in Graham Ovenden, *A Victorian Album: Julia Margaret Cameron and Her Circle* (New York: Da Capo, 1975), pl. 4.

3. Virginia Woolf and Roger Fry, *Victorian Photographs of Famous Men and Fair Women by Julia Margaret Cameron* (1926; reprinted Boston: Godine, 1973), p. 27.

4. Cameron to H. H. Vaughan, April 5, 1859; printed in Mike Weaver, *Julia Margaret Cameron 1815–1879* (Boston: New York Graphic Society, 1984), p. 153.

5. See Weaver, p. 23, and pls. 1.7, 1.8, 1.9.

6. The suggestion is made in Helmut Gernsheim, *Julia Margaret Cameron: Her Life and Photographic Work* (1948; reprinted Millerton, N.Y.: Aperture, 1975), p. 78.

7. Charles Hay Cameron, *Two Essays* (1835), quoted in Weaver, p. 70.

Henry White
British, 1819–1903

26 Untitled, n.d.
Albumen-silver print from glass(?) negative
Stamped on print: "HENRY WHITE"

Henry White joined the Photographic Society of London in 1855 but presumably not as a neophyte, since in the same year he won the highest medal for photography at the Exposition Universelle in Paris.[1] He was the same age as Roger Fenton, effectively the father of the Society, and was like him a solicitor by profession. It seems not unlikely that the two men compared notes. The French reviewer of an 1856 exhibition in Brussels linked the two men for special praise.[2] Unlike Fenton, White never seems to have attempted a subject that might be called heroic, and is remembered for his intimate and lyric landscapes of the country near Bettws-y-Coed, Wales, then a favorite resort of artists, tourists, and fishermen of salmon and trout.

This picture exhibits a very sophisticated grasp of the fact that technical limitations can be turned to expressive advantage. The illusion of deep space is created by the successive spots of hot sunlight that penetrate the dark tunnel of the tree-covered lane. If these areas of brightness were larger, the absence of detail would seem false and unsatisfactory; but in their present scale we read them not as areas of white paper but as patches of light too intense to reveal substance, as our eye would read them if we walked down that lane. J S

1. Mark Haworth-Booth, ed., *The Golden Age of British Photography, 1839–1900* (Millerton, N.Y.: Aperture, 1984), p. 50.

2. Ibid., p. 75.

Louis-Emile Durandelle
French, 1839–1917

27 *Ornamental Sculpture of the New Paris Opera,* 1865–72
Albumen-silver print from wet-collodion glass negative
10 15/16″ × 14 13/16″ (27.9 × 37.6 cm)
Inscribed in negative: "No. 31"; printed on mount: "31/LE NOUVEL OPÉRA DE PARIS/SCULPTURE ORNEMENTALE/ DUCHER et Cie, Editeurs./Durandelle, Photographe."

Durandelle, born in the year L.-J.-M. Daguerre's invention was announced to the public, belonged to photography's second generation, for whom the heady wide-ranging experiments of the generalists—scientists, painters, and historians—began to give way to specialization and the efficiencies of commerce. The firm Delmaet and Durandelle (Delmaet died in 1862; his widow married Durandelle and served as the business partner) specialized in construction photographs, in which role they served the interests of the architect or engineer in charge of construction. In a prospectus of 1868, the firm called attention to the potential legal value of these work-in-progress photographs: in the event, for example, that a party wall in bad condition has delayed construction, how advantageous it is for the judges to have before their eyes a photograph—superior to any other testimony—of the cause of litigation.[1] In keeping with this understanding of their function, Durandelle's pictures are as precise, dry, and narrow as legal briefs; but at their best they are also as beautiful as a good tool—as sharp as a knife and direct as a hammer.

The ornamental cartouche belongs to the Paris Opera, the masterpiece of Jean-Louis-Charles Garnier. Begun in 1861, construction was delayed by the Franco-Prussian War, and the building was not completed until 1875. According to the scale visible immediately below the sculpture, its horizontal dimension was four and one-quarter meters. J S

1. Elvire Perego, "Delmaet & Durandelle," *Photographies,* no. 5 (July 1984), pp. 55–75.

C. Famin
French

28 Untitled, 1860s or 1870s
Albumen-silver print from wet-collodion glass negative
10 3/16 × 7 7/8″ (25.8 × 19.9 cm)
Blindstamp on print: "C. FAMIN/PHOTOGRAPHE/PARIS"; inscribed in negative: "128"

When the invention of photography became public in 1839, one body of opinion concluded that the new medium would replace painting. The prediction proved to be greatly exaggerated except for a few specialties such as the miniature portrait. To some extent, as yet unmeasured, it also was accurate for the market in studies after nature. In academic terminology the phrase "study after nature" originally referred only to sketches a painter made for his own use. By the nineteenth century, it

also applied to commercially produced prints of figures, heads, accessories, elements of landscape, and other motifs, from which young artists learned by copying and seasoned professionals borrowed for their studio compositions.

Little is known about Famin except that in the 1860s and 1870s, he was in the business of producing photographic studies of landscape and rural motifs.[1] In the landscapes, as here, he often included a single figure to indicate scale. Whether the consumers of Famin's product—presumably painters—made extensive use of these photographs is not known. Nevertheless, the demand persisted into the twentieth century; among Eugène Atget's hundreds of *documents pour artistes* were scores of nature studies similar to Famin's.[2]

This picture probably was made in the Forest of Fontainebleau, to the southeast of Paris, originally a hunting preserve of French kings. Beginning in the 1820s landscape painters adopted the forest as a communal open-air studio, flocking there to paint or draw studies after nature. Soon this activity spawned maps and guidebooks to the forest, and collections of prints such as L. A. Castellan's *Fontainebleau: Etudes pittoresques,* a series of eighty-five etchings begun in 1828.[3] Famin's work was an outgrowth of this minor industry, and inherited its quiet, solitary view of nature. PG

1. As a commercial publisher, Famin was obliged by law to deposit examples of his prints at the Bibliothèque Nationale, Paris. See *After Daguerre: Masterworks of French Photography (1848–1900) from the Bibliothèque Nationale* (New York: The Metropolitan Museum of Art, 1980), nos. 61–64.

2. See *The Work of Atget,* vol. 1, *Old France* (New York: The Museum of Modern Art, 1981).

3. See M. Rieu-Edelmann, "La Forêt de Fontainebleau dans l'estampe et la photographie, d'après les collections topographiques du Cabinet des Estampes de la Bibliothèque Nationale, de 1780 à 1890" (typescript thesis, Ecole du Louvre, Paris, 1973; copy in the Bibliothèque Nationale).

Théophile Jaquen
French

29 *Batteries on the Point, Entrance to the Port of Brest,* 1860s
Albumen-silver print from wet-collodion glass negative
4¹⁵⁄₁₆ × 8¾" (12.5 × 22.2 cm)
Inscribed in pencil on mount: "Batteries de la point (entrée du port)"; blindstamp on mount: "THEOPHILE JAQUEN"

Nothing is known about Théophile Jaquen. This photograph was taken at the strategically located naval base of Brest on the west coast of France. The view is from the château on the battery known as Fer-à-Cheval and looks across the Penfield River toward another battery. In the distance is the Crozan Peninsula. The largest ship anchored in the inlet is reputed to have carried between ninety and a hundred cannons.[1] CE

1. Letter from Marjolaine Mourot-Matikhine, Musée de la Marine, Paris, November 15, 1984.

Carleton E. Watkins
American, 1829–1916

30 *Lower Multnomah Falls, Columbia River, Oregon,* 1867
Albumen-silver print from wet-collodion glass negative
20⁹⁄₁₆ × 16" (52.2 × 40.7 cm)
Inscribed in pencil on mount: "Lower Multnomah Falls 424"

By 1867 Carleton E. Watkins had been a photographer for more than a decade and was at the height of his powers as an artist, even if in a somewhat precarious situation financially. During the late summer of that year, he made a photographic trip from Portland, Oregon, some one hundred miles up the Columbia River, as far as the town of Celilo. It is possible that the trip was sponsored in part by the Oregon Steam Navigation Company,[1] but it seems clear that the photographer's chief purpose was to make pictures for public sale as part of the series *Watkins' Pacific Coast Views.* This picture is one of three mammoth (22 × 18") plates that he made of Multnomah Falls early in his ascent of the Columbia. During his stay of something over three months in Oregon, he made at least fifty-nine mammoth plates and more than one hundred stereo views.[2] Of the former, fifty-one were assembled in the luxurious leather and redwood album *Photographs of the Columbia River and Oregon* (1872), of which two copies are known to have existed. One remains in the Bender Library of Stanford University; the other, formerly the property of the University Club, New York, was sold at auction in 1979 and subsequently divided. *Lower Multnomah Falls* was the last picture in Watkins's album, but the Walter print is believed to have been purchased by the painter R. Swain Gifford in 1869[3] and thus antedates the production of the albums.

The remarkable beauty of all three Multnomah Falls pictures suggests that Watkins was perhaps making use of solutions that he had mastered earlier in his work at Yosemite. It should be added, however, that the Columbia River series in general represents Watkins at his best, whether or not his problems there were similar to those he had solved before. JS

1. David Featherstone, "Carleton E. Watkins: The Columbia River and Oregon Expedition," in *Carleton E. Watkins: Photographs of the Columbia River and Oregon,* James Alinder, ed. (Carmel, Calif.: The Friends of Photography, 1979), p. 15.

2. Peter E. Palmquist, *Carleton E. Watkins: Photographer of the American West* (Albuquerque: University of New Mexico Press, 1983), p. 34.

3. Sale catalogue, Sotheby Parke Bernet, New York, November 1, 2, 1979, lots 298–304.

Eadweard Muybridge
American, born England. 1830–1904

31 *Valley of the Yosemite from Mosquito Camp,* 1872
Albumen-silver print from wet-collodion glass negative
17 × 21⁹⁄₁₆" (43.1 × 54.8 cm)
Printed on mount: "BRADLEY & RULOFSON, 429

Montgomery St., S.F., Publishers. Valley of the Yosemite. From Mosquito Camp. No. 22. MUYBRIDGE, Photo."

This picture is one of forty-five mammoth-plate views of the Yosemite Valley taken by Muybridge in 1872 and published in 1873.[1] The prospectus for the series and the reviews it received leave no doubt that it had been conceived as a work of art.[2] In 1873 the pictures won a medal at the Vienna Photographic Exhibition, where Dr. Hermann Vogel praised them as "glorious specimens of landscape."[3]

Charles L. Weed was the first to photograph Yosemite, in 1859.[4] Two years later Carleton E. Watkins made the first of several campaigns in the valley, engaging in active competition with Weed.[5] Muybridge first photographed the valley in 1867 and with his series of 1872 captured a dominant share of the lively market for Yosemite views.

The topographical clarity of Watkins's view down the valley (fig. 6) is typical of Yosemite photographs of the 1860s. In a symmetrical image, aligned with the axis of the valley, Watkins presents the characteristic profiles of El Capitan (on the right) and Cathedral Rock (on the left). Muybridge's picture of 1872 is a variant of the same view, but El Capitan has disappeared behind the trees on the right and Cathedral Rock has retreated into the hazy distance.

To the extent that one can separate topography and art in nineteenth-century landscape photography, Muybridge has opted for art, replacing Watkins's clearsighted approach with an elaborate pictorial game. The eagerness with which every space is filled, the exciting reversals of light and dark, the rich unfolding of space from near to far, the complex unity of the whole: these are the signs of a sophisticated impatience with earlier, simpler pictures. Even the axe in the foreground strikes a note of deliberate artifice; one reviewer reported that Muybridge "cut down trees by the score that interfered with the camera from the best point of sight."[6]

Replacing the simple with the complex, the Yosemite photographers repeated a familiar pattern of pictorial development. What is remarkable is the speed with which they did so. The baroque exuberance of Muybridge is separated by little more than a decade from the classical restraint of Watkins.

The pictorial development is paralleled and perhaps partly explained by the early history of the white man's presence in Yosemite. White settlers first entered the valley in 1850. By 1852 most of the native population had been killed or driven out. By 1868 the valley had been surveyed and photographed; white man's place names had replaced the native terminology; trails and a hotel had been built.[7] The speed with which this appropriation was accomplished is astonishing. Less than twenty years after the white man first saw Yosemite, he had sealed it off from commerce and settlement, domesticating it to his civilized plan. By 1872, when Muybridge made his second campaign in the valley, it was no longer wild nature to be conquered and studied but grand scenery to be enjoyed—and pictured in art. P G

1. Bradley & Rulofson Gallery of Portrait and Landscape Photographic

Fig. 6. Carleton E. Watkins. *El Capitan and Cathedral Rock, View down the Valley,* 1866. Albumen-silver print from J. D. Whitney, *The Yosemite Book* (1868). The Museum of Modern Art, New York

Art, *Catalogue of Photographic Views Illustrating the Yosemite, Mammoth Trees, Geyser Springs, and other Remarkable and Interesting Scenery of the Far West* (San Francisco, 1873).

2. See Mary V. Jessup Hood and Robert Bartlett Haas, "Eadweard Muybridge's Yosemite Valley Photographs, 1867–1872," *California Historical Society Quarterly,* vol. 42, no. 1 (March 1963), pp. 5–26; R. B. Haas, *Muybridge: Man in Motion* (Berkeley: University of California Press, 1976), pp. 41–45; and *Era of Exploration* (New York: The Metropolitan Museum of Art, 1975), pp. 172–76.

3. Quoted in Gordon Hendricks, *Eadweard Muybridge* (New York: Grossman, 1975), p. 49.

4. Bill and Mary Hood, "Yosemite's First Photographers," in *Yosemite: Saga of a Century, 1864–1964* (Oakhurst, Calif.: Sierra Star Press, 1964), pp. 44–52.

5. Peter E. Palmquist, *Carleton E. Watkins* (Albuquerque: University of New Mexico Press, 1983), p. 15.

6. Quoted in Haas, *Muybridge,* p. 44.

7. See J. D. Whitney, *The Yosemite Book: A Description of the Yosemite Valley and the Adjacent Region of the Sierra Nevada, and of the Big Trees of California* (New York: Julius Bien, 1868). The survey had been undertaken in 1866, pursuant to acts of the U.S. Congress and the California State Legislature, setting aside the valley "for public resort and recreation" (p. 9).

Linnaeus Tripe
British, 1822–1902

32 *The Inner Façade of the Gateway of the East Gopuram, Great Pagoda, Madura, India,* 1856–58
Albumen-silver print from paper negative
11 3/8 × 14 7/16" (29 × 36.8 cm)
Plate IV in *Photographic Views in Madura,* by Captain L.

Tripe, Government Photographer. Part III, with descriptive notes by Martin Norman, Esq., MCS (1858)

33 *Aisle on the South Side of the Puthu Mundapum, from the Western Portico, Madura, India,* 1856–58
Albumen-silver print from paper negative
13 5/16 × 11 3/8″ (34 × 29 cm)
Plate II in *Photographic Views in Madura,* by Captain L. Tripe, Government Photographer, Madras Presidency. Part II, with descriptive notes (1858)

The concern of the British for the production of archaeological and ethnological records of Indian culture seems in retrospect remarkable for its depth and tenacity.[1] In the mid-nineteenth century, photography was added to the means by which that concern was expressed, and the achievement of British photographers in India during the medium's first generation constitutes a document of remarkable richness. The Photographic Society of Bombay was formed in 1854 (one year after the Photographic Society of London, which later became the Royal Photographic Society) and began publication of its own journal the next year. In 1856 similar (and fundamentally amateur) societies were formed in Calcutta and Madras.[2] This was five years before Samuel Bourne, the most famous of nineteenth-century photographers of India, left England. In 1855 the Governor of the East India Company's military school in Surrey recommended that officer candidates be given some instruction in photography, and in the same year the government of India assigned Captain Linnaeus Tripe to photograph archaeological sites in Burma. The following year Tripe was appointed official photographer of the Madras Presidency, a post he held for four years. During that time his work included the six volumes of *Photographic Views in Madura,* comprising more than one hundred large photographs and letterpress notes on the subjects by various contemporaries. Tripe apparently worked concurrently with paper negatives and with wet- and dry-collodion on glass, and the Madura albums include prints from both paper and glass negatives.[3]

Plate 32. A Gopuram is a tower, one of which stood at the center of each of the four exterior walls of the Pagoda. These walls formed the outermost of four concentric buildings: the inner one contained the lingam (or stylized penis that symbolized the Hindu god Shiva) and the image of Shiva's consort Minakshi. Non-Hindus were not permitted to enter the inner building.

Plate 33. The Puthu Mundapum was constructed by Tirumala Nayak between 1623 and 1645. The notes (by Martin Norman?) in Part II of *Photographic Views in Madura* say that it is unclear what function the 316-foot-long building was meant to serve, but suggest that it was chiefly to provide architectural balance to the approach to the Great Pagoda. JS

1. See Clements R. Markham, *Memoir on the Indian Surveys,* 2d ed. (London, 1878).
2. G. Thomas, "The First Four Decades of Photography in India," in *History of Photography,* vol. 3, no. 3 (July 1979), p. 219.

3. Janet Dewan, "Linnaeus Tripe: Critical Assessments and Other Notes," *The Photographic Collector,* vol. 5, no. 1 (n.d. [1984]) p. 55.

Felice or Felix Beato
British, born Italy. Before 1830–after 1904

34 *Lucknow, India: View of the Residency in Front, Showing the Room in which Sir H. Lawrence Was Killed,* 1858
Albumen-silver print from glass negative
8 9/16 × 11 13/16″ (21.8 × 29.9 cm)
Inscribed in ink on mount: "View of Residency in front, shewing the room in which Sir H. Lawrence was killed"

Beato was perhaps the most tenacious and resourceful photographer of war in the nineteenth century. Born in Italy, he later became a British citizen and worked assiduously for the British army, documenting the most far-flung victories and trials of the Empire. With James Robertson (c. 1831–after 1881), he photographed the Crimean War (1855–56) and the Indian Mutiny (1857–58), where his partnership with Robertson was dissolved.[1] Apparently on the strength of his work in India, Beato became attached to the Anglo-French expeditionary force in China, where he documented the advance upon and capture of Peking in 1860.[2] In 1884–85 he photographed the rebellion against the British at Khartoum in the Sudan. During the 1850s, '60s, and '70s, Beato also made fine topographical and architectural views throughout the Near and Far East, but the initial motive of his travels always seems to have been war.

The Indian Mutiny, or Sepoy Rebellion, was a bitter, bloody conflict, arising in part from the British annexation of the Kingdom of Oudh, in north-central India, in 1856.[3] The Mutiny and the ensuing repression were marked by extreme atrocities; while the uprising may be regarded as an early stirring of Indian independence, its immediate consequence was to strengthen British rule. In early 1857 the sepoys, or native mercenaries, of the Bengal army of the East Indian Company revolted, taking Delhi and laying siege to the Residency at Lucknow, capital of Oudh, where Sir Henry Montgomery Lawrence, Chief Commissioner of Oudh, had retreated with the British community.[4] Beato's photograph shows the Residency and the remains of the sitting room where Lawrence was mortally wounded by an eight-inch howitzer shell on the morning of July 2, 1857. The picture was made some nine months later, in March 1858, shortly after British forces recaptured Lucknow.[5] A drawing made in the fall of 1857, in the midst of the long siege, shows the Residency from the same viewpoint, battered but still whole.[6]

Beato's work belongs to an early chapter in the history of commercial photography, before the various stages of production and distribution were rationalized and divided. Beato was his own agent, cameraman, technical advisor, publisher, and publicist. Apparently he sold his prints directly to officers of the British army, on the spot. Colonel Francis Cornwallis Maude (incidentally, a cousin of Cornwallis Maude, husband of Clementina, Lady Hawarden; see pl. 21), recalled in 1894:

In the following March [1858], M. Beato, a Corfiote, made an excellent photograph of this spot [the British Mess House at Lucknow], as well as of several other places of interest, in Lucknow, Cawnpore, and elsewhere. …The moment they were taken I sent a set of them to my father, in London, who showed them to Her Majesty the Queen-Empress. That lady was graciously pleased to express her interest in them, they having been the first she had seen.[7] P G

1. See B. A. and H. K. Henisch, "Robertson of Constantinople," *Image*, vol. 17, no. 3 (September 1974), pp. 1–9; John Lowry, "Victorian Burma by Post: Felice Beato's Mail-Order Business," *Country Life*, March 13, 1975, pp. 659–60; and Richard Pare et al., *Photography and Architecture 1839–1939* (Montreal: Canadian Centre for Architecture, 1982), p. 245.

2. An album of ninety-two photographs taken on this campaign is in The Museum of Modern Art, New York. I have consulted Susan Sivard's excellent unpublished paper on the album.

3. The literature on the Mutiny is vast. I have used Christopher Hibbert, *The Great Mutiny: India 1857* (London: Allen Lane, 1978).

4. See Sheo Bahadur Singh, ed., *Letters of Sir Henry Montgomery Lawrence* (New Delhi: Sagar Publications, 1978).

5. For other photographs in the series see Claude Auchinleck, intro., *The Army in India 1850–1914: A Photographic Record* (London: Hutchinson, 1968), pp. 26–42; and Walter Chappell, "Camera Vision at Lucknow," *Image*, vol. 7, no. 2 (February 1958), pp. 36–40.

6. Brij Bhushan Sharma, "A 'Photographic' Book on the Indian Mutiny," *History of Photography*, vol. 6, no. 2 (April 1982), pp. 173–77, fig. 3.

7. Francis Cornwallis Maude, *Memories of the Mutiny*, vol. 2 (London: Remington & Co., 1894), p. 354.

Francis Frith and Company
British

35 *Mangalore(?), India*, 1860s?
Albumen-silver print from glass negative
9¾ × 8″ (25 × 20.3 cm)
Numbered in negative" "15319"; inscribed in pencil, verso: "Manga/Supplied by V&P/Frith"

Commercial photographic enterprises and the British military forces were two significant contributors to early Indian photography.[1] Commercial photographers made portraits, architectural views, and topographical studies for sale in Great Britain to an avid audience whose insatiable curiosity for information and whose passion for collecting were well-served by photography. The military contribution was promoted by the Governor General, Lord Canning, who wanted an extensive record of his experience in India. He encouraged officers and civilians alike to photograph Indian culture and daily life during their travels through the country. So intense was England's desire for a photographic record that as early as 1855, it was recommended that British cadets who were to serve in India be given instruction in photography.

Francis Frith and Company, of Reigate, England, was the largest photographic publishing firm of its time. Using negatives by photographers from around the world, it produced postcards, albums, and individual prints of exotic settings,

diverse ethnic types, and distant cultures to sell to the British who, as armchair travelers, wanted to learn about the places they could not visit. Although documentation of Frith's work on India is scarce, it has been established that one of the earliest Indian items in the collection of The Royal Commonwealth Society is the album *Frith Series: India, Vol. I.* It contains 150 albumen prints by Bombay photographers William Henderson and William Johnson of landscapes and portraits of Indian types, some of which also appeared in the *Indian Amateurs Photographic Album*, a series that ran for twenty-four numbers between December 1856 and October 1858. In addition, the *Album* ran a series of prints, contributed by Henderson and Johnson, called "Characters and Costumes of Western India."

This picture is typical of the genre. The photographer has carefully and simply arranged his subjects to suggest an ethnographical study, positioning them frontally, in profile, and in three-quarter profile. The details of their clothing contribute additional information about their culture. The photograph was probably made by Henderson and Johnson—or by a Lt. Churchill, whose photographs also were published by Frith and Company. The inscription, "Manga," in Victorian handwriting, is perhaps a shortening of "Mangalore," a city in southern India populated by dark-skinned people. S K

1. This note is based on two important articles about early Indian photography: G. Thomas, "The First Four Decades of Photography in India," *History of Photography*, vol. 3, no. 3 (July 1979), pp. 215–23; and John Falconer, "The Photograph Collection of The Royal Commonwealth Society," *The Photographic Collector*, vol. 2, no. 1 (Spring 1981), pp. 34–53.

Samuel Bourne
British, 1834–1912

36 *Poplar Avenue, from the Middle, Kashmir*, 1864
Albumen-silver print from wet-collodion glass negative
9 × 11¹⁄₁₆″ (22.8 × 28.1 cm)
Inscribed in negative: "Bourne"; inscribed in ink, verso: "A Grove of Poplars, Kashmir/801A"

37 *View in Narkunda Forest, Chini Valley, Himalayas*, 1863
Albumen-silver print from wet-collodion glass negative
9⁹⁄₁₆ × 11⁹⁄₁₆″ (24.3 × 29.4 cm)
Inscribed in negative: "250"; inscribed in ink on mount: "View in Narkunda Forest/Himaleh"

From 1863 to 1869, Samuel Bourne produced photographic views of India that were sold to a British market by the firm Bourne and Shepherd.[1] Finding it difficult to adapt the foreign landscape to conventional picturesque principles, he often limited himself to narrow details of the scene. Bourne also sought to take advantage of the brilliant Indian light, which he welcomed after the "dampness and thickness of the atmosphere" of England.[2]

In plate 36 the light animates an enclosed view. Upon his arrival in Srinagar, the principal city of Kashmir, Bourne spent

three days in "wanderings in search of the picturesque," planning the photographs he would make and noting the time when the light would be best.[3] Lines of poplar trees, to judge from Bourne's writing, were common to Kashmir, but it is probably this particular scene that Bourne described in a dispatch to the *British Journal of Photography*: "One of them is known as *the* 'poplar avenue,'...and is almost perfect—hardly a tree is wanting, and the effect on looking down it is very striking. It is carpeted with grassy turf, and a level grassy plain stretches on each side of it...."[4]

Bourne has made a photograph as striking and as perfect as the scene he saw. By placing his camera in one of the grassy strips between pathways, he has balanced the dark "V" of the grass against a wedge of open sky. Bourne has chosen the time of day when the sun is low and trees cast long shadows, perpendicular to the avenue, which just touch the bases of the trees opposite. The delicate light glances over the foliage of the poplars on the right and illuminates more fully the row across the road.

Plate 37 illustrates both aspects of Bourne's photographic strategy. Rather than present a scene of immense and sublime grandeur, Bourne has chosen a modest corner from a larger view, animating it with light. The photograph is probably one of a series he made along the Sutlej River in the high Himalayas, where steep cliffs rise as much as 5,000 feet. Bourne described them as "precipitous walls...so stupendous as to stagger both the sense and the imagination....With scenery like this," he continued, "it is very difficult to deal with the camera; it is altogether too gigantic and stupendous to be brought within the limits imposed on photography....But where the cliffs do not rise more than a few hundred feet, with the river rolling between them, they form admirable subjects for the camera, having a generally fine mountain background."[5] J P

1. See Arthur Ollman, *Samuel Bourne: Images of India* (Carmel, Calif.: Friends of Photography, 1983); and Susan I. Williams, *Samuel Bourne: In Search of the Picturesque* (Williamstown, Mass.: Sterling and Francine Clark Art Institute, 1981).

2. Samuel Bourne, "Photography in the East," May 5, 1863; *British Journal of Photography*, July 1, 1863, p. 268.

3. S[amuel] Bourne, "Narrative of a Photographic Trip to Kashmir (Cashmere) and Adjacent Districts," June 7, 1866; *British Journal of Photography*, January 4, 1867, p. 4.

4. S[amuel] Bourne, "Narrative of a Photographic Trip to Kashmir (Cashmere) and Adjacent Districts," June 7, 1866; *British Journal of Photography*, January 25, 1867, p. 38.

5. S[amuel] Bourne, "Ten Weeks with the Camera in the Himalayas," November 7, 1863; *British Journal of Photography*, February 1, 1864, p. 51.

Photographer unknown
British?

38 Untitled, n.d.
Albumen-silver print from glass negative
11 5/16 × 8 1/4" (28.8 × 20.8 cm)
Inscribed in pencil, verso: "Maharaja of Billiah"

Despite the picture's inscription, its subject's dress seems far too informal to be that of a Maharaja, and it is perhaps more likely that he was a prosperous merchant or minor nobleman. The place name Billiah has not been found on available maps, and neither Bilara (near Jodhpur) nor Bellary (in the state of Mysore) is a proper source for the subject's hat, which is specific to central India (the eleventh edition of the

Fig. 7. *The Rajah of Nagod*. Engraving after Emile Bayard, from Louis Rousselet, *L'Inde des Rajahs* (Paris, 1875)

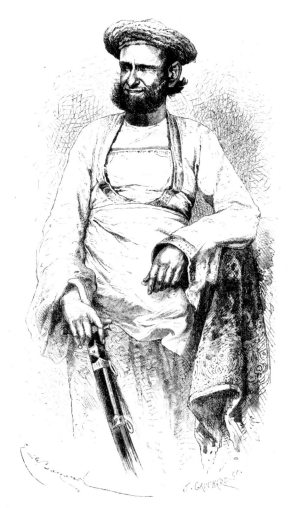

LE RAJAH DE NAGODE.

Encyclopaedia Britannica [1910–11] says that by costume alone one could identify the native region, religion, and social status of an Indian, but notes that the modern facility of communication has caused some homogenization). The studio furnishings, however, appear to be the same as those in a portrait of the real Maharaja Raghuraj Singh of Rewa, also by an unknown photographer.[1] Rewa (north of Jubbulpore and a stone's throw from Nagod) seems the right area for the subject's hat (fig. 7). J S

1. Reproduced in Clark Worswick, ed., *The Last Empire: Photography in British India, 1855–1911* (Millerton, N.Y.: Aperture, 1976), p. 102.

W. L. H. Skeen and Company
British

39 *Kandyan Chief,* c. 1890
Gelatin-silver printing-out-paper print
10¾ × 8⅜″ (27.5 × 21.3 cm)
Printed on mount: "KANDYAN CHIEF"

Between the beginning of the sixteenth and the end of the eighteenth century, Ceylon (since 1972 the Republic of Sri Lanka) was precariously dominated by first the Portuguese and later by the Dutch. The Dutch forces were overcome by the British in 1796, and the Dutch portions of the island were ceded to the British in the small print of the Treaty of Amiens (1802). British domination was restricted to the coastal areas until 1815, when they captured the King of the Kandyan interior, allegedly at the urging of his oppressed subjects. By the agreement of that year between the English and the Kandyan chiefs, control of the entire island passed to Great Britain. The subject of Skeen's portrait would not have been born in time for the serious revolt of 1817, but he might well have seen the minor rebellions of 1843 and 1848, which were easily suppressed.

William Louis Henry Skeen was born in Ceylon, studied at the London School of Photography, and returned to Ceylon in 1862 or 1863 to join the photography business that his father had founded in 1860 in the port city of Colombo. The firm's work concentrated on the commercial life of the island, but also produced pictures that served as souvenirs for the travelers and the bureaucratic class. The Kandyan chief may have been photographed between the late 1880s, when the firm opened a second branch in Kandy, and 1903, when the name of the firm was changed to F. Skeen and Co.[1] J S

1. John Falconer, "19th Century Photography in Ceylon," *The Photographic Collector,* vol. 2, no. 2 (Summer 1981), pp. 39–54.

Colin Murray
British, active 1870s

40 *Jagmandar: Water Palace at Udaipur,* 1872–73
Albumen-silver print from wet-collodion glass negative
7⅜ × 12⅜″ (18.8 × 31.5 cm)

41 *Stone Column at Baroli, Udaipur,* 1872–73
Albumen-silver print from wet-collodion glass negative
8¾ × 11″ (22.2 × 28 cm)
Inscribed in negative: "Bourne + Shepherd/2286"

Colin Murray was hired as chief photographer and printer for the Calcutta photographic firm Bourne and Shepherd after Samuel Bourne (pls. 36, 37) returned to Britain in 1869. In 1874 the firm published *Photographs of Architecture and Scenery in Gujerat and Rajputana,* a volume of thirty photographs taken between December 1872 and March 1873 by "Mr. C. Murray, partner of the firm," and text by archaeologist James Burgess. These pictures are from the album.[1]

Udaipur, known as one of the most romantic cities in all of India, is bounded on the north and east by a moat, on the south by steep hills, and on the west by Pichola Lake, formed by damming a mountain stream when the city was founded in the sixteenth century. Jagmandar is one of two islands on the lake. The Water Palace is a complex of buildings, most dating from the eighteenth century, but includes the Gul Mahal, a domed pavilion built between 1621 and 1628. The site may have had additional significance to Murray's English audience; sixteen years prior to the photograph, during the Mutiny of 1857, the Maharana of Udaipur offered Jagmandar as a refuge for European women and children.

The shimmering reflections in Murray's photograph present the palace as an ethereal phantasm, like the "fairy palaces of one's childhood" to which one guidebook compares it. Burgess's text for the plate quotes from Brooke's *History of Mewar:* "The palace itself is an extensive and imposing pile, but on nearer approach is found to exist of insignificant enclosures joined by narrow, dark passages, and a handsome triple-gated entrance."

The two abandoned temples in the background of *Stone Column at Baroli* are of the Nagara style and date from the early tenth century. For modern archaeologists, the site is of importance primarily as a fusion of two regional styles. The photograph, however, is far from a straightforward record. Rather than document the structure or decorative elements of any of these monuments, Murray presents an ensemble of two temples and two pillars but leaves out two other temples at the site.

Burgess's text for this plate, and the passage he quotes from James Fergusson's *Picturesque Illustrations of Ancient Architecture in Hindostan* (1848), states:

The temples of Baroli [are] one of the most beautiful groups of Hindu fanes of their age in India. The effect of their architecture is, however, as Mr. Fergusson remarks, "a good deal heightened by the beauty of the scene in which they are situated; perhaps also by its solitary loneliness, for there is not a tent or a house on the whole plain in which they are situated...." J P

1. A copy of the volume is in the Gernsheim Collection, Humanities Research Center, The University of Texas at Austin.

Frank Meadow Sutcliffe
British, 1853–1941

42 *The Water Rats*, 1886
Carbon print?
9⅝ × 11¾" (24.5 × 29.9 cm)
Signed in pencil on print: "Frank Sutcliffe"; numbered in
negative and retouched out on print: "115"

Sutcliffe was a provincial photographer who photographed the
fishing village of Whitby, in the north of York. His father Tom
Sutcliffe was a watercolorist, printmaker, and teacher of some
note, as well as an amateur photographer and his son's prin-
cipal teacher.[1] *The Water Rats*, Sutcliffe's most famous picture,
was greatly admired and frequently imitated from the year it
was made, when it was awarded a medal by the Photographic
Society of London.[2] In a broader sense, it exhibits some of the
qualities that would become characteristic of the pictorialist
movement during the next generation. One of the most per-
vasive of these characteristics was a preference, amounting
almost to a prerequisite, for foggy or misty weather for out-
door work. Sutcliffe was one of the first to make explicit his
distaste for working under a clear sky. "The first and best plan,"
he said, "is to keep the camera at home until nature herself has
wrapped the subject in a veil of mist."[3] The chief advantage of
such a procedure was that it enabled the photographer to
achieve almost automatically a clear and simple graphic dis-
tinction between the principal planes of the picture. That
Sutcliffe understood the effect of this device is made clear by his
recollection of a kind of painting he made as a child; the image
would be painted in black ink partly on an opaque ground
sheet and partly on successive sheets of tissue paper, construct-
ing a picture as a series of discrete receding planes.[4] JS

1. Charles Noel Armfield, "Mr. F. M. Sutcliffe," in W. Arthur Boord, ed.,
Sun Artists (London: Kegan Paul, Trench, Trubner and Co., 1891), pp.
55–60.

2. Margaret Harker, *The Linked Ring: The Secession Movement in
Photography in Britain, 1892–1910* (London: Heinemann, 1979), pp. 91,
94.

3. Michael Hiley, *Frank Sutcliffe: Photographer of Whitby* (London:
Gordon Fraser, 1974), p. 76.

4. Ibid., p. 14.

Photographer unknown
French?

43 Untitled, 1890s?
Gelatin-silver print
9¹³⁄₁₆ × 8⅝" (24.9 × 21.9 cm)
Blindstamp on print: "G. CROMER"

The tiny blindstamp on the print is not a signature but the
mark of the great French collector of photographs, Gabriel
Cromer. As John Pultz observes (p. 15), one of Cromer's main
motives for collecting was to recapture the recent past of
French culture. Few pictures could better have satisfied

Cromer's ambition than this one: a vivid document of the
overstuffed, hothouse atmosphere of fin-de-siècle academic
art.

The picture is carefully posed to invite comparison between
the clay portrait bust on the right and the living model, seated
with his back to the camera. The bust, another on the desk,
and the small clay sketches at the lower right and on the
armoire all apparently are the work of the sculptor in whose
studio the picture was made. The rest—reduced plaster copies
of the Parthenon metopes and of other ancient sculptures, casts
of fifteenth-century busts by Francesco Laurana and Mino da
Fiesole, an antique pistol, Oriental fabrics and an incense
burner, the medallion portrait by Jean-Baptiste Carpeaux, a
Japanese print, other prints and photographs, the pipes, open
book, and fan—these are the trappings of a milieu that equated
luxury with surfeit and art with technical skill and encyclo-
pedic knowledge.

At the top of the picture we see part of a large painting signed
"E. Brunet 1885," possibly a work by Eugène-Cyrille Brunet
(1828–1921), who was known primarily as a portrait sculptor.
If this is Brunet's studio, the bearded man must be an assistant,
for he is too young to be the master himself. P G

Hilaire Germain Edgar Degas
French, 1834–1917

44 *Pierre Auguste Renoir and Stéphane Mallarmé*, 1895
Gelatin-silver print
15⅜ × 11³⁄₁₆" (39.1 × 28.4 cm)

45 Untitled, c. 1900?
Gelatin-silver print
11½ × 15⅝" (29.1 × 39.8 cm)

In the mid-1890s Degas, then sixty years old, discovered a brief
but intense passion for photography.[1] Most of his best work as
a painter was behind him, and in this period he devoted a great
deal of energy to other interests, among them collecting art and
making photographs. Since the photographs occur late in
Degas's career, they contribute little to the debate over the
potential influence of photography on his painting.[2] Nev-
ertheless, it is significant that, despite the theoretical polarity of
the two media in the nineteenth century, Degas was readily able
to transpose the established concerns of his art to photography.

With a few exceptions, Degas's surviving photographic
work falls into three categories. First are several *tableaux
vivants*, in which Degas himself appears and which he
arranged but did not actually make.[3] The earliest, made in
1885, marks the beginning of Degas's involvement with pho-
tography. These often humorous scenes, obviously made for
fun, are not directly related to Degas's painting. Second, in the
1890s Degas made at least a few photographs (a nude, a ballet
dancer) as studies for paintings.[4] Third, he made a number of
pictures of himself and his friends, and these constitute the
majority of the surviving photographs. None served as studies

for paintings; rather, they drew upon and extended motifs of portraiture and genre that Degas had pursued in painting since the 1860s. The portrait of Renoir and Mallarmé belongs to this group.

Degas may have begun photographing his friends as early as 1889,[5] but he did most of the work in 1894 and 1895. In this period, especially in the fall of 1895, Degas frequently brought his camera when he visited friends in the evening. After dinner he transformed the salon into a studio and his friends into models, directing poses and ordering the placement of the lamps. Daniel Halévy reported that once Degas had brought out his camera,

...the *pleasure* part of the evening was over. Degas raised his voice, became dictatorial, gave orders that a lamp be brought into the little salon and that anyone who wasn't going to pose should leave. The *duty* part of the evening began. We had to obey Degas's fierce will, his artist's ferocity. At the moment all his friends speak of him with terror. If you invite him for the evening you know what to expect: two hours of military obedience.[6]

Degas worked with a small camera on a tripod; one of his cameras used glass plates of 8 × 10 cm, another 9 × 12. The negatives were enlarged by a Parisian photographic furnisher named Tasset, who made the prints reproduced here.[7] Enlargements only recently had become practical; thus these relatively large prints suggest a taste for the most modern materials. As Theodore Reff has suggested, Degas's interest in photography arose in part from a life-long appetite for technical challenge.[8] This outlook also lay behind his preference for photographing by artificial light. "Daylight is too easy," he told Halévy. "What I want is difficult—the atmosphere of lamps or moonlight."[9]

Degas had extensively explored the problem of artificial light in his theater pictures, in genre and portrait painting, and most recently in the dark-ground monotypes of the 1880s.[10] These explorations were not merely formal exercises; they lent an atmosphere of mystery and intimacy to the events of contemporary life. In the same vein, and as if in anticipation of Degas's later photographs, his friend Edmond Duranty wrote in "The Bourgeois Salon" (1867): "When in the evening the curtains are drawn and the lamp has become the sun of this little world, when it concentrates light and life around the table, while distancing and throwing into shadow all the furniture, this world expands and becomes mysterious, grave, and meditative."[11] By the 1890s the meditative, often melancholy mood of the closed interior had become a central theme of painting. In some Degas photographs, as in many paintings by Edouard Vuillard, the sitters approach the anonymity of figures in a genre scene. In others, as here, they retain a distinct identity, without shedding their generalized roles in the comfortable life of the bourgeois salon.

Degas painted portraits only of close friends and members of his family.[12] The sitters appear, as Degas put it, "in familiar and typical attitudes," often at home.[13] However, the effect is not, as in many Impressionist portraits, casual and spontaneous. Despite the informality of their poses, Degas's sitters possess a solemn grace, an air of gravity and psychological intensity. This, even more than astonishing formal inventiveness, is the

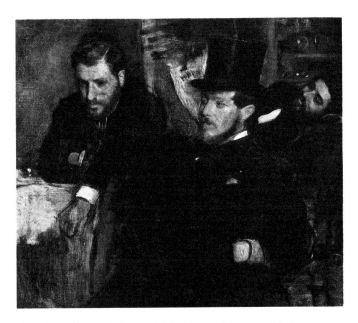

Fig. 8. Degas. *Jeantaud, Linet, and Lainé,* 1871. Oil on canvas. Musée d'Orsay, Paris

special mark of Degas's portraits. It persists in the photographic portraits, also exclusively of family and friends. The photograph of Renoir and Mallarmé, for example, may be compared to a portrait of three friends painted more than twenty years earlier (fig. 8).

Degas made the photograph in December 1895 at 40, rue Villejust, Paris, where Berthe Morisot had lived with her daughter Julie and her husband Eugène Manet, brother of the painter. Throughout the 1880s and early 1890s, Morisot had held her intimate salon there, often entertaining Claude Monet, Renoir, Degas, and Mallarmé and his family. When her husband died in 1892, Morisot and Julie moved elsewhere in Paris. After Morisot's death in March 1895, Julie Manet returned to the rue Villejust, where she lived with her cousins Paule and Jeannie Gobillard, also orphans. Together the three revived Morisot's salon. The intimacy of the circle, composed of great artists and young women, is reflected in the letters and journals of its members.[14] The salon continued until 1900, when in a joint ceremony Julie Manet married Ernest Rouart, son of Degas's good friend Henri Rouart, and Jeannie Gobillard married Paul Valéry.

In the picture Renoir is seated on a couch beneath the mirror.[15] Mallarmé stands beside him, hand in pocket in a familiar gesture recorded earlier in a portrait by Manet (Musée d'Orsay, Paris). Mallarmé looks at Renoir, Renoir at the camera. In the mirror we see Mallarmé's wife and daughter seated across the room, the camera, and the photographer himself, his head obliterated by the light of one of nine lamps used to illuminate the scene.[16] The image in the mirror (especially the disappearance of Degas's head) has been the subject of considerable speculation.[17] However, it would seem that Degas simply was experimenting further with complex effects of reflec-

tion and artificial light, which had fascinated him for decades. Certainly he anticipated his image in the mirror and must have enjoyed including himself in the group, but there is no reason to attach a special meaning to the glow that subsumes his head.

The picture as a whole has been interpreted as a self-conscious meditation on the relationship between Impressionism (represented by Renoir) and Symbolism (represented by Mallarmé).[18] To Degas, however, these men were not symbols of abstract ideas. They were old dear friends whose companionship had long been part of the fabric of his life. The portrait expresses the warmth of this bond and, through the image in the mirror, the intimacy and conviviality of the salon where the three so often met.

The other photograph (pl. 45) is a mystery. Along with a similar picture (fig. 9), it was handed down through the Rouart family. No other prints of the two pictures are known. The provenance of the pictures and the prints and mounts (exactly like others made by Tasset) support a confident attribution to Degas. According to a Rouart family legend, the pictures represent a gathering at the double wedding of Julie Manet and Jeannie Gobillard in 1900.

If this is true, then the young women in white in figure 9 must be the two brides. However, the building in the background is not Saint Honoré d'Eylau in Paris, where the wedding took place. Nor does the group appear to be dressed for a wedding. Perhaps it is a Sunday outing at Juziers, where Julie Manet had property. In any case the pictures parallel the portrait of Renoir and Mallarmé, for they extend to photography a familiar motif of painting. Degas had not treated the life of the boulevard as often as his Impressionist colleagues, but in the portrait of Lepic and his daughters (c. 1875; destroyed), for example, he had shown a taste for the informal pattern of figures against the blank ground of the street.

Because Degas was a great painter and especially because his work so often has been called "photographic," the first issue

Fig. 9. Degas. Untitled, c. 1900? Gelatin-silver print. Paul F. Walter Collection

raised by his photography is its relationship to his painting. Beyond this, Degas's photographs belong to an important but poorly understood episode in photography. Toward the turn of the century, smaller cameras, faster emulsions, and the services of furnishers such as Tasset made photography increasingly available to the amateur. This development opened visual culture to personal participation on a vast scale and led to a flood of imagery of casual and intimate life. Earlier, in Impressionist painting, and later, in advanced photography of the 1920s and 1930s, this vein of imagery was a central concern of a sophisticated artistic elite. The interim role of countless amateurs awaits systematic study; and despite his accomplishment as a painter, Degas as a photographer was an amateur, if indeed a very talented one. P G

1. Useful studies include Luce Hoctin, "Degas photographe," *L'Oeil*, no. 65 (May 1960), pp. 36–43; Ronald Pickvance, "Degas as a Photographer," *Lithopinion*, vol. 5, no. 1 (Spring 1970), pp. 73–79; Eugenia Parry Janis, "Edgar Degas's Photographic Theater," in *Degas: Form and Space*, Maurice Guillaud, ed. (Paris: Centre Culturel du Marais, 1984), pp. 451–86; and for its wealth of reproductions, Antoine Terrasse, *Degas et la photographie* (Paris: Denoël, 1983).

2. See Kirk Varnedoe, "The Artifice of Candor: Impressionism and Photography Reconsidered," *Art in America*, vol. 68, no. 1 (January 1980), pp. 66–78; and idem., "The Ideology of Time: Degas and Photography," *Art in America*, vol. 68, no. 6 (June 1980), pp. 96–110.

3. Terrasse, nos. 2, 40–45.

4. Terrasse, nos. 25, 26–33. See also Janet F. Buerger, "Degas' Solarized and Negative Photographs: A Look at Unorthodox Classicism," *Image*, vol. 21, no. 2 (June 1978), pp. 17–23.

5. See Janis, "Degas's Photographic Theater," p. 465, and figs. 316–18.

6. Daniel Halévy, *My Friend Degas*, Mina Curtiss, trans. and ed. (Middletown, Conn.: Wesleyan University Press, 1964), p. 82. This book contains a wealth of anecdote about Degas's photography, as does Jeanne Fèvre, *Mon oncle Degas* (Geneva: Cailler, 1949).

7. Much of our technical knowledge of Degas's photography is derived from his letters to Tasset from the Auvergne in August 1895. See Beaumont Newhall, "Degas, photographe amateur: Huit lettres inédites," *Gazette des Beaux-Arts*, 6th ser., vol. 61 (January 1963), pp. 61–64. Degas himself may have developed some of the negatives, as did his friend Louise Halévy, whom he called *la réveleuse* ("the developer"). However it appears that Tasset made all the enlargements.

8. Theodore Reff, *Degas: The Artist's Mind* (New York: The Metropolitan Museum of Art, and Harper & Row, 1976), p. 292. I am grateful to Professor Reff for reading an early draft of this note and for making several useful suggestions.

9. Halévy, p. 69.

10. On the monotypes, see Eugenia Parry Janis, *Degas Monotypes* (Cambridge, Mass.: Fogg Art Museum, 1968).

11. Quoted in Reff, *Degas*, p. 222.

12. See Jean Sutherland Boggs, *Portraits by Degas* (Berkeley and Los Angeles: University of California Press, 1962). For its treatment of artificial light, one portrait is particularly relevant to the photographs: *Mme Camus with a Fan*, c. 1870 (National Gallery of Art, Washington, D.C.); Boggs, pl. 66.

13. Theodore Reff, *The Notebooks of Edgar Degas* (Oxford: Clarendon Press, 1976), vol. 1, p. 118 (notebook 23, p. 46).

14. Especially Stéphane Mallarmé, *Correspondance,* Henri Mondor and L. J. Austin, eds., vols. 6 and 7 (Paris: Gallimard, 1981 and 1982); and Julie Manet, *Journal (1893–1899)* (Paris: Klincksieck, 1979).

15. Degas probably made the portrait on December 16, 1895; surely before December 22, when he showed it along with other "latest proofs" to Daniel Halévy, on a visit to Tasset (Halévy, p. 73). On December 3, Julie Manet had contracted a case of chicken pox and kept herself in quarantine. On December 8 she wrote to Mallarmé, inviting him to dinner on December 16 (Mallarmé, *Correspondance,* vol. 7, p. 312). If the portrait had been taken that evening after dinner, it would indeed have been a latest proof on December 22. Julie Manet doubtless referred to the picture when she wrote to Mallarmé on January 1, 1896: "We have been informed by M. Renoir that Degas's photographs came out and have been printed at Tasset's" (*Journal,* p. 76).

16. The identification of Mme and Mlle Mallarmé and the number of lamps derive from the account of Paul Valéry in *Degas Manet Morisot,* David Paul, trans. (New York: Pantheon, 1960), p. 40. However, Valéry could not have been present since he did not meet Mallarmé until 1898. Thus there is no reason to accept his claim that the exposure took fifteen minutes; the two minutes recorded by Halévy for another lamplit exposure is more likely (Halévy, p. 83).

17. Wayne L. Roosa, "Degas' Photographic Portrait of Renoir and Mallarmé: An Interpretation," *Rutgers Art Review,* vol. 3 (January 1982), pp. 81–96; and Douglas Crimp, "Positive/Negative: A Note on Degas's Photographs," *October,* no. 5 (Summer 1978), pp. 89–100.

18. In the articles cited in note 17.

Etienne-Jules Marey
French, 1830–1904

or

Georges Demenÿ
French, 1850–1917

46 Untitled, c. 1890–1900
Gelatin-silver print
6¹⁄₁₆ × 14⅝″ (15.4 × 37.2 cm)

Etienne-Jules Marey's medical training and interest in engineering led him to the study of human physiology predicated on a notion of man as a machine.[1] Marey was especially interested in the scientific analysis of movement (which he described as the product of time and space). He sought to improve the study of the human body by the invention of various graphic recording devices. These would compensate for what he saw as the inability of the senses to uncover scientific truths and the insufficiency of language to express and transmit them.

Georges Demenÿ, founder of the Cercle de Gymnastique Rationnelle (Club for Rational Gymnastics), worked with Marey from 1881 to 1894. Demenÿ saw in Marey's work the opportunity to "study the most effective means for the harmonious development of the human body by movement."[2] The perfecting of gymnastic practice had taken on political overtones in France at the time; the Prussian victory of 1870–71 was attributed in part to the physical strength Prussian soldiers had developed through exercise.

Although Marey and Eadweard Muybridge worked with a common problem, they approached the study of motion differently. Muybridge used a series of cameras to record the successive moments within a movement. Marey recorded motion with multiple exposures on a stationary plate in a single camera. Muybridge's technique produced a sequence of pictures that described precisely the posture of a body at successive points within a movement. Marey's chronophotography, while less clearly describing the exact form of the figure at each moment, makes graphic the flow of movement in time and space.

After Marey broke with Demenÿ in 1894, the latter continued his work at the school of military gymnastics at Joinville.[3] Michel Frizot has suggested that Demenÿ may have made this photograph at Joinville—using Marey's method—to analyze the sprinter's start.[4] As the sprinter gains speed, he covers progressively more ground between the regular exposures; his acceleration appears in the picture as increased distance between successive images from right to left. J P

1. See Michel Frizot, *E. J. Marey, 1830/1904: La Photographie du mouvement* (Paris: Centre Pompidou, 1977); and idem., *La Chronophotographie: Temps, photographie et mouvement autour de E.-J. Marey* (Beaune: Association des Amis de Marey, 1984).

2. Frizot, *La Chronophotographie,* p. 156, note 2.

3. Ibid., p. 156, note 19.

4. In conversation with Peter Galassi, November 1984.

Photographer unknown

47 *X ray,* 1917
Gelatin-silver print
15¹¹⁄₁₆ × 11¾″ (40 × 29.8 cm)
Paper label affixed to print, inscribed: "Pierre/A. Paré/ 9 janv 17"

X rays belong to a special class of photographic imagery in which otherwise hidden subjects are rendered visible in a picture. Discovered in 1895, they rapidly became an indispensable tool in medicine and other sciences. This X ray presumably records a bullet wound suffered by a French soldier (Pierre A. Paré) in January 1917. The print is unusual technically because it is a direct negative image on paper, in which the bones and flesh emerge as a ghostly presence from the dark void. In this respect the print is similar to photograms that artist-photographers such as László Moholy-Nagy and Man Ray began making a few years later.

Moholy in particular was interested in X rays; he published them in his didactic treatise *Malerei, Fotografie, Film* (1925) and exhibited them in *Film und Foto* (1929) at Stuttgart. Moholy's interest cannot be described as scientific, but neither was it merely pictorial. Indeed he praised X rays as purely objective pictures, admirable because aesthetic decisions had played no role in their making.[1] In a similar vein, Man Ray reproduced an X ray in *La Photographie n'est pas l'art* (1937),

with the caption, "Complete photograph, one hundred percent automatic." P G

1. See Joseph Harris Caton, *The Utopian Vision of Moholy-Nagy* (Ann Arbor: University of Michigan Research Press, 1984), pp. 72 ff.

Photographer unknown
French?

48 *Flood of the Seine, Avenue Ledru-Rollin, Paris, January 27, 1910*
Gelatin-silver print
8¾ × 11¼″ (22.3 × 28.6 cm)
Printed on mount: "PREFECTURE DE POLICE/DIRECTION GLE DES RECHERCHES/SERVICE DE L'IDENTITE JUDICIAIRE/ PARIS, le…, 19…" and "AFFAIRE"; inscribed in ink on mount: "Crue de la Seine—27. janvier 1910—/Avenue Ledru-Rollin" and "16"

This picture belongs to an album of photographs the Paris police department made to record a flood of the Seine River in 1910. It was taken on the Right Bank of the Seine near the intersection of avenue Ledru-Rollin and the rue de Lyon. The photograph is part of a systematic report of the disaster; the man on the left measuring the water level performs the same function in at least one other picture of the series. The mount contains a precise description of the incident following a practice that came into use in 1880, when Alphonse Bertillon, a Paris police chief, introduced the use of photographs in the identification of criminals.[1]

The flood began on January 20, when heavy rains caused the Seine to overflow. It continued to ravage the city and one-quarter of the country through February. At the time of this picture, the flood was at its peak and the Seine was three times its usual height. *The New York Times* covered the catastrophe at length and reported not only the facts (depth of water, damages estimated at $200 million, numbers of people rendered homeless) but also human interest stories, including accounts of the fear of typhoid, of death by suicide, shock, and starvation, and of looting by the Apaches, the loosely organized gang known for its savage behavior.[2] C E

1. Gail Buckland, *First Photographs* (New York: Macmillan, 1980).

2. *The New York Times,* January 20–31, February 1–6, 13, 20, April 10, November 4, 11, 1910.

Photographer unknown
British?

49 *London Terminal Aerodrome (Croydon),* 1921–22
Gelatin-silver print
14¹¹⁄₁₆ × 18¹⁵⁄₁₆″ (37.4 × 48.1 cm)
Printed in margin: "LONDON TERMINAL AERODROME (CROYDON)"; stamped, verso: "GEORGE GILL & SONS, LTD./

Sole Educational Agents to the/ The CENTRAL AEROPHOTO CO., Ltd./KILBURN./133 WARWICK LANE, LONDON E.C. 4"

In the early 1920s, aviation—and thus also aerial photography—was still very young. Nevertheless, by 1922 the managers of the Croydon Aerodrome had devised a huge sign that could be read—and photographed—only from the air. The airport, south of London, had been built in 1915 for the Royal Air Force and began to serve civil flights in 1920. It was London's principal airport until 1939. On the basis of certificates of airworthiness of the aircraft in the photograph, it may be dated no earlier than April 1921 and no later than September 8, 1922.[1] The aircraft, all but one under civil registration, are arranged for inspection. The many figures on the ground may be some of the 300 delegates to the Air Ministry's second Air Conference at Croydon on February 6, 1922.[2] In any case the photograph is not a casual snapshot but a professional document, made to record and advertise Britain's young but rapidly growing aviation industry. The relatively large size of the print implies that it was intended not for reproduction but for display, perhaps (as the distributor's stamp suggests) in schools and libraries as well as the Air Ministry.

Avant-garde photographers of the 1920s admired and learned from common photographs like this one, with its unusual vantage point and striking design.[3] The liberating influence of such pictures often is described in formal terms, and with good reason. Nevertheless, it is unlikely that the avant-garde artists were wholly indifferent to the worldly meanings of the common photograph; certainly the Croydon picture arose from the same enthusiasm for modern technology that inspired avant-garde photography. Nor is the formal inventiveness of vernacular pictures invariably a product of amateurish miscalculation. Here, for example, the intruding wings of the biplane place the viewer in flight, illustrating and celebrating the function of the aircraft displayed on the ground. P G

1. This and other facts about the picture were kindly provided by Mr. Douglas Cluett, Chairman of the Croydon Airport Society.

2. The event was reported in the Croydon *Times,* February 8, 1922.

3. For example, aerial views similar to this one were reproduced in László Moholy-Nagy, *Malerei, Fotografie, Film* (1925), p. 56; and Werner Gräff, *Es Kommt der neue Fotograf* (1929), p. 17.

Eugène Druet
French, active 1900

50 *Rodin's Age of Bronze,* c. 1898–1900
Gelatin-silver print
15⅝ × 11⅞″ (39.8 × 30.1 cm)
Printed with transparent overlay: "Aug. Rodin"

Beginning in the 1880s, photography became important to the sculptor Auguste Rodin (1840–1917) in the creation and dissemination of his work.[1] Rodin used photographs to distance himself from work in progress, to sketch alterations, and to

record transitional stages. He also met the demands of his worldwide popularity through the reproduction and sale of photographs. Although he made none himself, those taken by others show his works as he wished them to be seen. Rodin worked closely with the photographers of his sculpture, specifying the angles and lighting they should use and retaining final approval of proofs.

While Rodin used the services of many photographers, he seems to have worked especially closely with Eugène Druet, particularly between 1896 and 1900. The collaboration between the sculptor and photographer is suggested by the many Druet photographs in which the signatures of both appear. Plate 50, however, contains only Rodin's signature, printed into the photograph by means of a transparent overlay sandwiched with the negative.

Originally the proprietor of a café, Druet made, exhibited, and sold under contract with Rodin photographic views of his sculpture in conjunction with the retrospective exhibition Rodin staged in 1900. Later that year Rodin and Druet had a falling out. Although relations were reestablished the following year, Druet was never again as creatively involved with Rodin and his sculpture.

The Age of Bronze (1876) is the work with which Rodin made his debut in the Paris spring Salon of 1877. The photograph of the plaster cast was very likely made between 1898 and 1900 in the sculptor's house at Meudon. Unlike Druet's more radical photographs of Rodin's sculpture, taken from unusual and closer vantage points, the composition of this work is conventional.[2] Rather Druet (and Rodin) would seem more concerned with the work's relation to space and light. As in many of Druet's photographs, expectations of descriptive competency are ignored in favor of greater expressiveness. A shorter exposure of the negative would have rendered the plaster surface with specific texture and greater tonal subtlety. Instead Druet has dematerialized the substance: it no longer has the weight of plaster but the incorporeality of light. The surface is translated into white and gray tones, and halation gives the contour of the figure's left side the imprecise presence of a living power. J P

1. See Albert E. Elsen, *In Rodin's Studio: A Photographic Record of Sculpture in the Making* (Ithaca, N.Y.: Cornell University Press, 1980); Kirk Varnedoe, "Rodin and Photography," in Albert E. Elsen, ed., *Rodin Rediscovered* (Washington, D.C.: National Gallery of Art, and Boston: New York Graphic Society, 1981); and Hélène Pinet, "Les Photographies de Rodin," *Photographies,* no. 2 (September 1983), pp. 39–59.

2. Elsen, *In Rodin's Studio,* pls. 49, 65–70, 93–94.

Frederick H. Evans
British, 1853–1943

51 *Château d'Amboise, Chapel,* 1907
Platinum print
9⁹⁄₁₆ × 7⅛″ (24.3 × 18.1 cm)

Inscribed in pencil on mount: "Chateau Amboise, Chapel Frederick H. Evans"

By 1905 Frederick H. Evans had established a reputation in England and abroad as a photographer of architectural subjects, and was particularly known for his platinum prints of English cathedrals, which had been his obsession in the 1890s. In 1905 *Country Life* commissioned Evans to photograph the châteaux of the Loire Valley,[1] and the pictures appeared regularly in the magazine between 1908 and 1913.

The Château d'Amboise was built in the late fifteenth century for Charles VIII, and its chapel gained fame as the supposed site of Leonardo da Vinci's burial. Evans photographed the palace from the opposite bank of the Loire and from closer prospects, and he took side views of the chapel and details of the frieze over the door. This picture did not appear in the magazine; instead there was a closer detail of the chapel's principal façade (fig. 10). Evans worked on the assignment for *Country Life* from July to September 1906 and again in 1907, presumably in the late fall or winter since the trees in both pictures are bare. The photographs of Amboise appeared in two successive issues of the magazine in September 1909;[2] the second article also included views of Leonardo's house in nearby Cloux, where he lived from 1517 until his death in 1519.

Evans had explained his outlook in a lecture to the Royal Photographic Society in 1900:

Fig. 10. F. H. Evans. *Château d'Amboise: Chapel Entrance,* 1907. From *Country Life* (London), September 4, 1909

As regards my architectural work…I ought to say that the historical or merely architectural value of my subjects has always been of secondary interest to me; it is the beautiful rather than the antiquarian aspect that attracts me; and though, of course, all such attempts fall infinitely short of the beauty of the originals, yet I often wonder at the great truth and beauty which can form a photographic record of a fine piece of architecture, and that too from the point of view of "a work of art," much as a photograph's right to be so considered has been disputed.[3] C E

1. The commission is discussed in Beaumont Newhall, *Frederick H. Evans* (Rochester: George Eastman House, 1964), p. 25.

2. "The Chateaux of France, Amboise I and II: Indre-et-Loire, A Seat of the Duc d'Orleans," *Country Life*, September 4 and 11, 1909.

3. Beaumont Newhall, ed., *Photography: Essays and Images* (New York: The Museum of Modern Art, 1980), p. 177; reprinted from *The Photographic Journal*, vol. 59 (April 30, 1900), pp. 236–41.

Léonard Misonne
Belgian, 1870–1943

52 Untitled, 1919
Medibrome (oil pigment transfer?) print
11⅛ × 15⅜" (28.1 × 39 cm)
Signed on print: "Leonard Misonne/1919"

Léonard Misonne was Belgium's leading pictorialist photographer, and achieved considerable success in international circles during his lifetime. He was born in Gilly and studied engineering at the University of Louvain, where he became an enthusiastic amateur photographer. Upon graduation, Misonne, who was financially independent, did not practice engineering but devoted his time to painting, photography, and the piano. In addition, he traveled extensively in Europe.

After winning a photographic competition in 1896, Misonne dedicated his life to photography. His pictures were exhibited throughout Europe and in England, where he became a member of the London Salon.[1] Established in 1910 and active through the 1920s, the London Salon was created by photographers for the exhibition of international pictorialism. Its aim, as stated in the catalogue for its annual exhibition, was "to exhibit only that class of work in Pictorial Photography in which there is distinct evidence of personal artistic feeling and execution."[2]

Misonne is known for his pictures of the Belgian countryside. Helmut Gernsheim described them as "usually stormy views in late afternoon light, or with the sun breaking through the clouds after rain. This was by no means always a natural effect—a good sky negative served for many gum prints or bromoils, another controlled printing process invented in 1907. For nearly forty years Misonne remained devoted to this theme."[3] Like many of his pictorialist contemporaries, Misonne believed in the use of elaborately layered prints, often made with more than one negative, to create impressionistic effects. His pictures bore appropriately theatrical titles, such as *In the Country of the Winds* (1931) and *Melancholy* (1935).

Another characteristic of his work, as exemplified here, was the placement of small human figures in a large landscape. Making dramatic use of light and darkness, the picture suggests the vulnerability of man in the face of nature. S K

1. The best biographical sketch of Misonne appears in *Pictorial Photography in Britain 1900–1920* (London: Arts Council of Great Britain, in association with The Royal Photographic Society, 1978). See also *Leonard Misonne* (Vienna: Edition "Die Galerie," [c. 1934]).

2. *Catalogue of the International Exhibition of the London Salon of Photography* (London: Galleries of the Royal Society of Painters in Water-Colours, 1915), p. 7.

3. Helmut Gernsheim, *The History of Photography* (London: Oxford University Press, 1955), p. 353.

Drahomír Josef Růžička
American(?), born Czechoslovakia. 1870–1960

53 Untitled, early 1920s?
Gelatin-silver print
13⅛ × 10⁹⁄₁₆" (33.3 × 26.9 cm)
Signed in ink on print: "D J Ruzicka"; photographer's stamp, verso

Drahomír Josef Růžička took up photography as an amateur in 1904 while pursuing a career in medicine. He had graduated from New York University in 1891 and in 1894 opened a practice in New York.[1] With Clarence H. White, Alvin Langdon Coburn, and Gertrude Käsebier, Růžička co-founded in 1916 the Pictorial Photographers of America, an organization intended to serve as a replacement for the then defunct Photo-Secession.[2] By 1922 he had given up his medical practice.

Růžička often returned to his native Czechoslovakia, and during a trip in 1921 his work was included in an exhibition in Prague.[3] The young Czech photographers of the postwar generation were eager to make a break with the high-art style prevalent under the late Austro-Hungarian Empire, and they embraced the pure, objective aesthetic they found in Růžička's pictures.[4] Although his work is hardly radical, in the context of the decorative style of the influential František Drtikol, it is not surprising that younger photographers such as Josef Sudek (pl. 69), Jaromír Funke, and Jaroslav Rössler regarded Růžička's photographs as innovative and modern.[5]

Růžička's work was recognized internationally and published regularly in the annual of the Pictorial Photographers of America, and, during the 1930s, in *Das deutsche Lichtbild*. C E

1. Daniela Mrázková and Vladimír Remeš, *Tschechoslowakische Fotografien 1900–1940* (Leipzig: VEB Fotokinoverlag, 1983), p. 34.

2. Ibid.

3. Jirí Jeníček *D. J. Růžička* (Prague: SNKLHU, 1959), p. 11.

4. Petr Tausk, "The Roots of Modern Photography in Czechoslovakia," *History of Photography*, vol. 3, no. 3 (July 1979), pp. 254–56.

5. Ibid., pp. 259–65.

William M. Rittase
American, 1894–1968

54 *Light Rays on Trains, La Salle Street Station, Chicago,* 1931
Gelatin-silver print
9½ × 7⅝" (24.2 × 19.3 cm)
Photographer's stamp, verso; printed and inscribed in ink, verso: "Print No. X-720"

William Rittase was born in Baltimore, lived in Philadelphia, and was a highly successful commercial photographer. His clients included *Fortune* magazine and the American Railroad Association, for which this picture, from a series entitled "The Lone Traveler," may have been made. Although he worked on assignment, Rittase also had ambitions as an artist and frequently submitted his pictures to the photographic salons and pictorialist annuals of the 1920s and 1930s. Four photographs by Rittase appeared in the exhibition *Photography 1839–1937,* organized by Beaumont Newhall at The Museum of Modern Art, New York, in 1937.[1]

In 1930 Rittase wrote:

If I am a pictorialist, which this magazine has accused me of, it is because I make my living in this manner. The pictures I send to salons are picked from the day's work and were made to please the client primarily....To me

Fig. 11. Schell. *Rupert Brooke,* 1913. Gelatin-silver print. Paul F. Walter Collection

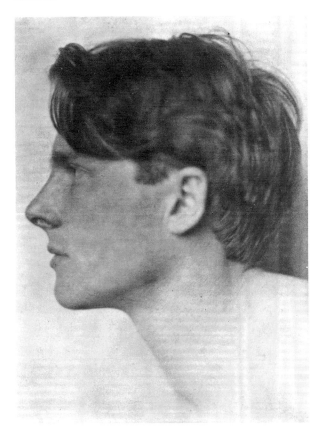

my commercialism is my pictorialism. They are inseparable. In addition, I am sometimes termed a modernist and as to what the world might call me, I have no control over that....[2]

Richard Roame Frame, a photographer and friend of Rittase, recalled that the latter's clients often specifically requested "The Rittase Touch." Frame continued:

What was this "Rittase Touch" and how was it identified? On analysis of early Rittase pictures with those made at a later date, all have certain characteristics in common: a striking use of black and white, black shadows and highlights that retain detail....More significant was Rittase's ability to immediately come to grips with the essence of the picture requirement at hand. He eliminated non-essentials and made the picture so simple and direct that the story was told with one glance.[3]

Rittase's pictures are no longer well-known, but this one appears to be typical of his commercial work. In contradiction to his statement of 1930, Rittase also made pictures of nude female models in the kitsch style of late pictorialism, which he submitted to the pictorialist annuals[4] and used as an annual year-end greeting card. SK

1. See Beaumont Newhall, catalogue of the exhibition *Photography 1839–1937* (New York: The Museum of Modern Art, 1937), p. 115.
2. William M. Rittase, "Why I am a Pictorialist Photographer," *Photo-Era Magazine,* vol. 65, no. 6 (December 1930), pp. 300–02.
3. Richard Roame Frame, "The Rittase Touch," *The Professional Photographer* (March 1970), pp. 52–55, 132–33.
4. See *Pictorial Photography in America,* vol. 4 (New York: The Pictorial Photographers of America, 1926), pl. 63.

Sherril Schell
American, 1877–1967

55 *Rupert Brooke,* 1913
Gelatin-silver print
9½ × 7¹¹⁄₁₆" (24.5 × 19.5 cm)

Sherril Schell was a professional photographer who worked internationally but about whom little is known. While living in London in the years before World War I, he made a series of portraits of English celebrities. In the spring of 1913, at the urging of friends, he asked the young Rupert Brooke (1887–1915) to sit for him. Brooke already was famous not only for his poetry but for his magical physical presence. Thirteen years later Schell recalled:

As far as I can remember I had never heard the word "beautiful" used to describe a man, and I was invariably amused whenever the most matter of fact English people spoke to me of the "beautiful Rupert Brooke," visualizing in spite of myself a sort of male Gladys Cooper or a Lady Diana Manners in tweed cap and plus fours. This bizarre picture remained fixed in my mind until...I learned from [a friend] that Brooke was a genial, wholesome fellow entirely unspoiled by all the adoration and adulation he had received from the great of the land—people like the Asquiths, the Lyttons, and the Wyndhams—an all round athlete, who spent most of his time outdoors, tramping the country roads, reading Dr. Johnson under the shade of oak and yew....[1]

Describing the sitting itself, Schell continued:

He was dressed in a suit of homespun, with a blue shirt and blue necktie. The tie was a curious affair, a long piece of silk wide enough for a muffler, tied like the ordinary four-in-hand. On any other person this costume would have seemed somewhat outré, but in spite of its carefully studied effect, it gave him no touch of eccentricity.

His manner was cordial and entirely unaffected, and the friendliness and honesty of his glance inspired instant confidence and liking.... And when he talked his charm was enhanced by a kind of spiritual radiance emanating from him.[2]

Schell made about a dozen portraits of Brooke, the last in a pose suggested by the poet himself, a profile baring his neck and shoulders (fig. 11). This refined portrait of perfected youth, reminiscent of Frederick H. Evans's portrait of Aubrey Beardsley (c. 1894), contributed to Brooke's legend when it was reproduced in his book *1914 and Other Poems,* published posthumously in 1915. It also was the model for a memorial medallion.

Here Brooke confronts the viewer with his vulnerability and promise. Schell's enthusiasm for his subject and the easy naturalness of Brooke account for the exceptional success of the portrait. Certainly Schell's story and photographs are in service to the legend of Brooke, particularly when we remember that the "beautiful" poet before us was to die two years later en route to Gallipoli. s k

1. Sherril Schell, "The Story of a Photograph," *The Bookman* (New York), no. 63 (August 1926), pp. 688–90.

2. Ibid.

Paul Strand
American, 1890–1976

56 *Rebecca Strand, New York,* 1923
Platinum/palladium print?
Inscribed in pencil, verso: "Paul Strand HS"

The relationship between Paul Strand and Alfred Stieglitz began in 1913 or 1914 when the neophyte Strand visited Stieglitz at his Little Galleries of the Photo-Secession, 291 Fifth Avenue, New York.[1] Over the next few years Stieglitz enlightened Strand on the potential of photography, suggesting that "the photographer must accept the great challenge of the objective world: to see profoundly, instantly, completely."[2] Nancy Newhall, who a quarter-century later spent many hours in the company of Stieglitz and Strand, observed that "during the slow, painful years of groping toward what he had to say, Strand went back to Stieglitz whenever he felt he had some advance to show."[3]

In 1915 Strand brought Stieglitz his revolutionary candid portraits of vendors and pedestrians on the streets of New York and his still lifes of kitchen bowls and fruit reduced to abstractions. The exhibition of this work at "291" in 1916 cemented a reciprocal photographic relationship, in which Paul Strand found in Stieglitz a mentor and Stieglitz found in Strand's work the embodiment of his photographic ideals.

In 1917 Stieglitz began an extended portrait of his future

Fig. 12. Strand. *Rebecca's Hands, New York,* 1923. Palladium print. Museum of Fine Arts, Boston. Sophie Friedman Fund. Reproduced by permission of the Museum of Fine Arts and the Paul Strand Foundation © 1971

wife, the painter Georgia O'Keeffe. It is possible that his approach to the series was influenced by Strand's early street portraits, radical in their extreme close-ups of faces. In turn, Strand looked to his mentor for inspiration. Nancy Newhall wrote:

In 1918–19, Strand served in the Army as an X-ray technician; on his release he found himself slow to regain his momentum. The photographs Stieglitz had been making, the passionate series of Georgia O'Keeffe, moved him to renewed activity.[4]

In 1945 Strand described Stieglitz's portraits in a lecture at The Museum of Modern Art: "He [Stieglitz] enlarged the concept of portraiture by showing that the sum of personality could be many different and photographable moments."[5]

Plate 56 is from Strand's series of his wife Rebecca, over one hundred negatives dating from 1920–25, 1928, 1929, and 1932.[6] The strong similarity between Strand's and Stieglitz's series, both in form and method, is remarkable. To realize the portraits Stieglitz and Strand used 4 × 5 and 8 × 10 cameras, platinum/palladium and gelatin-silver papers, and occasionally experimented with solarization. The photographs of Georgia O'Keeffe and Rebecca Strand include facial close-ups and profiles, details of their bodies (fig. 12) as well as truncated nudes. We see them in front of paintings, wearing black cloaks

and hats silhouetted against the sky, and in half-length and three-quarter-length views. The style of each series emphasizes the degree to which Strand and Stieglitz shared similar goals in photography.

Strand made his pictures in New York City; Georgetown, Maine; Mamaroneck, New York; Lake George, New York; and finally, by 1932, in Taos, New Mexico. These same locations were often the settings for Stieglitz's work of O'Keeffe. During the same period, Strand photographed Stieglitz, Stieglitz photographed Rebecca, and Rebecca photographed Strand.

Rebecca, the British-born daughter of Nate Salsbury, Buffalo Bill's partner and manager, married Strand in 1922. Like Georgia O'Keeffe, she was an artist, and her unusual paintings on glass were exhibited at Stieglitz's An American Place gallery in 1932 and 1936.[7] As Strand's friendship with Stieglitz evolved, so did the relationship between Rebecca and Stieglitz, although Rebecca and O'Keeffe never became close friends.[8] Like O'Keeffe, Rebecca Strand moved to New Mexico permanently, having broken with her husband in 1932.

A notable difference between the otherwise very similar portraits by Strand and Stieglitz arises from the personalities of the women they photographed. Physically, both Rebecca and O'Keeffe exhibited a clean, handsome look and strong confidence. Yet where O'Keeffe projected an ascetic countenance, a cool, artistic self-consciousness, Rebecca emanated sensuality and voluptuousness, charging Strand's work with an emotional impact not evident in the O'Keeffe series by Stieglitz. S K

1. *Paul Strand: Sixty Years of Photographs* (Millerton, N.Y.: Aperture, 1976), p. 176.

2. Nancy Newhall, *Paul Strand: Photographs 1915–1945* (New York: The Museum of Modern Art, 1945), p. 4.

3. Ibid., p. 4.

4. Ibid., p. 5.

5. "Photography and the Other Arts," a lecture by Paul Strand at The Museum of Modern Art, New York, 1945. Reprinted in *Center for Creative Photography, University of Arizona: Guide Series,* no. 2 (1980), *Paul Strand Archive,* p. 9.

6. I am grateful to John Rohrbach, Director of the Paul Strand Archive and Library, Millerton, N.Y., for enabling me to view some sixty photographs of Rebecca Strand and for providing information about the dates and locations of the pictures.

7. Biographical questionnaire completed by Rebecca Salsbury James, August 1952, for The Harwood Foundation, Taos, N. Mex.

8. See Sue Davidson Lowe, *Stieglitz: A Memoir/Biography* (New York: Farrar, Straus, Giroux, 1983).

Eugène Atget
French, 1857–1927

57 *Fête du Trône,* 1925
Arrowroot (vegetable-albumen-silver) print
6⅞ × 8⅞" (17.5 × 22.5 cm)

Inscribed in pencil, verso: "Fête du Trône 68"; photographer's stamp, verso; inscribed in negative: "68"

During the more than thirty years he photographed in Paris, Eugène Atget made some nine hundred pictures—perhaps a tenth of his total production—that he assigned to his Picturesque Paris series.[1] During the last three years of his life, the series was one of his most active concerns, and for it he produced many of the most remarkable pictures of his career, including the greatest of his photographs of shop windows and of the *fêtes foraines,* the street fairs that took place annually in their various quarters of Paris. The Fête du Trône was one of Atget's favorites, and from 1923 through 1926 he photographed it each April. Plate 57 shows a fragment of the exhibit "Armand the Giant," which also featured "the smallest man in the world." J S

1. See the third and fourth volumes of John Szarkowski and Maria Morris Hambourg, *The Work of Atget* (New York: The Museum of Modern Art) on Atget's organization of his work (Hambourg, "The Structure of the Work" in vol. 3, *The Ancien Régime* [1983], and his photographing of *fêtes foraines,* vol. 4, *Modern Times* [1985]).

Man Ray
American, 1890–1976

58 *Antonin Artaud,* 1926
Gelatin-silver print, printed later
9¼ × 7" (23.5 × 17.8 cm)
Inscribed in ink, verso: "A. ARTAUD/ [2bb?] MAN RAY"

When the American artist Man Ray moved to Paris in 1921, he supported himself through photography.[1] By 1924 he was well established as a portraitist. He produced hundreds of uninspired photographs on commission, but his real energy seems to have gone into portraits of the avant-garde artists and writers of his social and artistic circle. Man Ray was closely linked with the Surrealists, photographing them in group and individual portraits.

This photograph is one of a series Man Ray made in 1926 of Antonin Artaud (1896–1948), poet, essayist, actor, director, and playwright.[2] Artaud arrived in Paris in 1920 and quickly established relations with the leading figures of avant-garde art, literature, and theater. In 1924 he became associated with the newly formed Surrealist group led by André Breton. The following year he was the first director of the Bureau Recherches of the Centrale Surréaliste and edited the third number of the official Surrealist organ, *La Révolution surréaliste.* In 1926 Artaud began to withdraw from the Surrealists and founded the Théâtre Alfred Jarry based on the notion that theater should be provocative, painful, and anti-illusory. To support his work with experimental theater, he acted in French cinema.

Artaud's mental and physical health were problematic, beginning with a childhood case of meningitis. The pain he experienced throughout his life was central to his artistic

expression. In 1937 he was institutionalized and two years later diagnosed an incurable schizophrenic. J P

1. See *Man Ray Photographs,* intro. Jean-Hubert Martin (New York: Thames and Hudson, 1982).

2. Ibid., pls. 35–39.

Imogen Cunningham
American, 1883–1976

59 *Cala Leaves,* 1932
Gelatin-silver print
9⁹⁄₁₆ × 7⁹⁄₁₆″ (24.3 × 19.2 cm)
Signed in pencil on mount: "Imogen Cunningham"; printed label affixed to verso of mount: "Photograph by Imogen Cunningham/Mills College P.O./California/Title Cala Leaves/ Process Contact Print/Silver/Price"

Imogen Cunningham photographed plants and flowers throughout her seventy-five-year career. As a chemistry student at the University of Washington in the early 1900s, she worked part-time in the botany department making lantern slides of plants for study.[1] It was there, perhaps, that she formed her objective and scientific approach to photographing plants—an approach that never changed despite the other styles she subsequently developed, including the soft-focus pictorialism with which she began her serious artistic career.

In 1915 Cunningham married the etcher Roi Partridge and within two years bore three children, including twin sons. As Diane Wiseman has written:

Finding that portraiture was too demanding while raising her three sons, Imogen turned to her surroundings to discover that plants were ideally suited for the purposes of working at home. In contrast to her earlier more pictorial work, these bold and direct photographs of magnolias, agaves, water hyacinths, and succulents would become a main direction along with portraiture throughout her career.[2]

At least one of her lily pictures was included in the California Palace of the Legion of Honor exhibition *International Salon of Photography* (1928) in San Francisco. After seeing the show, Edward Weston, whom Cunningham had met in 1923, wrote to her: "As usual, most of it was rubbish…but I had one thrill, and it was your print, 'Glacial Lily.' It stopped me at once.…It is the best thing in the show Imogen.…"[3] The next year Weston, asked by the Deutscher Werkbund to nominate work of outstanding American photographers for the important *Film und Foto* exhibition in Stuttgart, selected ten examples of Cunningham's plant studies. The exhibition and the accompanying catalogue essays, including one entitled "America and Photography" by Weston,[4] defined the aesthetic of the New Realism in German photography as a precise rendition of pure forms. This aesthetic was shared by Edward and Brett Weston and by Charles Sheeler, other Americans represented in the show.

During the 1930s Cunningham was associated with a loosely organized group of photographers and friends living near San Francisco who met from time to time to talk about photography and show prints.[5] They called themselves the "f/64 Group," for the f/64 lens opening that provides the ultimate in detail and depth of field. Ansel Adams, a fellow participant, believed that membership should be restricted to "those workers who are striving to define photography as an art form by a simple and direct presentation through purely photographic methods"[6]—that is, without the fashionable soft-focus and manipulated effects of the pictorialists. Edward Weston and the f/64 Group provided the support that Cunningham needed to reject pictorialism in all phases of her work. S K

1. *Imogen Cunningham: Photographs,* introduction by Margery Mann (Seattle and London: University of Washington Press, 1970), n.p.

2. Diane Wiseman, "Imogen Cunningham 1883–1976," *Popular Photography,* vol. 79, no. 4 (October 1976), p. 51.

3. Letter from Edward Weston to Imogen Cunningham, reprinted in *Imogen! Imogen Cunningham: Photographs 1910–1973,* introduction by Margery Mann (Seattle and London: University of Washington Press, 1974), p. 77.

4. See catalogue of the exhibition *Film und Foto* (Stuttgart: Deutscher Werkbund, 1929).

5. See note 1.

6. Ibid.

Cecil Beaton
British, 1904–1980

60 *Edith Sitwell,* 1927
Gelatin-silver print
11⁹⁄₁₆ × 9⁵⁄₈″ (29.3 × 24.5 cm)
Signed in ink on mount: "Cecil Beaton"

In the exchange between portraitist and sitter, the degree to which each has helped the other invent a convincing image often is difficult to determine. Cecil Beaton's photographs of Edith Sitwell (1887–1964), however, present a well-documented example of artistic symbiosis.

Born to affluence and comfort, Beaton from an early age was delighted by photography, female glamor, and unabashed fantasy; in his own account, the three are thoroughly interdependent.[1] As a child, with the family butler as assistant and his sisters as models, he photographed in a style derived in part from Julia Margaret Cameron, in part from Edwardian celebrity portraits. Later he added to his admired models Edward Steichen, George Hoyningen-Huene, and Baron Adolf de Meyer. After withdrawing from Oxford and then from his father's business, Beaton sought to make his hobby his profession. He had little success until he met Edith Sitwell and her younger brothers Osbert (1892–1969) and Sacheverell (born 1897). By this time the three, especially Edith, were established figures of the British literary scene. Their reputation as modernist *enfants terribles* had been secured with *Façade,* an unconventional performance in which Edith recited her poetry —to William Walton's musical accompaniment—through a

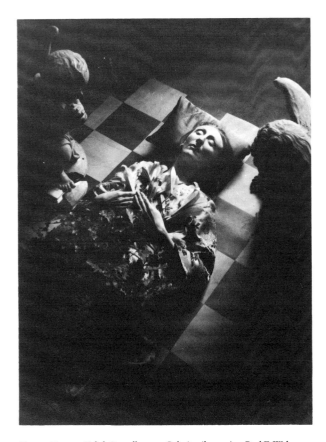

megaphone from behind a curtain. The initial presentation in 1923 had caused a minor scandal. Beaton first met the Sitwells at a party following a more polished and successful performance in June 1926.[2]

A few weeks earlier one of Beaton's friends had counseled him not to worry about his career: "Take it easy for a bit and become a friend of the Sitwells."[3] Edith's notoriously odd appearance—Beaton described her as "a tall, graceful scarecrow with the hands of a medieval saint"[4]—and her highly individual wardrobe made her a perfect model for Beaton. Having conceived her life as an elaborate costume fantasy, Edith readily submitted to Beaton's demand for ever more exotic poses. In one of these (fig. 13), Beaton recounted:

> She lay on the floor on a square of checkered linoleum disguised as a figure from a medieval tomb, while I snapped her from the top of a pair of rickety house-steps. At Renishaw Hall, the Sitwell house in Derbyshire, the ivy-covered ruins, stone terraces ornamented with large Italian statues, and the tapestried rooms made wonderful backgrounds for pictures of her. Here was the apotheosis of all I loved. With an enthusiasm that I felt I could never surpass, I photographed Edith playing ring-a-ring-of-roses with her brothers, plucking the strings of a harp, and, wearing an eighteenth-century turban and looking like a Zoffany, as in a huge four-poster bed, she accepted her morning coffee from a coloured attendant. Suddenly I found myself busy taking all sorts of exciting photographs. All at once my life seemed fulfilled.[5]

The feeling was mutual. After seeing his early photographs of her, perhaps including this one, Sitwell wrote to Beaton: "What an extraordinary gift you have. Really it is quite remarkable."[6] The judgment hardly was disinterested. If as a model Sitwell gave form to Beaton's talent, allowing him to realize his childhood fantasies in art, Beaton reciprocated by transforming her eccentricity into a commanding persona. PG

1. See Cecil Beaton, *Photobiography* (London: Odhams Press, 1951).

2. See Victoria Glendinning, *Edith Sitwell: A Unicorn among Lions* (New York: Knopf, 1981), pp. 71–86, and 109–11; and John Lehmann, *A Nest of Tigers: The Sitwells in Their Times* (Boston: Little, Brown, 1968), pp. 1–12.

3. *Photobiography*, p. 42.

4. Quoted in Glendinning, *Sitwell*, p. 109.

5. *Photobiography*, pp. 42–43.

6. Quoted in Glendinning, *Sitwell*, p. 111. For other photographs in this early series, see James Danzinger, ed., *Beaton* (New York: Viking, 1980); and Val Williams, "Façades: Cecil Beaton and Style in the Nineteen-Twenties," *The Photographic Collector*, vol. 3, no. 3 (Autumn 1982), pp. 158–70.

Florence Henri
French, born United States. 1893–1983

61 Untitled, c. 1931
Gelatin-silver print
11¼ × 9³⁄₁₆″ (28.5 × 23.3 cm)

Photographers and painters began learning from each other in 1839, but it was not until the 1920s in Europe that photography became an integral aspect of advanced art. At the Bauhaus, László Moholy-Nagy moved easily from one medium to another and treated photography as an essential element in his universal theory of visual art. One of his students for a brief period in 1927 was Florence Henri. The other teacher of the introductory course was Josef Albers, whose photography is intimately related to his work in other media.[1] Although the Bauhaus did not yet include photography in the formal course of instruction, it was there that Henri acquired her enthusiasm for the medium.

Born in New York of a French father and German mother, Henri was raised in Europe, where she traveled widely while in her teens.[2] First as a pianist and then as a painter, she became acquainted at an early age with avant-garde artistic circles in Germany, France, and Italy. In 1924 she settled in Paris, where she studied painting under Fernand Léger and Amédée Ozenfant. In 1928, after completing the introductory course at the Bauhaus, she returned to Paris and for the next decade devoted her best energies to photography. By 1929 her work was well known and began to appear in avant-garde periodicals and in exhibitions throughout Europe, including *Film und Foto* (1929) at Stuttgart. From 1930 she was a member of the Cercle et Carré group of abstract artists, which included Piet Mondrian. In 1939, at the outset of World War II, she gave up photography.

With the exception of a series of portraits of artist friends and a number of commercial assignments, Henri's photographs are mainly constructivist still lifes, which often include mirrors and simple, machine-made objects such as spools. The pictures are highly refined and elegant; nothing is ever out of place. This picture represents for Henri an extreme experiment, in which irregular natural forms and the implications they raise are allowed to enter her perfectly constructed world. P G

1. Several hundred photographs by Albers in the Josef Albers Foundation, Orange, Conn., are the subject of an unpublished study by Angela Tau Bailey. Four Albers photographs are reproduced in *Concepts of the Bauhaus: The Busch-Reisinger Collection* (Cambridge, Mass.: Harvard University, 1971). According to Bailey, Albers began to photograph in 1927 or 1928, that is, at the time or just after Henri was a student at the Bauhaus.

2. See *Florence Henri: Aspekte der Photographie der 20er Jahre* (Münster: Westfälischer Kunstverein, 1976); Maurizio Fagiolo, ed., *Florence Henri: Una riflessione sulla fotografia* (Turin: Martano Editore, [1975]); and *Florence Henri: Photographies 1928–1938* (Paris: Musée d'Art Moderne de la Ville de Paris, 1978).

Attributed to Tim Gidal
German, born 1909

62 *Beer Hall, Munich*, 1931
Gelatin-silver print
4⅞ × 6⅞" (12.2 × 17.5 cm)
Stamped, verso: "Presse-Illustration/Jos. Schorer/Hamburg 13, Rappstr. 20/Tel. 44 85 98"

The mechanical reproduction of photographs was not practical during the first four decades of photography. Instead they were reproduced as woodcuts, lithographs, and engravings by daily and weekly news journals (see fig. 4). Once the invention of the halftone process in 1880 liberated the photograph from graphic conversion, publishers made direct use of the halftone reproduction. Yet these pictures served primarily as supplements to lengthy texts. It was not until the founding between 1921 and 1933 of several press magazines in Germany, including the *Münchner illustrierte Presse, Berliner Illustrierte, Die Woche,* and *Arbeiter illustrierte Zeitung,* that the photo essay came into existence, creating an exciting new opportunity for photographers: to become freelance photojournalists.

Stefan Lorant, the noted editor of the *Münchner illustrierte Presse,* has stated: "We had no special photographer who worked solely for [us]. We used, like all other weeklies at that time, freelance photographers. With a couple of exceptions all German photographers freelanced for the several illustrated papers, selling their pictures and essays to the highest bidders."[1] The photographic agency was created to act as middleman between the photographer and the magazine. Dephot (Deutscher Photodienst), established in Berlin by former Bauhaus student Otto Umbehr (Umbo), was one of the most prominent, employing such photographers as Tim Gidal, Felix

H. Man, Lux Feininger, and Andrée Friedmann (Robert Capa).[2]

The creative use of photography through innovative graphic design began with the development of the small-format camera. Both the Leica and the Ermanox, marketed in Germany in 1924, used more light-sensitive film and faster lenses than earlier cameras, giving photographers the ability to make pictures at faster speeds. In addition, the Leica used roll film that could be advanced quickly. Consequently, many subjects never before attempted were possible. Since only available light was used, the atmosphere of the occasion remained undisturbed, and the viewer could be drawn into the photograph. In the early 1930s, for example, *Münchner illustrierte Presse* published photo essays on London nightlife, poverty in Hamburg, and the death of a pedestrian.[3] These subjects were presented in direct response to the economic and political turmoil in post-World War I Germany. As Ute Eskildsen has written: "The profound social changes of the early 1920s were not only a source of fear and insecurity but also challenged artists to face up to the situation of the time."[4] Tim Gidal described the atmosphere: "'Down with tradition!' 'Photograph living things and people as they really are!' was the mood of the new movement."[5]

This picture, attributed to Gidal, bears what is probably the stamp of a press agency on its reverse side. In the 1920s while studying law, history, and art history in Munich and Berlin, Gidal earned his living as a press photographer and worked for a number of press agencies, including Dephot, Mauritius, and Weltrundschau. The attribution is based on another photograph that appears to have been made the same afternoon.[6] The picture shows the interior of a beer hall as sunlight streams through its large windows. Although it is difficult to determine the relationship of the man and woman to those seated, they appear to be standing on either a table or bench. We do not know if they are performers, patrons, or employees. S K

1. Quoted in Wilhelm Marchwardt, *Die Illustrierten der weimarer Zeit* (Munich: Minerva Publikation, 1982), p. 111.

2. *Tim Gidal: Bilder der 30er Jahre* (Essen: Museum Folkwang, 1984).

3. Tim N. Gidal, *Modern Photojournalism: Origin and Evolution 1910–1933* (New York: Collier Books, 1973).

4. *Tim Gidal,* p. 6.

5. *Modern Photojournalism,* p. 12.

6. Reproduced in *Tim Gidal,* p. 16.

Ilse Bing
American, born Germany 1899

63 *French Cancan, Moulin Rouge, Paris*, 1931
Gelatin-silver print
6⅝ × 8¾" (16.7 × 22.4 cm)
Inscribed in ink on print: "Ilse Bing/1931"; inscribed in pencil, verso: "French Can-Can, Moulin Rouge Paris 1931 (Group)"

Ilse Bing first used a camera in 1923 to illustrate a paper she had written as a student of art history at the University of Frankfurt.[1] Soon she was making pictures on assignment for a Frankfurt newspaper. In 1929 she left the university and continued to photograph in Frankfurt, using first a Voigtländer camera, then a Leica. The next year she moved to Paris and began work as a freelance photojournalist.

Bing describes herself as new to the scene when, one evening in January 1931, she was sent on assignment to photograph the wax museum at the Moulin Rouge, a middle-class nightclub housing a floor show, a wax museum of its favored performers, and a dance floor for its patrons. While walking through the club, Bing was distracted and delighted by the cancan dancers, capturing their rushing movement in a series of pictures to which this one belongs.

Throughout her career, whether shooting portraits, still lifes, or street views, Bing used the Leica because it allowed her to record her immediate impressions of life. A few weeks after her assignment was completed, Emmanuel Sougez, photographic advisor to *Arts et Métiers Graphiques*, saw the cancan pictures in the window of La Pleiade, a bookstore on the boulevard Raspail, which served as a center for contemporary photography. Sougez wrote:

There were…four or six pictures, small, brutal in their contrasts and fascinating by virtue of an inexplicable rotating dynamism—what swirling of gowns, flowing scarves.…These were figures without detail, not that accidental blur some photographers cannot avoid (for here one felt it was intended; and without it these pictures would have been banal reportage) but a blur made up of superimposed instants. Movement decomposed and then recomposed in a single figure it seemed. Mystery and reality and, above all, something new.[2]

Sougez soon began to publish Bing's work. In 1934 he dubbed her "Queen of the Leica."[3] S K

1. Conversation with Ilse Bing, New York, September 30, 1984.

2. Emmanuel Sougez, "Ilse Bing," *L'Art vivant* (Paris), December 1935.

3. Emmanuel Sougez, *Bulletin de la Société Française de Photographie et Cinématographie* (Paris, 1934), p. 182.

August Kreyenkamp
German, 1875–1950

64 Untitled, 1930s?
Gelatin-silver print
9 × 6⅝" (22.9 × 17 cm)
Stamped, verso: "AUG. KREYENKAMP/PHOTOGR. KÖLN"

Kreyenkamp maintained a commercial studio in Cologne until 1939 and specialized in microphotography and photographs of works of art and architecture.[1] He was a member of the Gesellschaft deutscher Lichtbildner (Society of German Photographers) from 1936 until his death.

This picture doubtless was made on commission, after the sculptor (the man in work clothes at right?) had completed the two monumental angels and before they left the studio. Despite their size and idiosyncratic style, the sculptures remain unidentified. Although they are clearly angels and meant for public display, given their decorative flamboyance it is unlikely that they were intended for a church. P G

1. An example of Kreyenkamp's microphotography is reproduced in *Von Dadamax zum Grüngürtel: Köln in den 20er Jahren* (Cologne: Kölnischer Kunstverein, 1975), p. 145. A group of Kreyenkamp's photographs of Italian architecture and the city of Cologne—his two main subjects—is in the Canadian Centre for Architecture, Montreal. Further works are in the Folkwangmuseum, Cologne. Six of Kreyenkamp's Italian photographs were exhibited in the first *Photo-Kino Ausstellung* (Cologne, 1950).

Brassaï (Gyula Halász)
French, born Transylvania. 1899–1984

65 *"Juan-les-Pins," Folies-Bergère, Paris*, 1932
Gelatin-silver print
11¾ × 9¼" (29.7 × 23.4 cm)
Signed in pencil, verso: "Brassaï," with various photographer's copyright and address stamps

In 1932 Brassaï made a series of pictures backstage at the Folies-Bergère, the notorious Parisian entertainment palace. He photographed individual performers, clusters of costumed women in their dressing rooms, and views of the stage looking down from the scaffolding. Many of Brassaï's photographs of Paris night life appeared in *Paris de Nuit* (1933). Plate 65 is a variation (taken moments before or after) of one reproduced there. The caption for that picture reads: "In the wings of the Folies-Bergère the little women wait while chatting or sewing like a family, waiting for the curtain to rise on the sensational play of mirrors of an aquatic scene."[1]

The aquatic scene was "Juan-les-Pins in 1932," one of four *tableaux vivants* comprising the set piece "Sea Bathing," and one of some sixty *tableaux vivants* and individual acts in an evening's program at the Folies,[2] described in 1927 as:

Another riotous, eye-popping, head-pounding review. A Ziegfeld Follies and George White Scandals rolled into one. Not in talent and entertainment but in costuming and scenic investiture. A crash bang noisy spectacle with armies of nude girls and acrobatic dancers, and so many scene shifts you get dizzy.…[3]

Paris was a city of amusement in the years preceding World War II, and its theaters, music halls, and cabarets played an important part in the lives of its inhabitants and visitors, providing Brassaï with a photographic raison d'être.

Here Brassaï has created a disorienting mystery, as magical as the performances themselves. It is impossible to understand exactly how the mirror figured in the act. We only know for certain that there was a "sensational play of mirrors."[4] At first the picture suggests that it should be viewed horizontally, causing the reflected figures to appear upright and the real figures to recline and appear to be knitting on their backs with their legs in the air. The picture is filled with optical cunning,

engaging us in the ambiguous double image and the mysterious black line that bisects the picture. s k

1. *Paris de Nuit: 60 photos inédites de Brassaï* (Paris: Arts et Métiers Graphiques, 1933), n.p.

2. Program of the Folies-Bergère, 1932. Billy Rose Theater Collection, The New York Public Library.

3. Bruce Reynold, *Paris with the Lid Lifted* (New York: George Sully and Company, 1927), p. 148.

4. *Paris de Nuit*, n.p.

Henri Cartier-Bresson
French, born 1908

66 Untitled, 1929–30
Gelatin-silver print
11 × 9⅜″ (28 × 23.8 cm)
Inscribed in ink, verso: "Henri Cartier Bresson/31 rue de Lisbonne/Paris 8ᵉ"

67 Untitled, 1933
Gelatin-silver print
9¾ × 6⅝″ (24.6 × 16.9 cm)

In 1927 and 1928, Henri Cartier-Bresson studied painting in Paris under the Cubist pedagogue André Lhote and art and literature at Cambridge University, England. By 1929 he had acquired a serious interest in photography. In 1931, he abruptly exiled himself from the cultured society of Paris and left for the Ivory Coast of Africa.

I left [Lhote's] studio because I didn't want to enter into that systematic spirit. I wanted to reopen the question of my life, to be myself.... With Rimbaud, Joyce and Lautréamont in my pocket, I set off for adventure and earned my keep hunting in Africa.... I made a clean break.[1]

In 1932, a case of blackwater fever forced Cartier-Bresson back to France, but soon he was traveling again: throughout France, Germany, and Eastern Europe, then to Italy, Spain, and Mexico. Repeatedly he sought out poorer, less refined, and doubtless in his view more vital environments than the Paris he had left behind. This period of incessant travel—of escape from polite society and fashionable art—lasted for several years.

Cartier-Bresson's youthful restlessness crystalized into a highly original artistic talent in 1932 when he bought a Leica, a new hand-held camera that offered the photographer unprecedented mobility and quickness. He matched this technical versatility with his own agility, and since then his work has been regarded as the exemplar of photography's capacity to seize a fleeting scene. Nevertheless, the character of Cartier-Bresson's photographs is not always dependent on speed. These two early pictures of still subjects illustrate the resourcefulness of his visual imagination.

Plate 66 is one of Cartier-Bresson's few surviving pictures from the period when, before his trip to Africa, he worked with a camera that used small glass plates and stood on a tripod.

Superficially it reflects a taste for flat shapes and hard edges, in tune with Lhote's Synthetic Cubism. Yet it is hardly a routine exercise in graphic clarity. The cardigan hung out to dry has become a powerful, mysterious emblem, a heraldic image (Charlemagne's crown?). This transformation, completed by the disappearance of the clothespins scratched out on the print, illustrates a canonical principle of Surrealism: that the meaning of ordinary things is more complex and mysterious than everyday consciousness allows.

Whether or not the photographer had adopted this principle consciously, it is highly active in his early work. Before Cartier-Bresson, no photographer had so insistently and so successfully manipulated the elastic connection between subject matter and picture. Many of his best early pictures are not illustrations of his travels but of his own intense fantasies. In plate 67, the Surrealist transformation is extreme. Welcoming the banal clutter of the street, Cartier-Bresson has cast it as material for an outrageous visual pun. The pun may owe something to Cartier-Bresson's Cubist training, for it depends upon a pictorial intuition primed to anticipate the collapse of three dimensions into two. However, its playful irreverence toward aesthetic decorum is the photographer's own. p g

1. Translated from Yves Bourde, "Un Entretien avec Henri Cartier-Bresson," *Le Monde*, September 5, 1974, p. 13. The best account of Cartier-Bresson's early career is his introduction to *The Decisive Moment* (New York: Simon and Schuster, 1952).

August Sander
German, 1876–1964

68 *The Painter Heinrich Hoerle Drawing the Boxer Hein Domgörgen*, c. 1927–31
Gelatin-silver print
9 1/16 × 6 5/16″ (23 × 16.1 cm)

Sander photographed his countrymen with the ambition, first stated in 1924, to create a visual taxonomy of German society, ordered primarily by profession and trade.[1] He refused to collude with his sitters in the realization of sympathetic portraits. Instead, he claimed to document, with cool detachment, the subject's will to project his own social position through gesture, pose, and dress. This picture is unusual among Sander's group portraits, which otherwise represent only co-workers and couples. It shows Heinrich Hoerle, a socialist painter active in Cologne's Group of Progressive Artists, at work on a portrait of Hein Domgörgen, who became the European middleweight boxing champion in 1931. Sander also photographed Hoerle and Domgörgen individually.[2]

Directing the viewer to observe the transformation from model to drawing, Sander suggests the affinity between his own photographic work and the art of his friend Hoerle. Hoerle has exaggerated the underlying structure of Domgörgen's face, creating an archetypal image of a sad, emotionally simple, simian boxer. Hoerle included Domgörgen in his

Fig. 14. Heinrich Hoerle. *Contemporaries*, 1933. Oil and wax on wood. Location unknown

painting *Contemporaries* (fig. 14), along with himself, his wife (a painter), a lieder singer, and Konrad Adenauer (then mayor of Cologne). In the painting the boxer's physiognomy, so distinct in the drawing, is subdued by the dominant geometrical pattern. J P

1. See Ulrich Keller, *August Sander: Menschen des 20. Jahrhunderts* (Munich: Schirmer/Mosel, 1980), and Robert Kramer, *August Sander: Photographs of an Epoch, 1904–1959* (Millerton, N.Y.: Aperture, 1980).

2. See Keller, p. 86 (Domgörgen) and p. 323 (Hoerle). In these pictures the men appear to wear the same clothes as in the double portrait. Gerd Sander has suggested that the latter may have been intended as a publicity photograph for Hoerle's first exhibition at the Cologne Kunstverein. Since this did not occur until 1931, the three pictures, dated c. 1927 by Keller, should perhaps be dated 1931.

Josef Sudek
Czech, 1896–1976

69 *My Studio*, 1956
Gelatin-silver print
10⁹/₁₆ × 14⁵/₁₆″ (26.8 × 36.4 cm)
Inscribed in pencil in margin: "Sudek 1956"; and verso: "Můj atelier. 1956"

Sudek took up photography seriously in 1919 but did not mature as an artist until the early 1940s.[1] During these twenty years, he enjoyed steady commercial success and adopted the graphic style of advanced photography of the period. Neither suited his temperament, however, and from the onset of World War II, he increasingly turned away from both. From 1940 onward, Sudek's works are without exception contact prints and many are sharply focused, but in subject and style they represent a return to turn-of-the-century pictorialism. Dark in tone and mood, the pictures describe a closed world of melancholy and reflection. In his later work Sudek confined himself to a narrow range of subjects, each studied repeatedly in extended series: Prague and the Moravian landscape; the

"Magic Garden" of his friend Otto Rothmeyer; still lifes; and the interior, windows, and garden of his studio.

Sudek had taken up photography because the loss of an arm in World War I kept him from returning to the bookbinder's trade. In 1926 he revisited the site of his injury in Italy; the trip was so traumatic that he never again left Czechoslovakia. The following year he acquired the wood-frame studio where he would live until 1959 and work for the rest of his life. By the onset of World War II, the studio had become a haven of privacy and art, filled with treasured objects, souvenirs, and, once a week, close friends and musicians.

In 1940 Sudek began a series of photographs of the studio windows. Through the frost or dew that invariably covered the pane, there were blurred glimpses of the overgrown, untended garden outside. Beginning in 1950 and continuing at least until 1964, Sudek photographed the garden itself.[2] A few of the pictures capture the fresh daylight of spring, with buds on the branches. However, Sudek preferred to work in the fall and winter and late in the day. This picture, perhaps the best of the series, represents the extreme of this preference. The next day Sudek repeated the view (fig. 15), but slightly earlier in the evening so that the picture is more prosaic, the studio less compelling as a refuge of warmth and security. P G

1. The best biography in English is Petr Tausk, "Josef Sudek: His Life and Work," *History of Photography*, vol. 6, no. 1 (January 1982), pp. 29–58. See also Sonja Bullaty, *Sudek* (New York: Clarkson N. Potter, [1978]).

2. The latest I know is dated 1964; reproduced in sale catalogue *Photographs* (New York: Sotheby Parke Bernet, November 18, 1980), no. 409. Others in the series are reproduced in Lubomír Linhart, *Joseph Sudek Fotografie* (Prague: SNKLHU, 1956), pls. 154, 156–58, 194; Jan Řezáč, *Sudek* (Prague: Artia, 1964), pls. 26–35; W. Lippert and P. Tausk, *Josef Sudek* (Aachen: Edition Lichttropfen, 1976), pls. 18–20; Zdeněk Kirschner, *Josef Sudek* (Prague: Edice Fotografie-Osobnosti, 1982), pls. 5–6; and Tausk, "Sudek," fig. 21.

Fig. 15. Sudek. *My Studio*, 1956. Gelatin-silver print. Location unknown

INDEX TO PHOTOGRAPHERS